P9-DDV-614

MINIMALISM

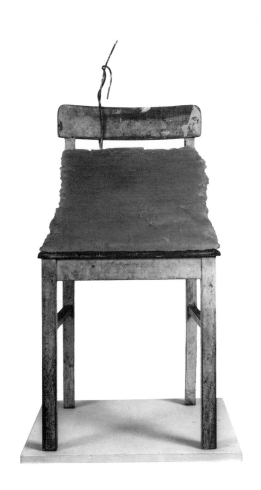

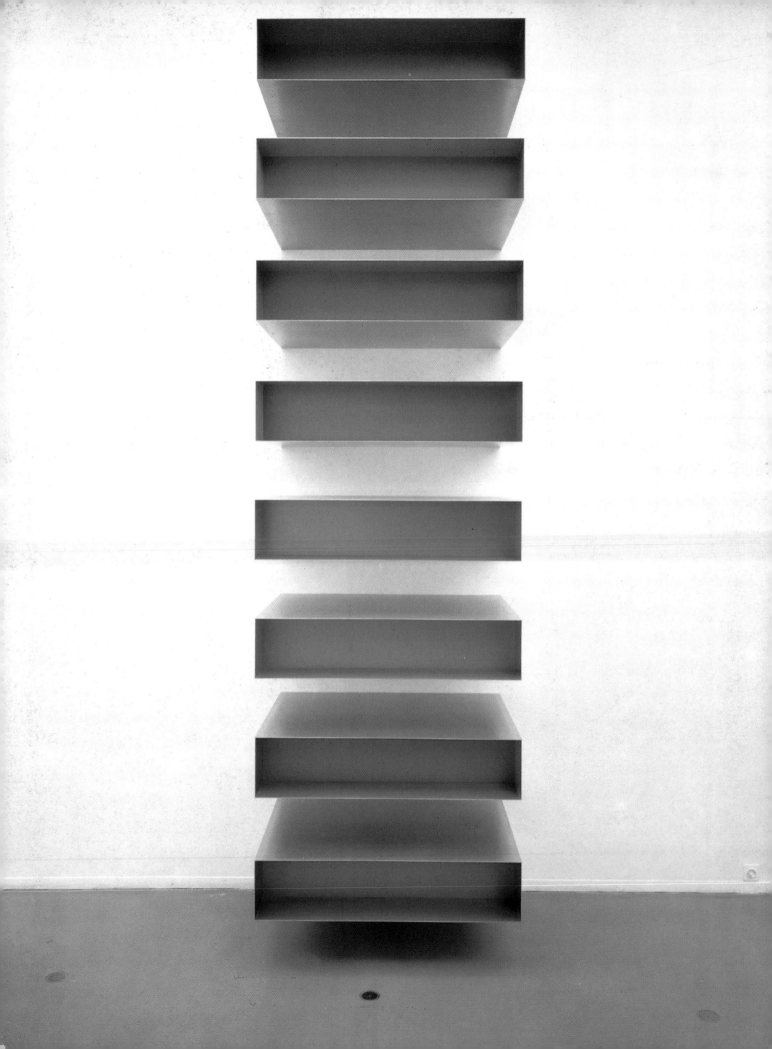

MINIMALISM

ART OF CIRCUMSTANCE

ABBEVILLE MODERN ART MOVEMENTS

ABBEVILLE PRESS ▪ PUBLISHERS ▪ NEW YORK

ACKNOWLEDGMENTS

Among the key ingredients of this book were intermittent conversations and correspondence with Gary Michael Dault, William S. Wilson, Anthony Thompson, Louis Asekoff, David Raymond, and Richard Fishman. Brian O'Doherty, Ingrid Sischy, and Jacolyn Mott offered needed perspectives on the manuscript at different stages, as did my editor at Abbeville, Alan Axelrod. The most steadfast and assiduous background contributor to the book has been my wife, Tonia Aminoff, to whom it is dedicated.

A brief book necessitates many omissions. Thanks are due to the many artists not cited here whose works have clarified pertinent issues for me in ways that words alone could not.

Jacket front:
Dan Flavin, *Untitled*, 1976
Pink, blue, and green fluorescent
light, 8 ft. high
Private collection

Jacket back:
Frank Stella, *Telluride*, 1960–61.
See p. 26

Front endpapers:
Richard Serra, *Splashing*, 1968
(detail). See p. 114

Back endpapers:
Robert Morris, *Untitled*, 1968–69
(detail). See p. 90

Frontispiece:
Donald Judd, *Untitled*, 1978
Steel and green anodized aluminum;
10 units, 9 × 40 × 31 in. each
Saatchi Collection, London

Half-title page:
Joseph Beuys, *Fat Chair*, 1964.
See p. 118

Epigraph page:
Carl Andre, *Copper Piece* (left),
Aluminum Piece (right), both
1969. See p. 115

Editor: Alan Axelrod
Designer: Julie Rauer
Photography editor: Lisa Peyton
Production supervisor: Hope Koturo

Published in the United States of America in 1988 by Abbeville Press, Inc.

First edition

ISBN 0-89659-887-X
ISSN 0898-1132

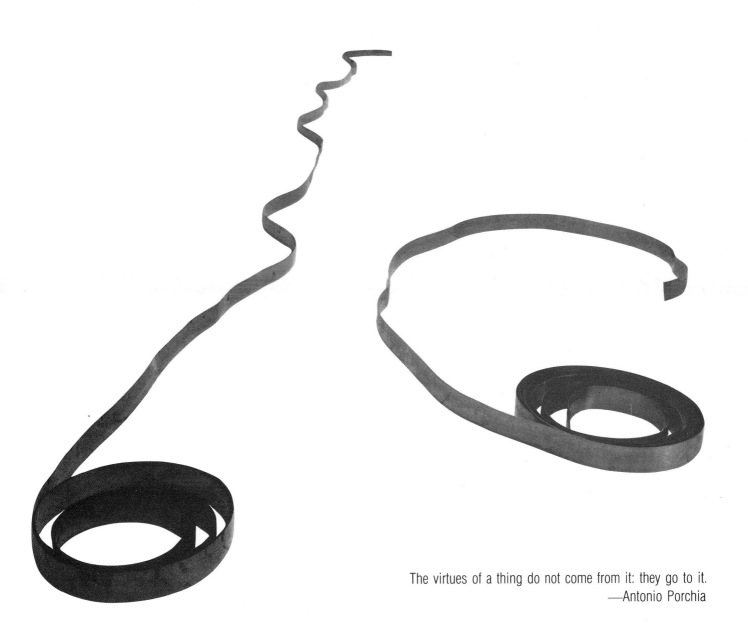

The virtues of a thing do not come from it: they go to it.
—Antonio Porchia

CONTENTS

O N E

Think of "Minimalism" as the name not of an artistic style but of a historical moment, a brief outbreak of critical thought and invention in the cavalcade of postwar American art. Because the artists, critics, events, and publications that contributed most to it were centered in Manhattan, this book focuses on New York art. Many of the American artists known as Minimalists have in common little more than the fact that their works met with some recognition and success in the New York art market as it began to set the pace of international traffic in contemporary art. Yet "Minimalism" is more than a New York art-world buzzword. A number of artists who worked on the West Coast during the 1960s, such as Robert Irwin, Larry Bell, and John McCracken, might be called Minimalists because they made highly refined objects and installations that raise questions about how art depends upon its viewers.

The word "minimal" is used loosely these days in reference to any stylistic austerity in the arts. The term "Minimalist" is only slightly more precise when applied to works of visual art. It carries two distinct implications, each with its own historical resonances. The term may refer to art, primarily sculpture or three-dimensional work made after 1960, that is abstract—or even more inert visually than "abstract" suggests—and barren of merely decorative detail, in which geometry is emphasized and expressive technique avoided. The works of artists such as Donald Judd, Ron Bladen, and Tony Smith qualify as Minimalist in this sense. The art-historical ancestry of this strain of work includes Suprematist, De Stijl, and Constructivist abstract painting and sculpture, from that of Russians such as Kasimir Malevich and Aleksandr Rodchenko to the work of Piet Mondrian and Josef Albers, both of whom lived in America late in their careers. Almost as important to this mode of Minimalism as its art-historical precedents is the broad background of American mass production. Artists such as Judd and Smith responded to the cynical superabundance of industry by using its services to produce objects calculatedly unlike what the cornucopia of mass production disgorges. These artists recognized that industry controlled the aesthetic physics of objects to a degree that no individual artist could, and they resorted to industrial fabrication in order to avail themselves of that control.

The other sense of "Minimalist" refers to the tendency of such people as Carl Andre, Dan Flavin, and Robert Morris to present as art things that are—or were when first exhibited—indistinguishable (or all but) from raw materials or found objects, that is, minimally differentiated from mere non-art stuff. Such works were often intended to throw into relief the perceptual and institutional terms of art's validation, though not everyone is willing or able to see those terms laid bare. The historical sources for this type of work include the found-object "readymades" of Marcel Duchamp and

Richard Artschwager, *Chair*, 1966
Formica, 59 × 18 × 30 in.
Saatchi Collection, London

9

the sculpture of Constantin Brancusi, works that tested the limits of "art" as nothing before them had done.[1]

The tension between these two currents of Minimalist sensibility—industrial aesthetics and the blurring of distinctions between art and non-art—gave American art of the 1960s a philosophical vividness scarcely seen in art before or since. The tension is apparent in contrasts between early works of, say, Ron Bladen and Carl Andre, and even in works from different years by the same artist, as in the cases of Robert Grosvenor, Robert Morris and Robert Smithson. Whether the concept or specifications of a work of art have priority over its material reality—and who decides this and how—were live issues throughout the Minimalist years. The works of some artists—despite what they may have said to the contrary—affirmed intellect as the determinative dimension of people and of art; others gave primacy to the observer's bodily awareness as the standpoint from which he must construe an artwork's rationale and his own role in determining what he sees. A widely held assumption in the New York art world of the 1960s was that in terms of the way his work resists easy reading, an artist might propose without words a theory of how and where meaning occurs and of what it is to see understandingly. Among the so-called Minimalists were artists who tried to do just that.

The impulse behind Minimalism—the drive to clarify the terms in which art takes a place in the world—motivated visual artists working independently in various countries in the 1960s. Joseph Beuys, Yves Klein, and Piero Manzoni in Europe, Anthony Caro and William Turnbull in England, and Ellsworth Kelly, Frank Stella, and Carl Andre in America all fall within the broadest definition that might be given the

John McCraken, *Untitled*, 1967
Fiberglass and lacquer,
94 × 14¼ × 1¼ in.
Saatchi Collection, London

Larry Bell, *Bette and Giant Jewfish*,
1963
Vacuum-coated glass, chrome-plated
metal, 16½ × 16½ × 16½ in.
Betty Asher, Los Angeles

Tony Smith, *Smog*, 1969
Bronze, 12 in. × 6 ft. 5 in.
× 9 ft. 5 in.
Estate of the artist

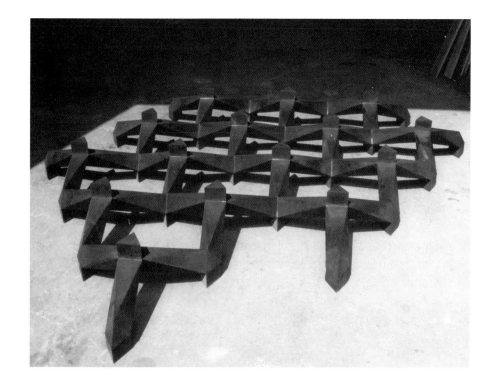

Carl Andre, *Joint*, 1968
Uncovered baled hay; 183 units,
14 × 18 × 36 in. each
Installation: Windham College,
Putney, Vermont
(Destroyed)

Kasimir Malevich, *Suprematist
Painting*, 1917–18
Oil on canvas, 41¾ × 27¾ in.
Stedelijk Museum, Amsterdam

Constantin Brancusi, *Torso of a
Young Man*, c. 1916
Maple on limestone base,
19 in. high
Philadelphia Museum of Art; Louise
and Walter Arensberg Collection

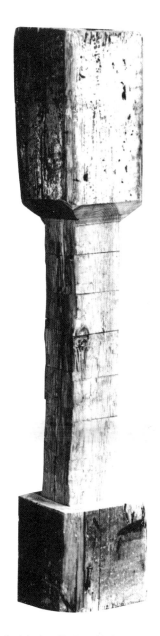

Carl Andre, *Chalice*, 1959
Wood, dimensions unknown
(Destroyed)

international phenomenon of "Minimalism." A major difference between the Europeans and the Americans and British is that when Europeans subverted the conventions that set art off from the rest of reality, they chose materials for metaphorical suggestiveness, as Beuys did, for example, in making sculpture from fat, felt, and rubber. On the other hand, Americans such as Donald Judd, Carl Andre, and Robert Morris, who also worked the margins of art, aimed to eliminate metaphor and make their sculpture as lucid and specific as possible. These artists tended to choose materials and forms for their matter-of-factness.

Countless other artists who never got recognition for their efforts might be numbered among contributors to the Minimalist project, which was, as Marina Tsvetaeva said of modern poetry in Russia, "an undertaking in common performed by solitary people."

In an overview of modern Western art, American Minimalism looks like a classicizing reaction against the Romantic exuberance and self-celebration of 1950s Abstract Expressionist painting. Both stylistic extremes may be plotted on a dialectical zigzag between hot and cool sensibilities stretching back to late eighteenth-century European art. We might even see the temper of Minimalism anticipated in 1950s literary culture in the austerities of Samuel Beckett's theater and of Alain Robbe-Grillet's "new novel."

New York Minimalism had sources closer to home in the distinctly American tradition of respect for plain facts and plain speaking, manifested in Shaker furniture and the pragmatist philosophy of Charles Sanders Peirce and William James, in the precisionist painting of Charles Sheeler, in the "scientific" realism of Thomas Eakins, the photographs of Paul Strand and Walker Evans, and the poetry of Williams Carlos Williams and Marianne Moore.

Piet Mondrian, *Composition 2*, 1922
Oil on canvas, 21⅞ × 21⅛ in.
Solomon R. Guggenheim Museum,
New York

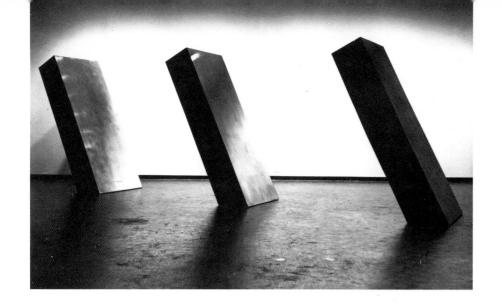

Ronald Bladen, *Three Elements*,
1965
Painted black steel and polished
aluminum; each element:
9 ft. 4 in. × 4 ft. × 2 in.
Private collection

In the long view of American culture, Minimalism figures as one of those periodic spasms of revolt against the "vulgar prosperity," as Ralph Waldo Emerson called it, spawned by the collision of democratic politics and capitalistic ambition. Minimalism embodies the frustrated American ideal of simplicity, refracted through formal idioms of modern art. "Though a failure as a societal ethic," writes historian David Shi, "simplicity has nevertheless exercised a powerful influence on the complex patterns of American culture. As a myth of national purpose and as a program for individual conduct, the simple life has been a perennial dream and a rhetorical challenge, displaying an indestructible vitality even in the face of repeated defeats. It has, in a sense, served as the nation's conscience, reminding Americans of what the founders had hoped they would be and thereby providing a vivifying counterpart to the excesses of materialist individualism."[2]

The Minimalist urge to clarify aesthetic experience so its determining factors may be recognized is deep in the American grain of pragmatic thought and, more remotely, rooted in the spirit of eighteenth- and nineteenth-century utopian social experiments, founded on a recognition of conventional society's perfidy. Those experiments typically had a religious or spiritual as well as a social animus, as in the case of the Shakers and of utopian communities such as Oneida and Brook Farm.

The Shakers are an important precedent to bear in mind. Their sectarian withdrawal from mainstream society was so complete that it necessitated becoming economically self-sufficient. Producing their own tools, furniture, and housewares in a self-effacing spirit, the Shakers developed a unique craft aesthetic. Their rejection of ornament for an elegance born of optimum economy and practicality of design has an unmistakable resonance with aspects of some Minimal art. There is an echo of the Shaker ethos in Carl Andre's remark: " 'Minimal' means to me only the greatest economy in attaining the greatest ends."[3]

The Minimalist moment of stylistic clarity and critical purpose in art was a brief one partly because no stable community existed to sustain it. Its social basis was the art world, a competitive, volatile subculture whose economy depends on perennial renewal of novelty both in art and in opinion about it.

The 1960s were a period of unprecedented cultural ferment in America. At the turn of the decade, Abstract Expressionist painting was still authoritative, albeit in a latter-day, mannered phase. Artists such as Allan Kaprow and Claes Oldenburg

pioneered "happenings" in Manhattan as the first Minimalist art was being made there. Happenings, the improvised theatrics in which performers and audience might switch roles at whim, were closer in spirit to Abstract Expressionism than to Minimalism. Happenings foreshadowed the assaults on pretension and hierarchy that would become a point of pride for the youth "counterculture" later in the decade, although, like certain works of Minimalism, they also strayed across the conventional limits of art. The word "happening" quickly became slang for any public event marked by improbable spontaneity.

In retrospect, the sixties counterculture appears to have been an epidemic of popular narcissism that swept the first generation to see its collective self on television. Minimalism was a more sober and high-minded tendency than anything the term "counterculture" connotes. Yet both were cultural symptoms of the long-standing American obsession with individuality, with the difficulty of reconciling the desire to be a law unto oneself and the inescapable demands of society. The conditions of mass society had rendered this obsession painfully anachronistic by the time events of the 1960s inflamed it. The nation's domestic recuperation from World War II entailed a slow, almost reluctant shaking off of the obedient conformity the war effort had demanded.

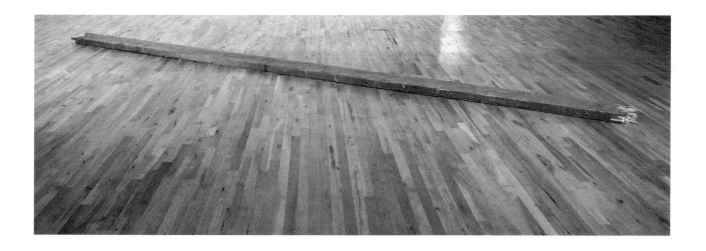

Robert Grosvenor, *Untitled*, 1974
Wood, 18½ ft. long
Paula Cooper Gallery, New York

With the rise of a new generation in the 1960s came a new wave of indigenous exuberance at the sheer fact of individual identity. Growing prosperity seemed to offer new freedom for personal growth and for experimentation with ways of living. "By 1964," according to Abe Peck, "meaningful numbers of protesters and dropouts were populating their own communities, off college campuses and in large cities. As the years went by, New York's Saint Mark's Place, Berkeley's Telegraph Avenue, Los Angeles' Sunset Strip, San Francisco's Haight, Chicago's Wells, and Madison's Mifflin streets turned into enclaves as well as addresses."[4] However, these possibilities were circumscribed by mass institutions of commerce and bureaucracy that paid lip service to the integrity of individuals' lives while negating it in their real policies and operations. The conflicts over civil rights and the Vietnam War dramatized the divergence between official doctrine and everyday life. The ideology of freedom and justice for all ran counter to people's real experiences of racism, discrimination against

women, educationally enforced conformity, and oligarchic government. Such contradictions engendered desperate protestations of human worth and demands for social justice. Meanwhile, the media mechanisms for shaping collective opinion and behavior became rapidly more refined. All thoughtful people faced questions about duties owed to society and to themselves and about the value of personal experience and judgment in a world top-heavy with institutional authority. For a generation coming into adulthood, pervasive doubt about the legitimacy of institutions deepened the innate difficulty of distinguishing individuality from subjectivity: both these aspects of private life were being subtly, persistently denied by bureaucracy and by the very nature of consumer goods and services. The popular manias for psychoactive drugs and for sexualizing public demeanor were symbolic of a common uncertainty about what it is to be—and be acknowledged—an autonomous person. A psychedelic drug experience is a bath in subjectivity, in sheer susceptibility to sensation, emotion, and the body's own electrochemistry. Such experiences were misrepresented in counterculture lore as special insight into personal identity. Yet in the dilemmas of self-definition, the limits of subjectivity are an unremitting issue that no altered mental state resolves. As Thomas Nagel sums up the problem, "How, given my personal experiential perspective, can I form a conception of the world as it is independent of my perception of it? And how can I know that this conception is correct?"[5]

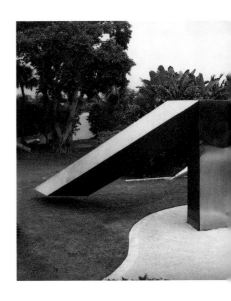

Robert Grosvenor, *Tapanga*, 1965
Stainless steel and paint, 9 ft. 6 in.
× 19 ft. 10 in. × 3 ft. 8 in.
The Lannan Foundation

Boundaries between individual and collective life, between male and female, the personal and the impersonal, the permissible and the forbidden, public and private, convention and invention, art and non-art, all became newly indistinct during the 1960s. The questions raised by Minimal sculpture seem a lot less abstruse when you remember how pervasive (though how inconsequential from the vantage point of power) was the issue of the individual's capacity to judge the meaning of events in his own life and in the larger world. In Minimalism and Pop Art, though with very different emphases, the nature of human selfhood and the weight (or weightlessness) of direct experience were interconnected themes.

The critical temper of Minimalism is most apparent in works that are on the edge or over the edge of artistic nonentity or of meaninglessness. It is those works that demanded the most overt commitment—favorable or hostile—from the public. The demise of Minimalism is the story of how that critical spirit was neutralized by the art business and by the general backlash in American society against the liberal spirit of the 1960s and in favor of a kind of self-righteous millenarian avarice.

By the mid 1970s, Minimal art had become the currency of lucrative careers for a number of artists, notwithstanding the contradiction in works of critical import being converted to glamour commodities. The political ardor associated briefly with Minimalism reemerged in the late 1960s in conceptual art, which reached the conclusion implicit in Minimal sculpture that elimination of the artwork-as-commodity was the only logically consistent basis on which artists could criticize the culture from within. The conceptual artists' basic strategy was to eliminate the art object completely, offering only written or spoken ideas or quizzical performances as works, leaving little or no artistic residue except documentation. Of course, because documentation can be treated as salable goods, not even conceptual art could short-circuit the art market. Still, certain conceptual art activities that were never documented— and so eluded the commodity system—continue to live in people's memories as a kind of intellectual folklore of the art world.

While Pop Art—predominantly painting—was wry, campy, garish, and cynical, Minimalism, which primarily took the form of three-dimensional art, was cool, philosophically severe, and, initially at least, dead set against seduction and entertainment.

Artists such as Roy Lichtenstein and Andy Warhol borrowed prefabricated images and sentiments from mass culture to siphon off some of its brash energy into painting and sculpture. They tainted with irony whatever they adapted from American popular culture. In winning a new mass audience for painting, they also intensified public curiosity about the style and content of their scavenged, demotic subject matter.

Both "Pop Art" and "Minimalism" are creations not only of artists, but of ancillary art-world professionals—curators, critics, dealers, journalists, historians— who render art palatable to a public hungry to assimilate novelties and impatient with specifics. The term "Minimalism" is part of the lingo of this subsidiary industry that processes art for public consumption. None of the artists branded with the Minimalist label accepts it. Unfortunately, there is no way to avoid using it, for it is already embedded in the literature and in common speech.

Some of the most misleading terms in the jargon of modern art end in "ism." A few, such as "Futurism" and "Surrealism," were coined by artists, and backed up with manifestos, to serve as code words for a stylistic or ideological agenda. Most subsequent "isms" have originated as the shorthand of critics seeking to spotlight affinities in works of various artists, irrespective of the artists' professed intentions. "Minimalism" is an example: what the term really denotes is a manner of remembering, grouping, and ranking certain artworks of the recent past.

Through vagaries of usage it superseded non-starters such as "ABC Art," "Primary Structures," "Cool Art," "Specific Objects," and "The Art of the Real." Several of these tags served as titles of exhibitions intended to define the new strain of "hard-edge" sensibility in American and British art of the 1960s.

The word "Minimalism" was first put forward as an art term in 1937, for purposes very different from those it serves now, by the maverick Russian-born American artist John Graham. At the heart of a windy, provocative tract he called

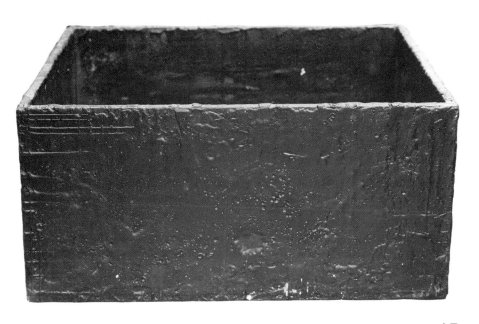

Joseph Beuys, *Rubberized Box*, 1957
Pine covered in rubber and tar, 39⅜ × 39⅜ × 19¾ in.
Hessisches Landesmuseum, Darmstadt, West Germany

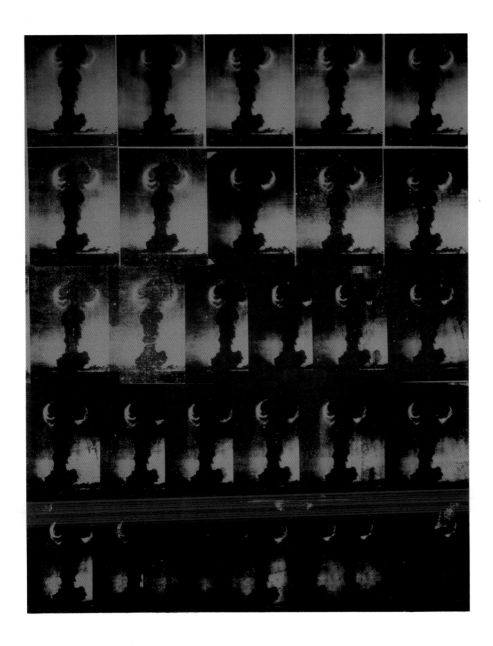

Andy Warhol, *Atomic Bomb*, 1965
Silk screen on canvas,
104 × 80½ in.
Saatchi Collection, London

"System and Dialectics of Art," published in Paris, Graham offered a spate of definitions, including this one: " 'Minimalism' is reducing of painting to the minimum ingredients for the sake of discovering the ultimate, logical destination of painting in the process of abstracting. Painting starts with a virgin uniform surface and if one works ad infinitum it reverts again to a plain uniform surface (dark in color), but enriched by process and experiences lived through."[6] Although he added to this statement, "Founder: Graham," his own paintings look nothing like what his definition promises. The monochrome paintings of Brice Marden and of California artist James Hayward fit Graham's prescription as well as those of any American artist.

It was not Graham's text, but Richard Wollheim's 1966 essay "Minimal Art" that made it critically respectable to speak of "Minimalism."[7] Wollheim, a well-known British philosopher, observed a groundswell of new art in the early 1960s with what he characterized as "minimal art content." He made no distinction between the tactics

of appropriating prefabricated imagery, as Andy Warhol and Roy Lichtenstein did, and of contracting industry to fabricate "original" works, as Donald Judd and Robert Morris did. He saw both these practices as means of minimizing the "art content" of the finished product.

Wollheim saw various artists subverting the notion that what transformed raw materials into works of art was their own skilled labor. He formulated their challenge in terms of how things are to be recognized as works of art once all the customary earmarks, such as personal workmanship and expressive inflection, have been effaced. However, he did not construe this question as the artists intended. Many of the artists wanted viewers' uncertainty to redirect their attention to unacknowledged factors—such as the isolation of the gallery space and the intimidating authority of art institutions—that "make" something a work of art. Wollheim took the artists to be exhausting every possible sense that might be given their own productive activity. He argued, for example, that because painting typically involves many acts of effacing visual information, as the painter revises decisions on canvas, the process of effacement itself might be promoted legitimately to a mode of "work" in its own right, on a par with the more obviously constructive acts of painting. And he cited Ad Reinhardt's black paintings, in which no trace of gesture can be seen.

Painting gets short shrift in this book because most of the artists who might be called Minimalist painters—Robert Ryman, Jo Baer, Agnes Martin, Brice Marden, and Ellsworth Kelly, among others—did not take abstraction to a point where it made

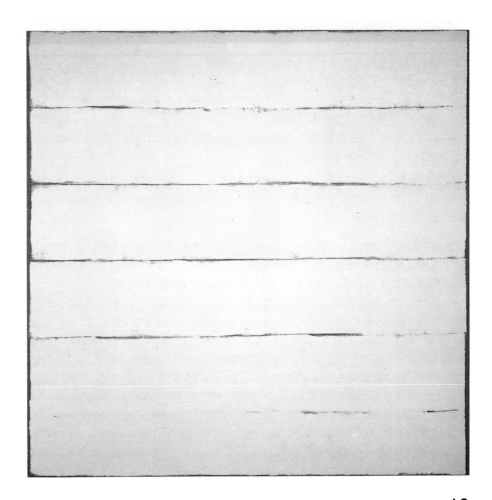

Robert Ryman, *Mayco*, 1965
Oil on canvas, 76 × 76 in.
Saatchi Collection, London

19

their works unrecognizable as paintings, at least not during the 1960s. Agnes Martin has all but abandoned paint for graphite at times, but as long as she works on stretched canvas, her work's affinity with painting is unmistakable. Robert Ryman's paintings thematize the process of covering a surface in a Minimalistically methodical and self-effacing spirit. And Brice Marden's airtight encaustic canvases have a density that seems to announce the historical closure of pictorial depth, a sort of metamorphosis of painting into as-yet-unworked surface for sculptural relief. Yet the works of all these artists are commonsensically recognizable as paintings, at least as objects qualified by pictorial conventions, even if their point is to flout such conventions. They don't cross the line into the realm of hard-to-place objects. Perhaps Richard Tuttle's stained, unstretched, polygonal canvases of the 1960s might qualify as Minimalist works in that they raise doubts materially about whether they are intended to be paintings. But Minimalism, as I use the term, connotes more deliberately anti-pictorial modes of art.

Many artists of the Minimalist generation started working the ambiguous terrain *between* painting and sculpture, which had been opened up by such people as Robert Rauschenberg, Joseph Cornell, Ed Kienholz, H. C. Westermann, and Louise Nevelson. Stressing the categorical ambiguity of an object highlighted the processes by which it was promoted to the status of art. The middle ground between media was so arable, it soon yielded such strange artistic fruit as earthworks and the uses of their own bodies as fields of action by people such as Dennis Oppenheim and Vito Acconci. Because no terminology existed to cope with the new forms and materials of art, a consensus developed that Minimalism had expanded the definition of ''sculpture,'' which meant merely that everyone began to use ''sculpture'' more loosely than ever before.

Wollheim seems to have set the intellectual style of talk about ''Minimal Art'' by writing about it as if the artistic choices it involved were merely tactical, not aesthetic. He pinpointed Marcel Duchamp's ''readymades''—the common manufactured items Duchamp designated his ''work''—as the historical precedent for artists to play free with the art quotient of their output. But Wollheim construed this link to mean that the minimization of art content by artists of the 1960s must be as conceptual an affair as Duchamp's abandonment of painting for intellectual pranks had been before 1920.

Defenders of Minimalism tend to overemphasize a conceptual or strategic reading of it for reasons different from Wollheim's. He simply didn't look at Minimal Art as if looking were what mattered. Those who wish now to defend the Minimal work of artists such as Ellsworth Kelly, Donald Judd, and Sol LeWitt often give it a conceptual reading because they are uneasy about its market success. There is no denying that the work's marketability has compromised its original refractory intent.

The argument of this book is that Minimalist art made possible new strains of art experience, but that the Minimalists' methods inevitably failed to fix or objectify those possibilities of experience in ways that enable us to know whether or not we can still partake of them. Those possibilities may well have been contingencies of historical circumstance that can never be reconstructed. Minimalism was (and arguably still is) the project of disclosing and exploiting the contingent, contextual aspects of making—and of instituting something—a work of art. But because contextual circumstances change, we can never be sure in what sense, if any, the Minimalist

Marcel Duchamp, *Bottle Rack*, 1914
(replica 1964)
Steel, 25½ in. high
Collection Arturo Schwarz, Milan

works we see today are what they were when they were first put forward. From a conservative critical viewpoint this is the crux of Minimalism's weakness as art: its failure to seal itself or its meaning against erosion by circumstances that were certain to change.

An earmark of Minimalist art is the tendency to locate content outside the art object, in its physical setting or in viewers' responses, rather than "inside" it, in the literary or psychological import of an image, for example. Minimalist art proves itself not by preserving a range of aesthetic values against the ravages of history and human forgetfulness, but by its power to keep us mindful of art and its meaning as creations of the social order, not just of gifted individuals.

Most Minimal sculpture and painting is thoroughly modernist in one sense: it presupposes that thinking about experiences of art can alter the ways people draw

conclusions about the world. It presupposes too that an encounter with an art object may provoke a significant rupture in a person's unreflective consciousness of life. An activist impulse to change people's attitudes underlies much so-called Minimalist work. This activism foundered on a contradiction built into the art world: the institutional forces that make art known and meaningful to the public tacitly assert a hierarchy of values in which power and money predominate, as does the coercive authority their consolidation requires. Minimalism is a compelling and important episode in American art because it clarified the fact that artists, despite their ambitions, can only play at superseding the values by which society's ruling groups legitimize their power. At its best, Minimalist art was and is a plea for commitment to values—such as clear, contemplative vision, the recognition of illusions for what they are, and a love of physical reality for its own sake—that are not, and probably cannot be, widely shared in a highly technologized, economically volatile mass society, irrespective of its form of government.

Richard Tuttle, *Tan Octagon*, 1967
Dyed cloth, 54 in. diameter
Saatchi Collection, London

Ellsworth Kelly, *Wall Study*, 1956
Oil on canvas, 28 × 22 in.
Collection Ernie and Lynn Mieger

Jo Baer, *Untitled (Red Wrap-Around)*, 1969
Oil on canvas, 48 × 52 in.
Saatchi Collection, London

Agnes Martin, *Night Sea*, 1963
Oil and gold leaf on canvas,
72 × 72 in.
Saatchi Collection, London

Brice Marden, *4:1 (for David
Novros)*, 1966
Oil and wax on canvas,
60 × 65 in.
Saatchi Collection, London

Haim Steinbach, *artful balance*, 1985
Mixed media construction,
17½ × 37 × 12 in.
Private collection

Artists of every postwar generation concur that to accept without question the seemingly self-explanatory quality of everyday life in America is to be duped by entertainment, advertising, and political spectacle into dwelling thoughtlessly in a world of engineered illusions. The question is whether contemporary art offers any real contrast to the passivity of consumer consciousness. Minimalist artists tried to do that by confronting people with the cold perceptual facts of art, making them scrape bottom, so to speak, rather than inviting them to immerse themselves comfortably in aesthetic reveries.

For the Minimalists, direct vision is a kind of absolute: there can be no conceptual, or mediated, equivalent to laying eyes on something in its presence. This is a point upon which they diverge decisively from Duchamp's attitudes. They accept the implication of his readymades, that we live in circumstances where anything may legitimately turn out to be the stuff of art. However, they do not share Duchamp's— or Wollheim's—indifference to the precise physical reality of the art object. (Duchamp had no qualms about authorizing editions of the lost "original" readymades.) For artists as different as Robert Ryman and Richard Serra, or Donald Judd and Eva Hesse, the meaning of a work of art cannot be skimmed from its physical reality. As Judd said of his own work, "You can think about it forever in all sorts of versions, but it's nothing until it is made visible."[8]

History has reduced to a noble illusion the Minimalist faith in aesthetic experience—or in the phenomenology of perception— as something more fundamental than the codes by which cultural institutions mold thought, response, and opinion. Nothing attests more drearily to this fact than the stylistic novelty of the mid 1980s known as "Neo-Geo." The Neo-Geo artists, who include Peter Halley, Meyer Vaisman, and Haim Steinbach, recycle period qualities of Minimalism—geometry, rejection of handicraft, acceptance of industrially determined forms—in works that assert the anachronism of the adversary stance the Minimalists tried to take. Haim Steinbach, for example, will make a formica-covered shelf and array upon it groups of identical mass-market items, such as "Star Wars" alien dolls or convection "glob" lamps. The form of the shelf harks back to the geometry of early Minimalist sculpture, while the look-alike commodities make newly media-conscious reference both to the readymade strategy and to the Minimalist interest in serial forms. Richard Artschwager, who more than any other artist straddled the differences between Pop Art and Minimalism in the 1960s, may be the true progenitor of Neo-Geo.

The difficulty in writing about Minimalism in retrospect is that it is no longer possible to put most works of the Minimalist period to the test of the experience they

promise—an experience, moored to an art object, of dwelling upon the pace, solitariness, and contingency of self-conscious perception, where perception is vivified by uncertainty as to the object's validity as art. Some installation works by James Turrell offer this sort of experience, but Turrell makes use of light and architecture rather than objects. The confrontational qualities of all but a few well-known Minimalist works—such as Walter De Maria's *Lightning Field*, a work of "land art" done in 1977—have been irreparably blunted by the works' rapid absorption into the canon of modern art, or at least into the art system. The question of an object's recognizability as art—the question that freshens one's first perception of it—is rendered trivially rhetorical by museums when they display Minimalist works as tokens of a movement and a period. By the mid 1980s, the issue of recognizability was so tame that it had become the butt of cartoonists.

I deviate deliberately from the common critical practice of distinguishing between Minimalism and Post-Minimalism because the distinction implies that the nomenclature is more precise than it can be. "Minimalism," as I use the term, arguably comprehends everything from the early sculptures of Donald Judd and Tony Smith to early and recent deployments of materials and processes by Tony Cragg, Meg Webster, Wolfgang Laib, and the Italians identified with Arte Povera. Meanwhile, the artists themselves concur in little but their rejection of "Minimalism" as a term appropriate to what they have done. "Art excludes the unnecessary," Carl Andre wrote in 1959, and added, twenty-five years later, "That is the only true sense for me of 'minimalism.' "[9]

Jeff MacNelly, "Shoe,"
November 11, 1984
Reprinted by permission: Tribune
Media Services

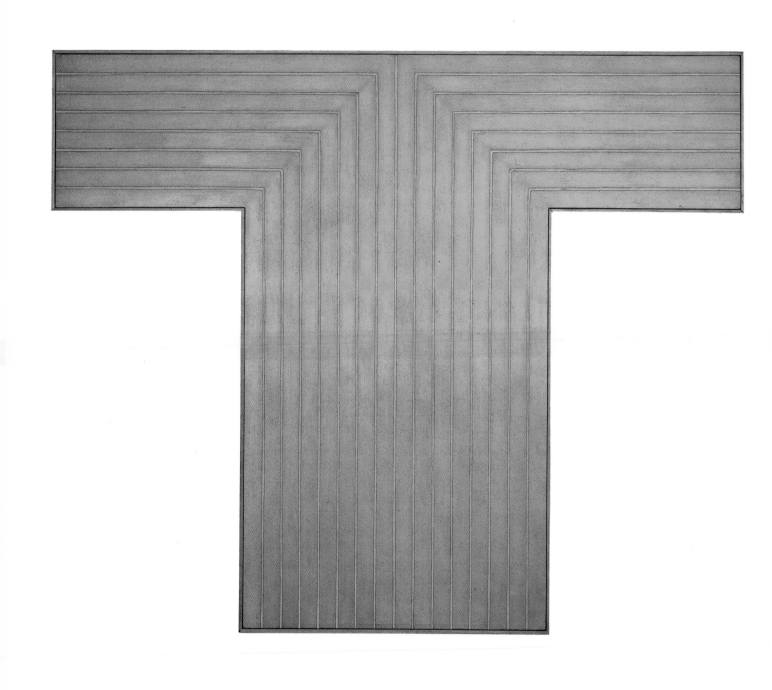

T W O

The further World War II recedes in time, the more it appears to have been a prime cause of the subsequent ascendancy of American art. "In art as in politics," William Carlos Williams wrote in 1952, "in spite of our faults, the time-drift favors America."[1]

The Allied victory, from which the United States emerged as the new hub of world military and economic power, resolved by brute force the cultural inferiority complex American artists had long suffered.

The New World—with New York as its capital—was where a fresh start truly could be made then, as generations of immigrants to North America had always believed. Historical events validated at last the American artist's perennial estrangement from the ancestral ground of high culture. Modern warfare had exploded the never-to-be-assimilated European past, along with America's real and fancied isolation from international power politics. Suddenly, the American continent was no longer a province, but the center of the new capitalist empire.

Although the empire's heyday was still years away, by 1950, especially in New York, where so many European modernists were in exile, American artists had begun to feel the exhilaration of living at the center, rather than the periphery, of contemporary culture. As Jack Tworkov expressed it, "Post-World War II painting in New York moved against two repressive experiences—the rhetoric of social realism, preached especially by the artists and ideologues on the arts projects of the thirties, and the hegemony of Paris in modern art. The response was an art that stood against all formula, an art in which impulse; instinct, and the automatic, as guides to interior reality, were to usurp all forms of intellectualizing. I cannot remember any period in my life that so went to my head as 1949. It marked the foundation of the Artist's Club in New York and heralded a decade of painting as fruitful and revolutionary as the Impressionism of 1870."[2]

Abstract Expressionism, or Action Painting, as the art of Tworkov, Jackson Pollock, Willem De Kooning, Franz Kline, Philip Guston, and others came to be called, had European sources; but it was American in spirit. Among ambitious painters, the indigenous American orientation to the future, to the untried, came into its own, vivified by the vague threat that the new atomic weapons might blot out the future in a literal sense that had been inconceivable before. The existentialist thought of Jean-Paul Sartre, which appealed to many artists at the time, expressed the prevailing sense of onerous opportunity, of the pressure to act individually upon whatever possibilities presented themselves. Sartre's theme of human existence as an inescapable burden of self-definition chimed with the Action Painters' perception of their work as a demonstration of freedom and of the very nature of taking action. "We are a freedom

Frank Stella, *Telluride*, 1960–61
Copper paint on canvas,
87 × 84 in.
Max Palevsky

27

which chooses," Sartre wrote in a famous passage, "but we do not choose to be free. We are condemned to freedom."[3]

Some European expatriates, such as Hans Hofmann, attributed the shared sense of a fresh start to the American political system. "It is the privilege of a democracy like ours," he said, "that it expects the artist to be, through his art, the personification of its fundamental principles in being the highest example of spiritual freedom in his performance of unconditioned, unrestricted creativeness."[4] Others weren't so sanguine.

Abstraction was the course painting had to take because, as Mark Rothko put it, "the familiar identity of things has to be pulverized in order to destroy the finite associations with which our society increasingly enshrouds every aspect of our environment."[5] The renunciations of abstract painting permitted the past to be used as a springboard. Artists could adapt whatever they needed from, say, Picasso, Mondrian, or the Surrealists, because if they transformed and transcended it successfully, they would become the new torchbearers of the avant garde.

The leading painters of the so-called New York School did more than just adapt forms, techniques, and attitudes from their European modernist heroes. They abstracted from the growth of modernism the Romantic struggle to originate something new. And they accelerated it as well, purporting to detail in each work an effort at innovation that in an earlier decade might have occupied months or years. The struggle to produce something authentically new, which they understood as a search for the content of painting in the very activity of executing it, became the primary theme and justification for their art. For them, painting was no longer a skill "that can be taught in reference to pre-established criteria," as Robert Motherwell said, "but a process whose content is *found*, subtle and deeply felt."[6]

A painting that simply recorded the drama of its own spontaneous making would be the perfect vindication of the American artist's isolation from European tradition. Although acknowledging that a complex history of art preceded it, Abstract Expressionism demanded to be judged primarily on the character of each creative performance. "Attached neither to a community nor to one another," Harold Rosenberg commented in 1948, "these painters experience a unique loneliness of a depth that is reached perhaps nowhere else in the world. From the four corners of their vast land they have come to plunge themselves into the anonymity of New York, annihilation of their past being not the least compelling project of these esthetic Legionnaires."[7]

Rosenberg's "Action Painting" has proved to be an unusually apt and durable term, especially for the 1950s works of Pollock, De Kooning, Kline, Hofmann, and their emulators. "At a certain moment the canvas began to appear to one American painter after another," Rosenberg wrote, "as an arena in which to act—rather than as a space in which to reproduce, re-design, analyze, or 'express' an object, actual or imagined. What was to go on the canvas was not an object but an event."[8]

The efforts of these artists proposed the painter's confrontation with inert materials and empty canvas as a metaphor for the unremitting human need to act. And the committed action that improvisational painting demanded was, from the artists' viewpoint, a rejoinder to the hollow, unexamined conduct of conventional society. "The materialism of the middle class and the inertness of the working class," Motherwell wrote, "leave the modern artist without any vital connection to society save that of *opposition*," and the urge to "replace other social values with the strictly aesthetic."[9]

The anti-intellectual strain in American culture may have provided just the friction needed to rekindle hopes that the modernist avant garde in painting might shine again, after political and military conflagration in Europe had stolen its fire.

However, the illusion that a European-style avant garde could take root on American soil in the postwar world was short-lived. An artistic avant garde could not flourish for long in the American context if only because the mass media here have become increasingly adroit at neutralizing all forms of cultural opposition, either by condemning them to obscurity, in the sense of denying them a public, or by appropriating them as "products," "news," or "entertainment." The publicity media of the art world have come to operate in much the same way, for in the art world of today, as in the wider business world, the largest possible paying constituency is the common goal of museums, publishers, art dealers, and self-interested artists.

Few people foresaw the growth of the mass media in America into a nexus of institutions having almost instant simultaneous access to millions of homes, and thus potentially to every citizen's consciousness. Only a few expatriate European intellectuals, such as Theodor Adorno, Max Horkheimer, and Leo Lowenthal, seem to have intuited in the late 1940s that forms of mass entertainment would soon coalesce to produce the illusion of an ongoing parallel reality by which people would come to judge their own direct experience of life.

This development of industrially mediated images into a spectacle more "real" than reality, because so thoroughly suffused with the coercive authority of big money, is one of the benchmarks of the postwar period in America and a key factor in the background of Minimal art.

During the anti-communist hysteria of the early 1950s, the propaganda elves in government and media realized that art could be touted as a wacky, but telling, sign of the times, to prove that even in the way its artists registered the common anxiety about the bomb, America was on top.[10] The works of Pollock and De Kooning made good press for the likes of *Life* magazine because they were visually jazzy, yet baffling to most people, and fit perfectly the popular view of artists as idiot savants giving vent to fears and intuitions most people are too busy and too sensible to confront consciously. Contemporary art and mass culture have been feeding off each other ever since. The aesthetics of Minimalism have trickled down into television commercials, furniture design, and the interiors of hip clothing stores. Today it is hard even to imagine the oppositional edge Minimalist work appeared to have when it was new.

Like other extremes in modern art, the heroic stance of abstract painters in the 1950s proved difficult to maintain. According to Tworkov, "By the end of the fifties, I felt that the automatic aspect of Abstract Expressionist painting of the gestural variety, to which my painting was related, had reached a stage where its forms had become predictable and automatically repetitive. . . . I began to look around for more disciplined and contemplative forms."[11]

Meanwhile, to a younger generation that first encountered it as aesthetic doctrine in the art world or in academic art departments, Abstract Expressionism had long since begun to look mannered and overwrought. Of course, the New York School had its contemplatives, such as Rothko and Barnett Newman. On the West Coast, painters such as David Park and Richard Diebenkorn had developed their own less flamboyant variants of improvisational picture-making. And all during the 1950s, artists as different in age and temperament as Ad Reinhardt and Ellsworth Kelly had forsworn completely

Barnett Newman, *Vir Heroicus Sublimis*, 1950–51
Oil on canvas, 7 ft. 11⅜ in. ×
17 ft. 9¼ in.
Collection, The Museum of Modern Art, New York; Gift of Mr. and Mrs. Ben Heller

the excesses of gestural painting. But these options were out of the limelight.

In the 1950s, the art world had only begun to attract adventurous new collectors who saw contemporary art as grist for profitable speculation. Slowly, over the subsequent two decades, more and more people were persuaded that it was both chic and financially savvy to buy contemporary American art, until the traffic in art became a high-rollers' game.

The great art-business success story of the Minimalist years was that of Leo Castelli, a suave, indomitably optimistic Italian from Trieste who ventured into art-dealing after his marriage to the wealthy Ileanna Sonnabend made it unnecessary for him to exploit his experience in insurance and banking. In 1957, some years after immigrating to the United States, he began to show contemporary art in his father-in-law's Upper East Side town house in New York, where he lived at the time.

When Castelli opened his gallery he was committed to showing American art but was also convinced that Abstract Expressionism had run its course. Serendipity and good instincts led him to give a solo show early in 1958 to a completely unknown artist named Jasper Johns. It was an event that sent shock waves through the New York art world, establishing Johns almost overnight as an artist of singular cleverness and depth. Johns's paintings, incorporating images, such as flags and targets, and odd objects, such as plaster casts of body parts, had the sensuous intensity and mystery of Action Painting with none of its demonstrative qualities.

Six months before Johns broke upon the scene, Meyer Schapiro had published an appreciation of postwar American painting whose rhetoric is characteristic of the time. "The object of art," he wrote, "is more passionately than ever before the occasion of spontaneity or intense feeling. The painting symbolizes an individual who realizes freedom and deep engagement of the self within the work. It is addressed to others who will cherish it, if it gives them joy, and who will recognize in it an irreplaceable quality and will be attentive to every mark of the maker's imagination and feeling. . . . Hence the great importance of the mark, the stroke, the brush, the drip, the quality of the substance of the paint itself, and the surface of the canvas as

a texture and field of operation—all signs of the artist's active presence. The work of art is an ordered world of its own kind in which we are aware, at every point, of its becoming."[12] With their encaustic surfaces that bogged down gesture and their cryptic, impersonal repertoire of inherently flat images, Johns's paintings ran counter to Schapiro's enthusiasm on just about every point.

One of Johns's most provocatively deadpan pictures, an American flag painted flat and flush with the rectangle of the canvas—a true representation of the national emblem's abstractness—caught the eye of Frank Stella (born 1936), who had just moved to New York after earning a degree in art at Princeton University.

Shortly before graduating, Stella had turned his back on the Abstract Expressionist aesthetics preached by the art faculty and had begun filling canvases with fields of stripes. He resumed work on those paintings, without resolving them, while working as a house painter in New York. The complete coincidence of image and painted object in Johns's *Flag* showed Stella how he could take the slack out of his abstract stripe paintings. Using house paint, and applying it so that it soaked into the canvas, Stella began a series of black paintings that today seem more than ever to have been a watershed in the art of our time. They appear to have been the most radically anti-expressionistic pictures he could contrive, although Stella insists that "the only significant difference between my work of the late fifties and early sixties and most of the work surrounding it was the way it looked to other people. . . . I thought I had found a way to make pigment and the space described by its manipulative gesture a bit more definite, a bit more discrete, and quite a bit more concrete." Yet when you contrast his early paintings with the work of De Kooning or Tworkov, it is hard to believe him when he says, "I was surprised by the hostility and ridicule it evoked. I had expected to be criticized for not being different enough, for not having developed enough."[13]

His stripe paintings eliminated color, regimenting composition into rigid all-over patterns of ruled bands, keyed, like the stripes in Johns's *Flag*, to the edges of

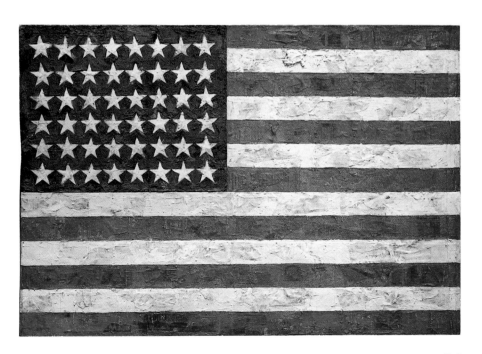

Jasper Johns, *Flag*, 1954–55
Encaustic, oil, and collage on canvas, 42¼ × 60⅝ in.
Collection, The Museum of Modern Art, New York; Gift of Philip Johnson in honor of Alfred H. Barr, Jr.

each picture. The regular stripes shackled "expressive" gesture, dictating a paint-handling that was matter-of-fact as could be.

When Leo Castelli discovered these paintings to the art world, they induced in critics a frustration that Stella came to appreciate, however much he may have been surprised by it at first. "I began to feel very strongly about finding a way of working that you couldn't write about," Stella recalls, "something that was stable in a sense, something that wasn't constantly a record of your sensitivity, a record of flux."[14]

"I still feel rooted in Abstract Expressionism—or New York School," Stella said in 1966, "as I probably always will be."[15] But like a number of other artists of his generation, he saw Abstract Expressionism as licensing—and depending upon—ways of talking about art and the world that were deceptive and sentimental. He set about methodically making paintings that would rebuke the rhetorical habits engendered by Action Painting and expose the ways people really use art objects. "I always get into arguments," he said in 1962, "with people who want to retain the 'old values' in

Frank Stella, *Arundel Castle*, 1959
Oil and enamel on masonite,
17¾ × 12 in.
Robert and Jane Rosenblum,
New York

painting—the humanistic values that they always find on the canvas. If you pin them down, they always end up asserting that there is something there besides the paint on the canvas. My painting is based on the fact that only what can be seen there *is* there."[16] Later in the decade, other artists who adopted Stella's early precept found that to see merely what is there may require an equally focused effort not to see anything that is not there.

Critics accused Stella of "nihilism," of being a neo-Dadaist, an anti-artist bent on bringing the art of painting to a historical dead end. Similar accusations were soon to be made against Andy Warhol and Roy Lichtenstein for their introduction of vulgar content into high-art formats. The denunciations are worth noting as reminders of how much resistance new moves in painting could still elicit in the early 1960s.

Soon after they were first shown, people began to realize that Stella's "stripe" paintings were more than "abstract." By 1960, other artists, such as Kenneth Noland

and Gene Davis, had made paintings consisting wholly of stripes. Ellsworth Kelly and Agnes Martin had already made similarly simplified and systematic pictures. What set Stella's stripe paintings apart was the way he heightened one's awareness of their physical reality by eliminating pictorial space. The objectivity of paintings had never been quite so baldly put, for painting in the European tradition had never gone quite this far from representation.

Stella's black pictures and the succeeding series done in metallic paints deny the viewer access to an inner or virtual dimension of the art object. No matter where you try to see beyond the surface of a canvas like *The Marriage of Reason and Squalor*, you find your eye shunted to the edge of the picture—to the bounds of the object—by the "grooves" of exposed canvas that separate the bands of black. Stella further emphasized the paintings' objective qualities by mounting some of his canvases on stretchers as thick as the stripes are wide. In these ways he proposed newly blunt relations between one's awareness of a painting as a fabricated thing and one's confidence in it as a bearer of meaning.

This reinvention of the relations by which we qualify an object as a work of art is what makes Stella's early paintings seem in retrospect like decisive documents of shifting sensibility. The new emphasis I refer to is more than a matter of systemic as opposed to "sensitive" composition, or of pre-planned work replacing make-or-break improvisation. Stella's banishment of illusionistic space had more than formal implications. Partisans of Abstract Expressionism were slow to see that Stella had made paintings that illuminate people's obliviousness to artworks as material structures. He was determined to overcome the common fixation on the "inner" and "ineffable" subtleties of art object and of viewer response.

To those accustomed to swoon with the atmospherics of Abstract Expressionism, Stella's black paintings appeared moodless, dehumanized, and empty. Yet their uncompromising rigor could not be ignored. They were like barriers to what such educated viewers as Meyer Schapiro and Harold Rosenberg had seen as the trajectory of postwar American painting.

Champions of Abstract Expressionism objected that Stella had renounced the psychological and "existential" content that had finally, justifiably, brought American painting to the notice of the world. He appeared to be—and he was—flouting the vaunted practice of abstract painting as a metaphor for human self-definition through action.

The loose finish of paintings by such artists as De Kooning, Pollock, and Kline corresponded nicely to the inner sensation, articulated so well by Sartre, of oneself as perpetually unfinished. By resolving pictorial finish as methodically as he did, Stella abolished the resonance between the viewer's self-doubts and craving for fixed identity, and the painter's risks and hesitations. Because no emotionally engaged response to his paintings seemed possible, Stella's critics insisted the inevitable result was boredom. "[Boredom] is an effect of disrupting the normal movement between the self and the external world," Harold Rosenberg reflected. "Boring art is the mirror of the repetitiveness, unexpressiveness, abstractness, and obsession with detail of daily life."[17] Stella, however, did not want his paintings to "mirror" anything, but simply to make sense as constructions in their own terms. He was, as he insisted, "rooted in Abstract Expressionism" in the sense that he wished his paintings to be viewed as logically self-sufficient structures, not as having a dependent, merely

Frank Stella, *The Marriage of Reason and Squalor*, 1959
Oil on canvas, 7 ft. 6¾ in. ×
11 ft. ¾ in.
Collection, The Museum of Modern Art, New York; Larry Aldrich Foundation Fund

"pictorial" relationship to the rest of the physical world.

However, his work differed from Action Painting—which also stressed the "autonomy" of the art object—in that it did not invoke painting's representational history as a treasury of known but unchosen possibilities. In banishing illusionistic space, he eliminated its nostalgic symbolism of the past and of the potential of imagery and narrative in painting. "All I want anyone to get out of my paintings, and all I ever get out of them," he said in 1962, "is the fact that you can see the whole idea without any confusion."[18]

In effect, Stella reinvigorated the attack made by European modernist painters on the notion of painting as a mirror of the world. He intuited that Abstract Expressionism was not as abstract as the catch phrase implied. By inviting the viewer to project emotional and psychological narrative into its ambiguities, Abstract Expressionist art promoted the notion that the interior of a painting parallels somehow one's sense of oneself as a vessel of unfathomed inner depths. Stella's black and metallic paintings effected a violent revision of this notion, which is one reason they met with vitriolic response.

Stella is the first artist I discuss not just for chronology's sake, but because his early paintings were a rejoinder, which other artists would soon elaborate and amplify, to the philosophical biases of Abstract Expressionism. Stella shifted emphasis from the artist's activity as a metaphor for human self-definition to the viewer's activity of studying art objects for clues to the metaphysics of experience. When he said his painting was "based on the fact that only what can be seen to be there is there," he unwittingly voiced what would become a recurring tacit theme in much Minimal work: a rephrasing of the terms of "art" to favor the objective qualities of artworks and the observable, describable aspects of people's reactions to them.

Stella's early paintings set the tone for Minimalism in that they were devoted to clear vision, to the banishment of illusions or to their exposure as the illusions that they are. This theme was formulated in retrospect by Marcia Tucker and James Monte,

of the Whitney Museum of American Art, when in 1969 they organized an exhibition called "Anti-Illusion: Procedures/Materials." Although the show did not include Stella's early work, much of what it did include stemmed from attitudes toward materials, execution, and aesthetic experience manifested first in his black paintings.

Rosenberg was on the right track when he spoke of Stella thwarting the traffic between the self and the outside world, because Stella's painting challenged the view that self and world are distinct domains. At least since the seventeenth century— when René Descartes invented the modern idea of the mind as a private space transparent only to its individual "owner"—the notion of painting as a mirror of the world has run parallel with the notion of the mind as a mirror of the world and of knowledge as accurate inward representation of external states of affairs.

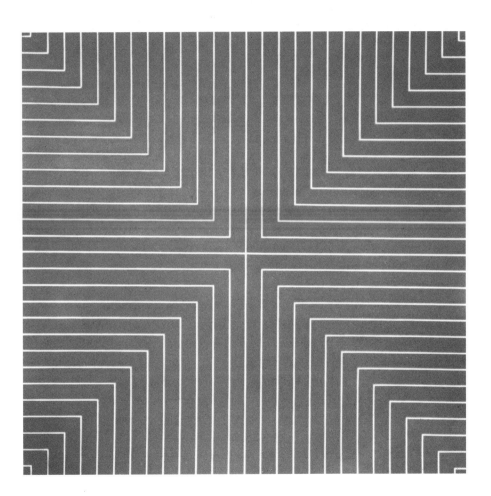

Frank Stella, *Delaware Crossing*, 1961
Oil on canvas, 77 × 77 in.
A. Alfred Taubman, Bloomfield Hills, Michigan

Stella's early work, and much of the Minimal sculpture that later affirmed it as a watershed, revised the Cartesian psychology behind Abstract Expressionism and behind the language of most critical responses to it. The emphatic objectivity of Stella's paintings implied a rethinking of the analogy between a painting's content and the "inner" capacities of its viewers. As more artists began to take clues from Stella's work, questions arose whether "deep" responses are incommunicable because they are profound or because "depth" is misunderstood and needs to be rethought or re-envisioned. This need for revision is a theme that echoes throughout Minimal

art of the 1960s, and continues in the work of some artists considered to be post-Minimalists, such as Joel Shapiro, Jannis Kounellis, and Tony Cragg.

Questions raised by Stella's early work and brought into focus by other artists include: What patterns of attention to objects reinforce our thrall to the idea that the mind is an invisible dimension of ourselves secreted within the body? Can those patterns of attention be altered so as to recast the image of human beings as fleshly vessels of ghostly individuality? Might not the image of the mind as an unlocatable space be a product of Western culture's obsession with measurement, certainty, and predictability?

The implicit analogy between works of art and their viewers had to be undone, in the Minimalist view, because the distinction between the animate and the inanimate, between active, responsible beings and inert ones, is an obvious first principle for an effort to see and think about the world clearly.

The intuition is reiterated often in Minimal art that the vocabulary we are taught for evoking complexities of experience actually shrinks the world as a common ground of human attention and intelligence. Artists as diverse as Carl Andre, Dan Flavin, Robert Smithson, and Walter De Maria recognized that even the most informal

Tony Cragg, *New Stones—Newton's Tones*, 1987
Plastic, 10 ft. 10 in. × 7 ft. 8½ in.
Collection Arts Council of
Great Britain

Jannis Kounellis, *Untitled*, 1986
India ink on paper, propane tank,
copper tubing, metal sheets,
79 in. × 15 ft. 10½ in. × 4 in.
Private collection

Frank Stella, *Sanbornville III*, 1966
Fluorescent alkyd and epoxy paint
on canvas, 8 ft. 8 in. × 12 ft. 2 in.
Whitney Museum of American Art,
New York; Gift of Joseph A. Helman,
New York

responses to art involve unarticulated theories of the mind, of perception, and of society. For these artists and many others, making art was a means not only to call people's attention to their own unexamined assumptions about selfhood and vision, but also to criticize those assumptions.

The Minimalist revision of aesthetics began on several fronts. One was a questioning where fullness lies, and in what it consists, in a culture that seems committed to vapidity as a defense against thinking about life. This inquiry got off on a more dandyish footing at about the same time with Pop Art. The terms "Minimalism" and "Pop Art" suggest a clear-cut dichotomy, whereas some of Andy Warhol's better early paintings are Minimalistic in their seriality, their acceptance of banal pictorial content, and their skepticism about the spontaneity of viewer response. Until recently, nomenclature alone seems to have kept most people from noticing the affinities between Warhol's art and that of artists such as Carl Andre and Donald Judd.

In 1985, Charles and Doris Saatchi, England's most ambitious collectors of contemporary art, opened a "private museum" in London with a selection of works they acquired that made a point of similarities between Warhol's early work and certain serial, commercially fabricated works by Donald Judd. The event was noteworthy as an instance of stagecrafted hindsight and of a new curatorial aggressiveness on the part of private collectors. Using their own collection and facilities, the Saatchis tried to give their own inflection to the public's recall of American art of the 1960s. To judge by critical reviews, they succeeded.

This episode is one more reminder of the limits of terminology. It has become

Frank Stella, *Chocorua III*, 1966
Fluorescent alkyd and epoxy paints
on canvas, 10 ft. × 10 ft. 8 in.
Milwaukee Art Museum; Gift of
Friends of Art

Frank Stella, *Empress of India*, 1965
Metallic powder in polymer
emulsion on canvas,
6 ft. 5 in. × 18 ft. 8 in.
Collection, The Museum of Modern
Art, New York; Fractional gift of
S. I. Newhouse, Jr.

conventional to speak of Minimal art—unlike Warhol's—in terms of reduction. The very word *minimal* implies something diminished or stripped to essentials. ("If my work is reductionist," Donald Judd once commented, "it's because it doesn't have the elements that people thought should be there."[19]) Pop Art, on the other hand, is supposed to be porous to the culture as a whole, soaking up commonplace imagery from all over and feeding it back, transfigured, or revalued, into the society's fund of images. But as some of Stella's statements suggest, the paring away of superfluous complexities by Minimalist artists was done in order to supplant the false richness of a fragmented and fragmenting popular culture with the true fullness and continuity of perception itself. Pop Art, too, may be viewed as an argument not against the notion of depth but against pretensions to finding any kind of depth beyond the play of surface meanings the culture produces willy-nilly. Both Minimalism and Pop Art appear to promote the idea that depth refers not to hidden dimensions but to ways of construing what is on the surface of life.

In Stella's case, simplifications of the process of painting resulted in a clarified vision of a picture's exterior shape—the very profile of its reality—as an active ingredient in its meaning. He developed his work into the mid 1960s by complicating and refining relations between each canvas's surface pattern and its external shape, elaborating in such paintings as *Empress of India* and *Sanbornville III* a new convention dubbed the "shaped canvas."

Perhaps the easiest way to see the affinity between Stella's early paintings and other Minimalist works is to think of the various artists as striving to make us "see the whole idea without any confusion," by seeing the object *as* the idea, that is, making meaning identical with the object's physical presence. For Stella's work might also be taken to mark the beginning of another tendency of the Minimalist years, the rejection of metaphor in favor of "things as they are," which Michael Fried would later disparage as "literalism."

T H R E E

"Avoid pulpits, platforms, stages, and pedestals. Keep to the hard ground; it is the only way you can judge your approximate stature as a man."
—Antonio Machado, "Juan de Mairena"[1]

No artist rejected metaphor more explicitly than Carl Andre. He was born in 1935 in Quincy, Massachusetts, where, as a boy, he was fascinated by the local steelyards and granite quarry. After moving to New York in the late 1950s, he was looking for a studio in which to carry out some ideas for wood sculpture when Hollis Frampton, the photographer and filmmaker, introduced him to Frank Stella. All three happened to be graduates of Phillips Academy at Andover. Andre shared Stella's studio in 1958 and 1959.

Unlike Stella, Andre was not pushing off from Abstract Expressionism. Neither was he sympathetic to it. Instead, he was under the spell of certain literary and visual artists and artworks—Gertrude Stein, Constantin Brancusi, Russian Constructivist sculpture, Stonehenge—and was bent on fabricating some things in response to them.

Working in Stella's studio, he made sculptures by cutting patterns of high relief into blocks of wood with a chisel or a radial arm saw. Brancusi's work was the direct inspiration for these pieces, in so far as they owed anything to other sculptors. Several of them echoed the regular zigzag rhythms of Brancusi's *Endless Column*. Most of the pieces made with a radial saw bore legible traces of the operations that had produced them, foreshadowing an emphasis on process that would preoccupy other artists in the succeeding decade. The first work marked by Andre's distinct artistic intelligence was a series of objects made of stacked square beams that echoed directly the stripes in Stella's paintings.

Cedar Piece is a stack of cedar beams six and a half feet high notched and fitted together where they cross, like the logs at the corners of a log cabin. The exterior profiles of the piece are those of a rectangular solid stood on end, but the stacked elements, all of the same length, are stepped inward from the bottom toward the center of the structure, and outward again toward the top, so that their ends form an X pattern on each of the object's four sides.

Cedar Piece is a tremendously satisfying construction in which, as in Stella's paintings, no quarter is given to sentiment, illusion, or whimsy. To see just how out of step it was with the expressionist temper in sculpture at the time, you have only to refer to the concurrent work of David Smith, John Chamberlain, Herbert Ferber, or Richard Stankiewicz.

In 1960 Andre made some simple objects using scavenged scraps of precast

Carl Andre, *Copper-Aluminum Plain*, 1969
Copper and aluminum,
⅜ × 72 × 72 in.
Anne and William J. Hokin

41

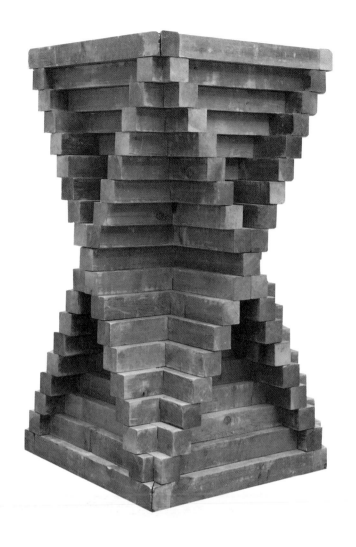

Carl Andre, *Cedar Piece*, 1959
(destroyed, reconstructed 1964)
Original made of cedar, remade of
fir; 74 units, 4 × 4 in. each;
63¾ × 36½ × 36½ in. overall
Oeffentliche Kunstsammlung Basel,
Museum für Gegenwartskunst, Basel

steel, and he conceived a major group of works to be done with uncarved cedar beams, the "Elements Series," which he could not afford to execute until 1971. Then in the early 1960s he got sidetracked into making accumulations of poured cement and raunchy assemblages of detritus, which he later destroyed.

Meanwhile, he had taken a job as a freight conductor and brakeman on the Pennsylvania Railroad. Critics like to trace Andre's subsequent use of modular units such as bricks and metal plates to his experience maneuvering boxcars into ordered rows. The artist himself has a different view of why the brakeman's job was important to his art. "On the railroad I worked intimately with masses of many hundreds of tons," he recalls. "As a result, I do not have the typical American sculptor's romance with the gigantic."[2]

In much of his work Andre has used units of material that are small enough to be lifted and moved by hand, as if to stress that there is no hierarchy of position or relationship among the parts of his sculpture, and to affirm that anyone's labor would suffice to assemble his work. Andre modifies the materials he uses as little as possible so that, outside the art-world context, his sculpture would be all but indistinguishable from raw material. In fact, *Cedar Piece* had to be replicated after it was burned as firewood by someone staying in Frampton's apartment, where it was stored.

The parallel to Duchamp's readymades is obvious. Where Duchamp chose, say, an ordinary hat rack or a snow shovel and turned it into art by fiat and by appending a whimsical title to it, Andre proposed as sculpture such things as a plain, square wooden post (*Herm*), a row of 137 abutted firebricks (*Lever*), and tight rectangular arrays of square metal plates. Andre's work has always drawn power from people's reluctance to accept it as art. But while Duchamp admitted to making an intellectual game of exposing the art object as a cultural institution, Andre intends the things he makes to be contemplated as the foundation of a new way of seeing the world, not as conceptual pranks. This is what he means by referring to his sculpture as "a pedestal for the rest of the world."[3]

Many people—at least outside the art world—still cannot accept the notion that someone might "make" art without transfiguring raw materials. But part of Andre's point in eliminating transformative labor from his work has been precisely to provoke a rethinking of the question who, or what, "makes" something a work of art.

To understand the challenge Andre poses, we have to take seriously his claim that his work "has never been conceptual in any way."[4]

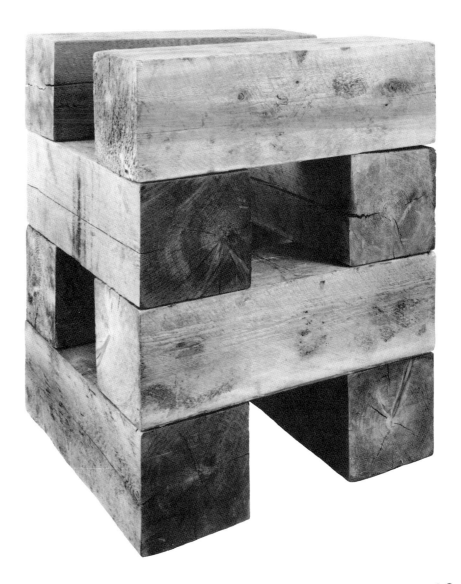

Carl Andre, *Pyre (Element Series)*, proposed 1969, made 1971
Western red cedar; 8 units, 12 × 12 × 36 in. each; 48 × 36 × 36 in. overall
Sondra and Charles Gilman, Jr.

When they see for the first time a work such as *Herm*, many people experience only a frustrating inability to understand how something is to be recognized as "art" in the absence of workmanship, decoration, imagery, expressiveness, and anything else that might be called "content." Because the object before them appears to hold no answers, they either dismiss it as fraudulent or fall back upon the institutional clues to the work's art status, deciding whether or not to accept the validating authority of the museum or gallery that happens to house it. Andre intends to impugn the authority of art-world institutions by means of the skepticism his work arouses. Nonetheless, how *can* his work be recognized as art—except by reference to the presentational matrix of the art world? This question is too central and commonsensical to be dismissed as a matter of context.

Carl Andre, *Small Weathering Piece*, 1971
Aluminum, copper, steel, magnesium, lead, zinc (placed outside to weather); 36 units, six plates in each metal, ⅜ × 7⅞ × 7⅛ in. each; ⅜ × 47¼ × 47¼ in. overall
Private collection

Pressing the question forces us to acknowledge that an uncarved beam, a row of bricks, or an array of metal plates *cannot* be recognized as art outside the frame of reference provided by art institutions, at least not in the same senses in which we recognize a blue jay, the Statue of Liberty, or a rare postage stamp for what they are. With the righteous air of someone willing to face facts where others are not, Andre deliberately eliminates from his objects anything that might serve as an obvious criterion of arthood. Yet it is his very willingness to propose what seem to be preeminently inert things as works of art that attests to Andre's seriousness.

Arthur Danto, a philosopher who writes art criticism for *The Nation*, has explained well the timeliness of the quandaries Andre's sculpture presents. "In periods of artistic stability," Danto observes, "there can be little doubt that works of art very frequently were found to have properties, failure of which would call seriously in question their status as artworks. But that time has long since passed, and just as anything can be an expression of anything, provided we know the conventions under which it is one and the causes through which its status as an expression is to be explained, so in

this sense can anything be a work of art. . . . Of course it does not follow from the fact that everything can be a work of art that everything is one. . . . The typewriter I am writing on could have been a work of art, but it happens not to be one. What makes art so interesting a concept is that in nothing like the sense in which my typewriter could be a work of art could it be a ham sandwich, though of course some ham sandwich could be, and perhaps already is, a work of art."[5]

Although the time may have passed when it was appropriate to look at works of art for earmarks of their arthood, the cultural habit of doing so still has us in its grip. Andre is one of the few artists to exploit that reflex to critical ends.

Andre's *Equivalent VIII* is every bit as inert as it appears to be. It belongs to a series of pieces, each made of 120 sand-lime bricks, stacked differently in every case. *Equivalent VIII* consists of two tiers of bricks, six stretchers in length by ten headers in width. Gravity holds the work together. This object presents us with the simple decision whether or not to accept it as "art" in general and as "sculpture" in particular. If you deny it the status of sculpture and of art, there is nothing more to do, unless you feel compelled to decry it, as some critics have done, as a sign of the sorry state to which the visual arts have sunk.

However, if you are willing to accept *Equivalent VIII* as art, at least hypothetically, it may suddenly seem more absorbing than before, to the extent you become willing to contemplate its unvarnished reality as an aesthetic phenomenon. "The materiality, the presence of the work of sculpture in the world, essentially independent of any single individual, but rather the residue of the experience of many individuals and the dream, the experience of the sea, the trees and the stones—I'm interested in that kind of essential thing," Andre declared in 1969.[6] The starkness of *Equivalent VIII*, its lack of decoration and of all ingratiating qualities except those of its material, may be taken as an exhortation by the artist to savor physical reality in its untransfigured givenness. The point to notice here is that viewing the object under a changed assumption alters your relationship to it, occasioning more activity on your part, or a greater awareness of observation as conduct that in some degree constructs the thing seen.

When you contemplate the object *as sculpture*, its deadpan qualities are not magically enlivened. Rather, they seem connected by a logic that eludes impatient observation. The fact that *Equivalent VIII* is only two bricks high, for example, will no longer seem arbitrary. It will now appear to be the most economical possible demonstration of stacking as a constructive technique and of gravity as a fastening force. The work's tightly packed structure will consequently read not just as a way of making the thing look as little like "art" and as much like stored bricks as possible, but also as the obvious means of displacing all interior space from the sculpture, much the way Jasper Johns squeezed illusionistic space from his *Flag* picture by making the image coincide perfectly with the painted surface.

Simple observations of this order establish *Equivalent VIII* as a touchstone, a standpoint from which to rethink relations between oneself and objects. This kind of reflection is implicit in Andre's outline of his art as a progression toward a sculpture of "place," which would be the antithesis of architecture. "My work has never been architectural," he insists. "I began by generating forms, then generating structures, then generating places. A place in this sense is a pedestal for the rest of the world."[7]

The most placelike of Andre's indoor works are his arrays of metal plates, such

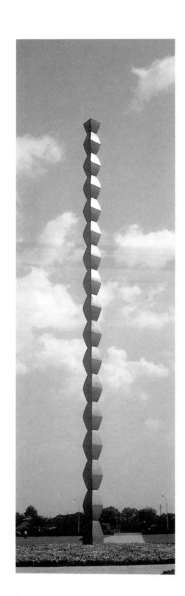

Constantin Brancusi, *Endless Column*, 1937–38
Cast iron, 96 ft. 3 in. high
Tîrgu-Jiu, Romania

as *Twelfth Copper Corner*, which are meant to lie flat on the floor, tightly abutted. The viewer of this work is welcome to walk upon it, so that his own upright posture reiterates the gravitational vector that consolidates the sculpture physically and logically. We are not meant to experience the aspect of place in such enterable works merely theatrically, as the ambience given an empty room by a foreign object. Rather we are to understand the object's coherence by means of gravity as an invocation of the earth, the "source" of gravity and the ground of all bodily sense of "place."

Treading upon one of Andre's metal-plate arrays not only establishes a physical relation to the art object far more direct than most works of art permit, it also verifies that the sculpture contains no space of its own that might serve as a metaphor for the transcendence of the art object by its meaning. All of Andre's mature works betoken his rejection of the notion that the meaning of a work of art is a numinous metaphysical accompaniment to the visible object. In several works made of small magnets, such as *Brooklyn Field*, Andre played almost satirically with the idea of a work's meaning or coherence as an invisible force holding it together. Since the mid 1960s, he has tried to make sculpture that occupies space without filling it, hence his resort to floor level in an effort to achieve "enterability without architecture."

The question where sculpture belongs in the world is one of the issues Andre inherited from earlier modern art. The question arises whenever the framing device— platform, pedestal, or architectural support—is absent from sculpture. You can see this easily when you look at contemporary public sculpture, most of which looks out of place regardless of where or how it is installed.

Andre understood that sculpture could be a means to question whether things belong where they happen to be—whether they belong in the world at all—because sculpture itself comes into question whenever it is placed on a common footing with furniture, vehicles, and its viewers. Andre's simplest work, *Herm*, is an object that, when contemplated as sculpture, changes in aspect in a way that renders relations among things around it newly vivid and questionable. *Herm* begins to look like sculpture as soon as you notice that it resembles an empty pedestal. Suddenly it

Carl Andre, *Equivalents I–VIII*, 1966
Sand-lime bricks, 2½ × 2½ × 9 in. each
Installation: Tibor di Nagy Gallery, New York

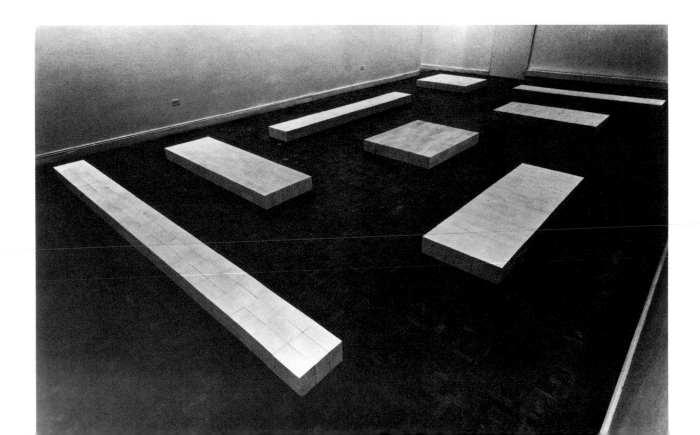

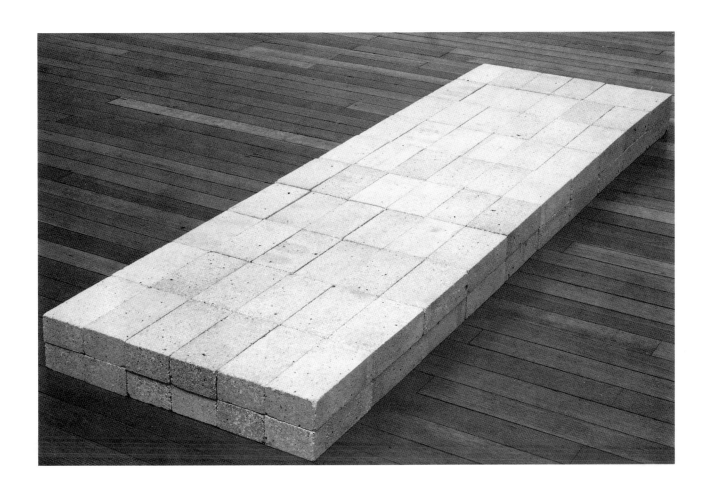

Carl Andre, *Equivalent VIII*, 1966
Sand-lime bricks,
5 × 27 × 90¼ in.
Tate Gallery, London

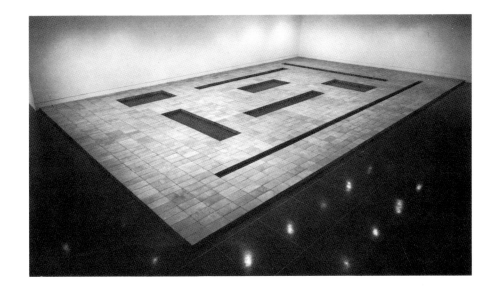

Carl Andre, *8 Cuts*, 1967
1472-unit rectangle with eight 30-
unit rectangular voids; concrete
block capstones; units, 2 × 8 ×
16 in. each (approximate); 2 × 30
ft. 8 in. × 42 ft. 8 in. overall
Urs Raussmüller, Switzerland

starts to look like a presentational prop one moment and a sufficient sculpture—a base-as-sculpture—the next.

The shift of aspects is easy to see if you are aware of Brancusi's intricate plays upon the ambiguous status of the sculpture base. The work's title stirs further associations when you know that a "herm" in ancient Greece was a roadside monument to the god Hermes, usually consisting of a pillar fitted with a symbolic bust and sometimes with genitalia, Hermes having been associated with male fertility as well as with travel. By titling his cedar beam *Herm*, Andre acknowledged its crude phallic symbolism, brought in a reference to ancient Greece, ancestral ground of Classical sculpture, and amplified the object's quality of seeming to mark the spot where it happens to stand.

The antithesis of Andre's work with respect to the issue of how sculpture ought to occupy space is the work of British artist Anthony Caro (born 1924). Certain critics put Caro's sculpture of the 1960s in the category of Minimal Art because of its spare elegance. What Caro and Andre shared was the conviction that sculpture must prove itself as art in real space, on common ground with other, less exalted objects, and without the aid of framing devices such as the traditional pedestal.

Like Andre, Caro made use of industrially prefabricated forms. However, he cut, bent, or otherwise shaped them and fastened them at whim. His work of the sixties is marked not only by compositional graces that Andre shunned on principle, but by a tendency to affect perceptibly the space it occupies. (In Donald Judd's view, art like Caro's appeared "anthropomorphic" precisely because of its interaction with space: "A beam thrusts; a piece of iron follows a gesture; together they form a naturalistic and anthropomorphic image. The space corresponds."[8])

Red Splash (1966) offers an unusually explicit example of the spatial effect of Caro's work. This sculpture, made of welded pre-cast steel parts and painted bright red, has four corner elements, standing cylinders that differ slightly in length and diameter. They support two spans of coarse steel screen that cross diagonally between them.

If you position yourself so that the larger cylinders are foremost, the sculpture offers surprising contradictory aspects. The four cylinders read, on the one hand, as similar objects of different sizes and, on the other, as identical objects at different distances. Thus, while the sculpture plainly stands fast as an object in real space, in the way it appears to alter the measure of the space it occupies, it nonetheless achieves through composition the distancing effect that a framing device might otherwise have provided. Moving around the sculpture yields the rare sensation of being able to study the workings of a spatial illusion while partaking of it.

Carl Andre, *Twelfth Copper Corner*, 1975
78 copper plates: ¼ × 19⅝ × 19⅝ in. each; ¼ in. × 19 ft. 8¼ in. × 19 ft. 8¼ in. overall
Installation: Corcoran Gallery, Washington, D.C., 1976
Collection of the artist

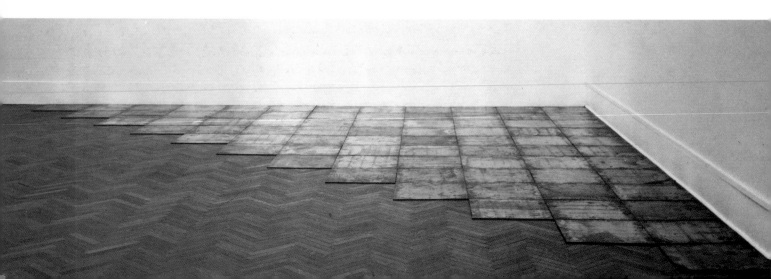

Carl Andre, *Brooklyn Field*, 1966
Alnico magnets; 356 units, 1 ×
1³⁄₁₆ in. each; 22 × 22 in. overall
Private collection, Elko, Belgium

The self-distancing aspect of Caro's *Red Splash*, which many of his larger works of the 1960s achieve in other ways, is a metaphor for the meaning of an art object. *Red Splash* evokes a notion of meaning as a virtual dimension of the object, accessible only to aesthetic contemplation, dependent on the sculpture's precise structure, and therefore on the artist's special skills as composer.

The presumption that art's meaning originates with the ineffable skills of the individual artist was one that Andre and many other American artists of his generation wished to explode. Donald Judd and Frank Stella saw it reflected in the demonstrative techniques of Abstract Expressionism, while to many of the so-called Pop artists, it was most obvious in the exercise of rarefied taste that seemed to be the point of so much painting then, as now. In retrospect, the impulse to deflate the exalted and the mysterious in art seems like a cultural symptom of the 1960s, a decade marked by giddy upsurges in anarchic democratic sentiment.

Stella and Andre may have disdained the Abstract Expressionists' sense of themselves as custodians of soulfulness in an age of deadening conformity and bureaucracy, but they saw their own works as subversive not only of the false sanctity of art, but also of precepts of the culture at large. However, the recognition accorded them contradicts the image Stella and Andre had of themselves as spokesmen for adversary viewpoints. Their works' celebrity makes it all but impossible now to taste the refractory attitudes they once betokened. For almost everyone who sees these works today, information about them preempts the kind of cold-shower experience the art of Stella and Andre provided when it was new.

Trying to talk in detail about Stella's and Andre's early works still gives an inkling of the difficulties they presented before they were tamed by official assent. Stella had set out to make paintings that couldn't be written about, at least not in the

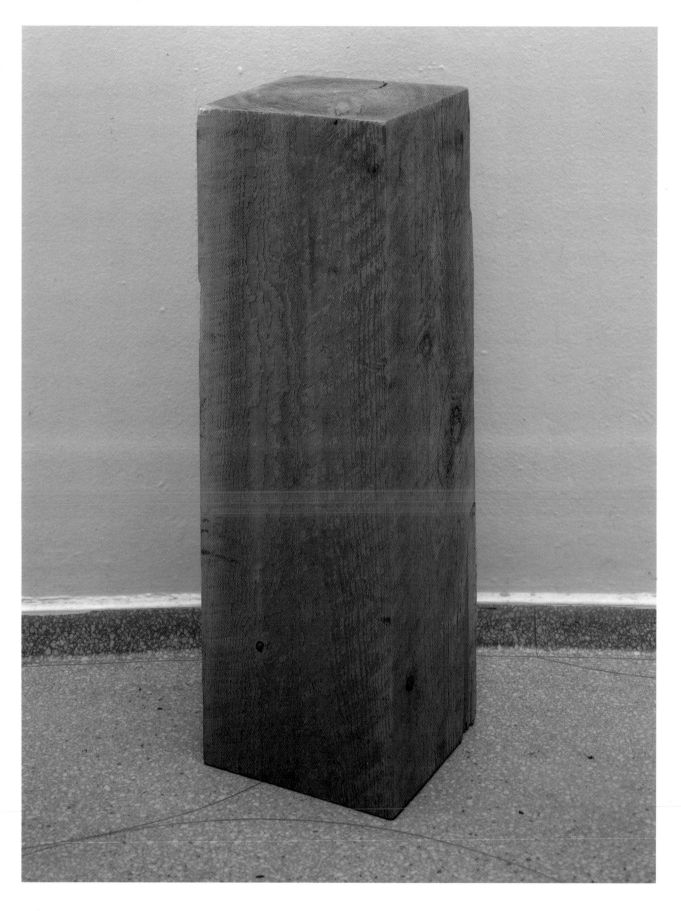

50

fulsome language Action Painting seemed to license. As Andre's sculpture developed, it too entailed a critique of thoughtless language that is still pertinent to our lives.

The commonsense unrecognizability of Andre's work as art is also the point of departure for certain reflections on language. If we wish to "recognize" one of his objects as art in other than the trivial sense of spotting a famous landmark, then we have to rethink the meaning of "recognize." If we set aside the fact of their validation by the art world, Andre's objects can be "recognized" as art only in the way we might recognize another's right to privacy or his rationality, or the legitimacy of a rule: that

Anthony Caro, *Red Splash*, 1966
Steel painted red,
45½ × 69 × 41 in.
Private collection

is, by active acknowledgement. A conscious commitment is required, a decided willingness to speak and behave in certain ways, and to put one's own actions and speech to the test of engagement with the autonomous viewpoint embodied by another individual, an unfamiliar rule, or a dubious artwork.

Contemplating a piece of Andre's work, you discover quickly that the figurative language in which art experience is so often described rings hollow and false when applied to it. You cannot say of his work unselfconsciously that it "moves" or "insults" you, or even that it "bores" you, for plainly it *does* nothing at all. We do the doing and read things around us in terms of our activity.

Look at Andre's work coolly, and you can see that inertness is what it has in common with seemingly self-evident works of art. Paintings by Rembrandt or Monet, sculptures by Bernini or Rodin, do not *do* anything more to us than Andre's metal plates. The most that any of these works of art "do" is cause us to have certain responses once we have primed ourselves with the right habits and conventions of speech, action, and understanding. It is we who project ourselves imaginatively into the structure of a painting or sculpture and construe a meaning for it, using the materials offered by the artist and by our own cultural background and individual lives. It is we who dwell upon, describe, discuss, and relate art objects in efforts to make various possibilities of experience and understanding real and available to ourselves and to others.

Being of a generation that reacted against florid language in criticism, Andre made objects so barren of expressive inflection as to seem impervious to words. He confronts us with the possibility that the content of our art experiences may be mere projections of our own wishes, expectations, and habits of thought onto inanimate things that have been contrived to favor such projections. The big psychological motive for such projection is a desire to deny such responsibility as we have for patterning the way the world presents itself to us.[9]

In taking matters to this extreme, Andre saw himself as clarifying, rather than stripping down or sterilizing, the terms of aesthetic experience. "My work has not been about the least condition of art but about the necessary condition of art," he claims. "I will always try to have in my work only what is necessary to it."[10] In this spirit he has chosen often to use elemental metals—substances that are irreducible chemical elements—as sculpture materials. When he assembles a floor sculpture from plates of lead or zinc or aluminum, we are to understand the materials' fundamentality as consonant with their placement at "ground" level and with the forbearance of artifice that this placement signifies. Internal consistencies such as this, and analogous affinities among his works, are the stuff from which Andre would have us construe meaning for his sculpture.

The impulse to externalize meaning or content is one Andre shared with other Minimal artists, such as Donald Judd, Robert Morris, Sol LeWitt, and Richard Serra. The impulse being a critical one in every case, it could not be reiterated or renewed indefinitely, if only because the critical thinking might modify the issues to which these artists addressed themselves. In Andre's work, the stark terms of the viewer's encounter with a new sculpture were meant to throw into sharp relief all one's mundane physical, linguistic, and imaginative trafficking with objects. The astute observer of everyday life might even discern in Andre's stylization of art experience the gist of Marx's concept of commodity fetishism.

From the perspective of Andre's work, the typical effusive account of art experience, in which an object "does" all sorts of life-enhancing things to the person who sees it, is a special case of the consumer's overdetermined response to a desired commodity. As Marx understood it, alienated labor—the common condition of work in the modern world—causes people to project onto things made for sale the very human spontaneity that the economic terms of survival—wage labor—force them to suppress in themselves. From this situation arises the habit, aggravated and exploited by advertising, of thinking and speaking unselfconsciously in figurative terms about what things can "do" to us or to others on our behalf. The unconscious theme of this habit is the yearning to buy in objectified form the human possibilities of which one is cheated by the need to broker one's labor for survival. This is the habit Andre rebukes obliquely by offering as "sculpture" things so baldly untransfigured that they seem to disqualify as mere projection any effort to characterize them in emotive or figurative language.

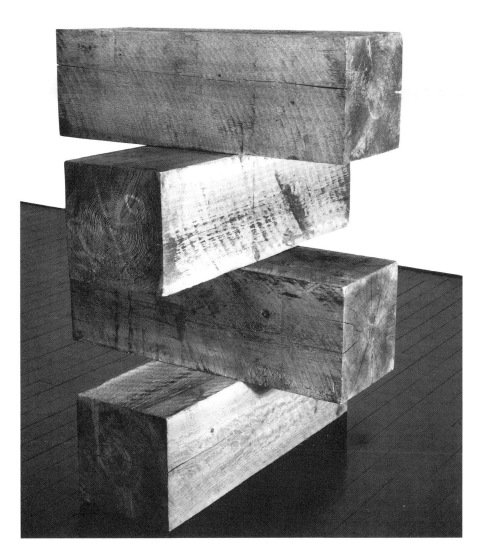

Carl Andre, *Stile (Element Series)*, proposed 1960, made 1975
Western red cedar; 4 units, 12 × 12 × 36 in. each; 48 × 36 × 36 in. overall
Collection of the artist

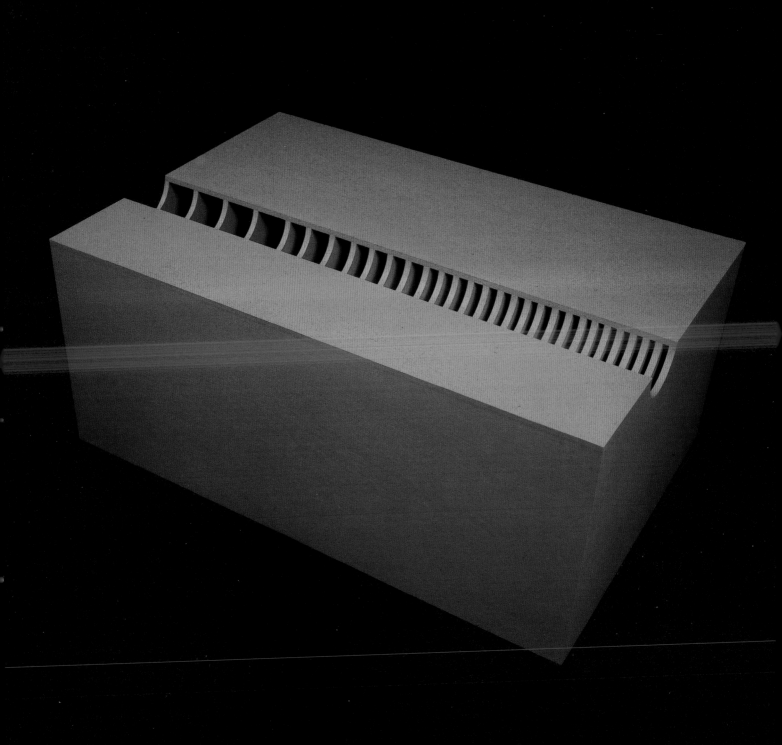

F O U R

Andre has always wanted viewers of his work to confront the anonymity of the labor behind its components. In a culture where alienated labor is the rule—that is, economic coercion to work irrespective of one's personal stake in the productive outcome—the artist is necessarily a kind of romantic figure. He is the marginal individual, so goes the myth, who sacrifices conventional security and respectability to do work he chooses, work that is the expression of his own desires and temperament. The Abstract Expressionist artist might appear to conform handily to this stereotype, but Andre does not. His forbearance of personal workmanship calls attention to the faceless labor that has made his materials and their settings available. His limiting constructive effort to simple operations such as stacking and aligning objects signifies a refusal to heroicize "creative" activity on the one hand and, on the other, an insistence that physical labor is the least important determinant of "art."

Possibly the only sculptor more committed than Andre to renunciation of personal workmanship is Donald Judd. He too seems to have been predisposed by temperament to invert the aesthetics and ethos of Abstract Expressionism.

Judd (born 1928) has rejected the term Minimalism more strenuously than any other artist to whose work it has been applied. From the outset of his work in sculpture, he has stressed the physical and perceptual qualities specific to materials and their configurations and scale. Categorical terms such as Minimalism encourage a categorical way of seeing against which he set himself as a young artist.

Born and raised in the Midwest in a family that moved frequently, Judd enlisted in the Army after high school, knowing he would qualify for educational aid under the G.I. Bill. In 1953, he graduated *cum laude* from Columbia with a B.S. in philosophy. While enrolled at Columbia, commuting from his parents' home in New Jersey, he studied at the Art Students League in Manhattan.

Against his family's wishes, he had decided after he left the army that he wanted to be an artist. He lived poor and unconnected in New York through the heyday of Abstract Expressionism, trying to make his way in painting and largely meeting with frustration. He managed to get some of his early paintings exhibited in the mid 1950s but abandoned them soon afterward and registered at Columbia as a graduate student in art history with an eye to teaching as a means of supporting himself. He finished his course work successfully, studying with Meyer Schapiro and Rudolf Wittkower along the way, and received a master's degree in 1962.

In 1959, Judd began publishing art criticism in *Arts* magazine, edited at that time by Hilton Kramer, and continued as a regular contributor of reviews for the next six years. A more gregarious artist might have hammered out his artistic principles

Donald Judd, *Untitled*, 1963, realized 1969
Oil on wood, 19½ × 45 × 30½ in.
Anne and William J. Hokin

55

Donald Judd, *Relief*, 1961
Asphaltum and gesso on
composition board mounted on
wood, with aluminum-pan inset,
48⅛ × 36⅛ × 4 in.
Collection, The Museum of Modern
Art, New York; Gift of Barbara Rose

in the bars that then served as intellectual foundries of the New York art world. For Judd, however, airing opinions in print, even inflammatory ones, was a more comfortable way to position himself relative to the quickening currents of contemporary art.

Although he continued to paint, Judd had by the late 1950s conceded his ultimate dissatisfaction with painting. He disliked the fact that whatever might be done on the surface of a picture tended always to fall inside the object, to sink into the virtual dimension of pictorial space. He had tried various means of emphasizing a picture's surface to make it seem as important as the object's physical profile: using encaustic and mixing sand with paint, adhering foreign materials to the surface, painting on wood or masonite so he could rout lines into the surface rather than just mark upon it. But none of these procedures resulted in the fully objective unity he wanted his work to have.

In 1961, he made an untitled piece that in retrospect seems pivotal. It is a rectangular panel, painted a tarry black, in the center of which is sunk a small, empty aluminum baking pan. With a kind of vehement literalness, the baking pan wedges a niche of real space into what purports to be the surface of an abstract painting. The empty pan reads as a mocking declaration of the art object's contentlessness. Judd would soon suppress the hint of Dadaistic humor he allowed himself in early works such as this.

Around the turn of the 1960s, he and many other artists began to view the open terrain between painting and sculpture as the most promising ground to explore. It yielded ambiguities completely independent of the possibilities of pictorial illusion and imagery. Judd's early non-pictorial objects have an almost Surrealistic strangeness that he would purge from his work as soon as he started having others fabricate things to his specifications. That slightly eerie quality lingers, highly distilled, in some of the simplest of Judd's objects from the late 1960s, such as the untitled, shelflike rectangular slabs that protrude from a wall, their frontal sides rounded into half-cylinders.

Untitled (To Dave Shackman) (1964) marks a kind of midpoint between the makeshift early works that Judd built himself and the icily refined objects made by professional fabricators that would soon form the bulk of his work. This piece was actually made by Dave Shackman, a filmmaker and part-time plumber to whom, following his death in 1968, Judd dedicated it.

An open structure of pipes and joints, it is a kind of skeletal version of the rectangular box of which Judd subsequently would devise countless variants. The pipes' network of fittings, pat as a circulatory system, foreshadows the seemingly self-explicating structural logic that would become a hallmark of his work.

The absolute regularity of *Untitled (To Dave Shackman)* rhymes with the standardized uniformity of its parts. Where artists such as David Smith and Anthony Caro used the predetermined forms of industrial steel as a foil for their own inventive dexterity, Judd conformed the structure of his piece to the simplest possibilities implied by straight pipe and right-angled joints. The orthogonal junction of pipes at the core of the object serves ironically to demote the center from its presumed priority as focus of interest, for the redoubling of symmetry there is just as matter-of-fact as what happens at the sides and corners of the work.

The public and critics who saw early exhibitions of Judd's sculpture sensed its authority but understood it primarily in terms of what it excluded. After the heady intensity of Abstract Expressionism and alongside the campy diversions of Pop Art, Judd's art was bound to seem a campaign of deprivations: Harold Rosenberg was

Donald Judd, *Untitled (To Dave Shackman)*, 1964
Iron pipe, 54¾ × 88 × 54¾ in.
Collection of the artist

not the only critic to pronounce it boring.

Meanwhile, Judd believed himself to be producing objects with a kind of fullness that Abstract Expressionist art and most art of the European past merely pretended to have. He believed that most modern art trained people in habits of attention that made it difficult to see the world clearly, encouraging them to think iconically and to focus on ideas about things at the sacrifice of direct observation of them. He made sculpture partly in order to propose new, self-clarifying patterns of attention. His work would cleanse the attentive viewer's perception, at least momentarily, of falsely climactic emphases, of susceptibility to tricks of illusionism, and of the restless drive to penetrate behind "mere" appearances.

To these ends, he tried to eliminate "relational" order from his objects along with referential qualities. By "relational" order, he meant the camouflaged hierarchies of internal detail and focus that underlie the expressiveness of painting, representational or abstract. "Take a simple form—say a box—and it does have an order," he explained in 1964, "but it's not so ordered that that's the dominant quality. The more parts a thing has, the more important order becomes, and finally order becomes more important than anything else."[1]

Many people see Judd's sculpture as art from which almost everything *but* order has been purged. However, his preference for the cleanest, simplest configurations was a matter of wanting each sculpture's physical character to be the entirety of its art content. Putting "one thing after another" compositionally was in his view the best way to keep an object's structure from appearing to betoken an invisible—because unspecified—scheme of coherence, transcendent of the thing itself.

Some of the popular and critical hostility Judd's art aroused early on may be ascribed to the fact that things as blank as an open aluminum box lined with plexiglas or a long, slender wedge of perforated steel were not easily understood as "sculpture" when he first thrust them into the art context. These objects appeared to use up space pointlessly and to betoken nothing but the artist's aggressive refusal to exploit "expressive" resources at his disposal.

The fact that he did not fabricate objects himself also counted against him, opening his work to misconstruction as a kind of conceptual exercise. Yet from Judd's vantage point, surrendering personal handiwork was a great advantage: it meant he could avail himself of techniques and material effects he could never have commanded if restricted to his own skills and expertise. Acting as contractor rather than fabricator increased the control he could have over the precise physical qualities of an object. And nothing matters more to him than that kind of control.

Donald Judd, *Untitled*, 1965
Galvanized iron and red lacquer,
14⅝ × 76⅝ × 25⅝ in.
Walker Art Center, Minneapolis;
Harold D. Field Memorial
Acquisition, 1966

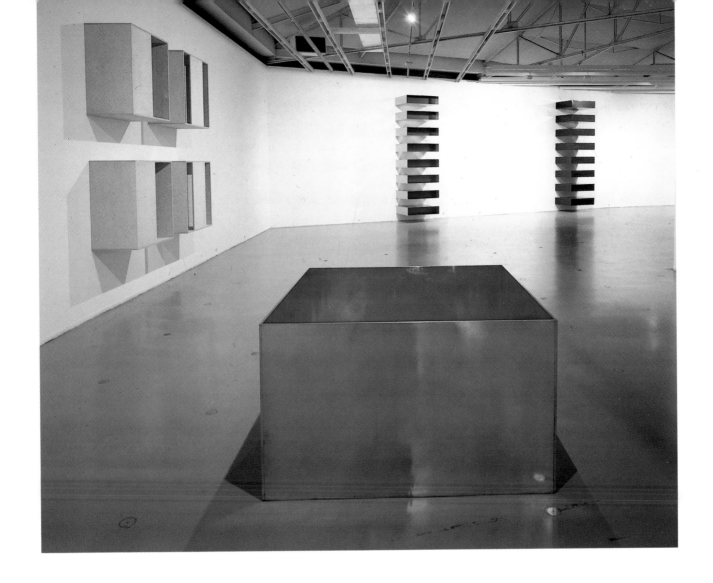

Donald Judd, *Untitled*, 1972
Copper and light cadmium-red
enamel on aluminum,
3 × 5 × 5 ft.
Saatchi Collection, London

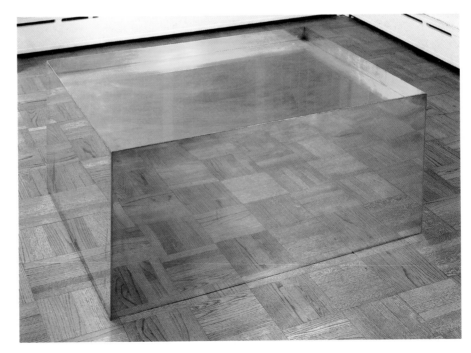

Donald Judd, *Untitled*, 1970
Brass, 22 × 50 × 37 in.
Collection Morton Neumann,
Chicago

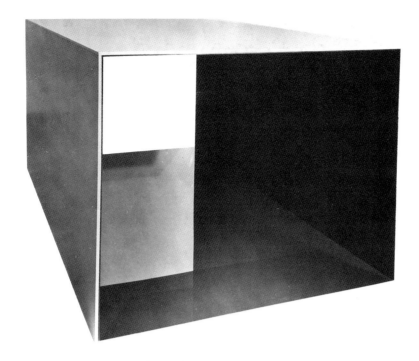

Donald Judd, *Untitled,* 1969
Anodized aluminum and plexiglas,
48 x 108 x 61 in.
Private collection

Judd developed a number of formal strategies to enable him "to work and do different things and yet not break up the wholeness that a piece has."[2] He would present series of identical simple forms or volumes as single works, permitting distinct objects to read as parts one moment and as wholes the next, as in the many "stacks." Or he might choose a basic format and set of dimensions, as in the small, galvanized-iron floor boxes of 1971, and alter the composition of each piece to achieve a maximum of variety with what seems like a logical minimum of structural differences. The crowning example of this procedure is the series of one hundred mill-aluminum boxes made in 1984 and 1985, funded by the Dia Art Foundation, and permanently installed at the Chinati Foundation, near Judd's residence in Marfa, Texas.

The one hundred boxes, fabricated with perfect precision by the Lippincott Foundry in New Haven, Connecticut, were to be the core of The Art Museum of the Pecos, a project underwritten by the Dia Art Foundation. Dia, funded by revenues from Schlumberger Industries, a multinational oil industry service corporation, emerged in the mid 1970s as patron of several Minimalist artists, including Judd, Dan Flavin, and Walter De Maria.

Donald Judd, *Untitled,* 1965
Perforated steel, 8 × 120 × 66 in.
Whitney Museum of American Art,
New York; Fiftieth Anniversary Gift
of Toiny and Leo Castelli

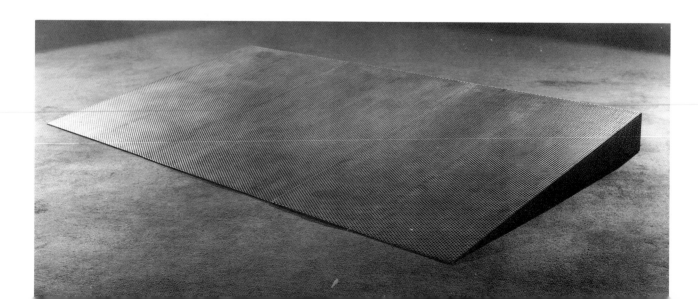

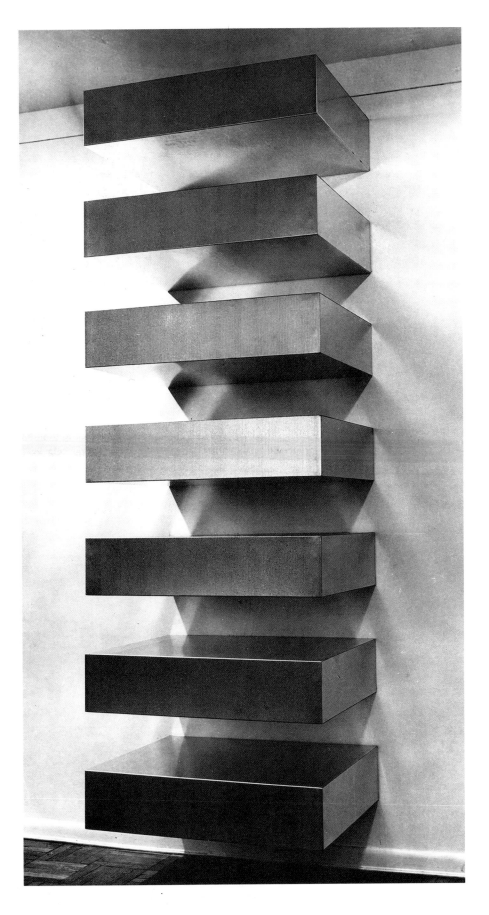

Donald Judd, *Untitled*, 1966
Galvanized iron; 7 units,
9 × 40 × 31 in. each
Private collection

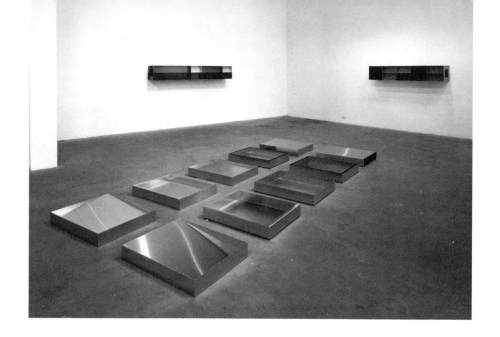

Donald Judd, *Untitled*, 1976–77 (10 units of a 21-unit work)
Stainless steel; ten units,
4 × 27 × 23 in. each
Installation: Margo Leavin Gallery,
Los Angeles

The foundation signed an agreement with Judd to develop a museum devoted to permanent display of his work and that of Dan Flavin, John Chamberlain, and the late Barnett Newman. Against Judd's advice, Dia bought the grounds and buildings of an abandoned military compound on the outskirts of Marfa. The costs of the project grew enormously during the early 1980s, while Dia's revenues shrunk due to the world oil glut. When work on the project was suspended, Judd threatened to sue Dia for breach of contract. However, a settlement was reached that gave him title to the one hundred aluminum boxes and the buildings and land, and enough money to form the Chinati Foundation, which, at this writing, is raising funds to maintain the Marfa installation permanently.

Donald Judd, *Untitled*, 1980–86
Mill aluminum; 100 units,
41 × 51 × 72 in. each
Installation: Chinati Foundation,
Marfa, Texas

Donald Judd, *Untitled*, 1976
Plywood, 3 × 5 × 5 ft.
Private collection

When you walk among the mill-aluminum boxes, which are all identical in dimensions but different in structure, you keep thinking you've caught Judd repeating himself. This sensation is enhanced by the fact that the boxes sit in rows between floor-to-ceiling windows that overlook the sun-dazzled West Texas prairie. Light ricochets among the icy-looking aluminum surfaces, making it difficult to distinguish reflections, shadows, and solid planes. But when you double check, you find that each of the one hundred objects is structurally unique. You become aware of a kind of perceptual torpor that causes you to try to see what you believe before you check belief against reality.

Judd's art has never been very responsive to developments in the art world at large. Significant exceptions are the few pieces he has done that might be characterized as site-specific. The first and best example is the double-ring piece in hot-rolled steel made for the Guggenheim Museum's "International" exhibition in 1971, now in the museum's permanent collection.

This untitled work consists of two concentric rings of sheet steel stood on edge. The rings differ in height around their circumferences. The inner ring is a constant twenty-four inches, while the outer one, properly positioned, changes in height so that its upper edge is a level circle, compensating for the slope of the Guggenheim's spiral ramp, where the work is intended to sit. The disparity between the rings gives objective form to the bodily awareness of clashing frames of reference that you have when you stand on the museum ramp. Meanwhile, the work's circularity echoes that of the Guggenheim's architecture.

The appeal to the viewer's consciousness of his body in the 1971 Guggenheim rings is a clear instance of the grounds for calling Judd's objects sculpture in the strong sense, rather than just in the sense that they are three-dimensional art. Judd's best work is scaled and structured so as to sharpen the observer's awareness of connections between the object's aspects and his own posture, eye level, mobility, and earthboundness. Whereas traditional sculpture objectified human powers, motives,

and possibilities of action in representations of the body, Judd contrives objects that evoke such fundamentals by patterning the viewer's awareness of his own body in the act of observation.

The "stacks," for example, consist of identical box elements to be hung on a wall at even intervals from floor to ceiling. These works are de-idealizing devices that recall the bodily basis of abstract concepts we use to sort out what we see. They remind you that your body conditions what you may take for the objective facts of a situation. Faced with a sequence of boxes that appear to be consistent in material and dimensions, you think of them at first as identical and interchangeable. But what you actually see of them is determined by your own height and standpoint. The relations between what you believe you know about each box and what you see of it vary because each element has a different position. This simple observation highlights the power of inference as a faculty of the body (one that hints at a non-Cartesian concept of mind) to compensate for its own limits. Inference is one of the skills for which the term "mind" serves as shorthand. The "human" content of Judd's art lies in such evocations of mental acts as prerogatives of the body.

Michael Fried once called Judd's sculpture "anthropomorphic" because so much of it is, or appears to be, hollow. Fried was suggesting that Judd's sculpture pretends

Donald Judd, *Untitled*, 1971
Hot-rolled steel; outer circle: 32¾ in. high, radius 90 in.; inner circle: 24 in. high, radius 80¾ in.
Solomon R. Guggenheim Museum, New York

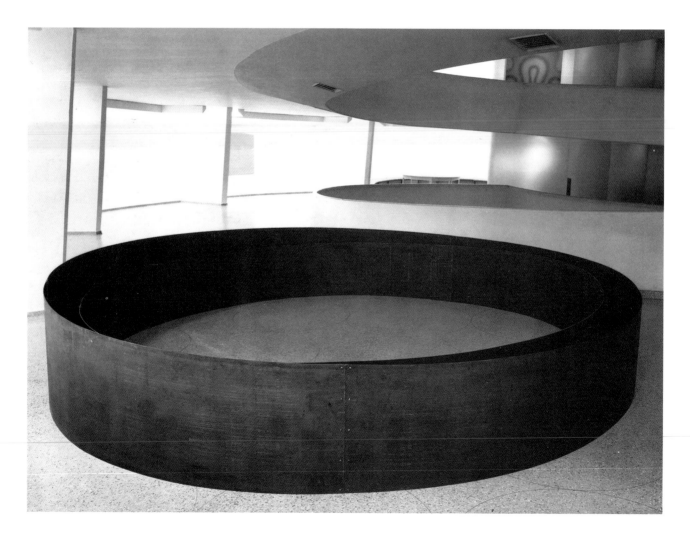

to be abstract, while in fact it reiterates the figure of a hollow, mind-enveloping vessel in terms of which we have learned to think inappropriately about people. Fried was right in pointing out that Judd does not strive to keep us from recognizing a hollow object as hollow. However, the evocation of human embodiment in Judd's sculpture is far more indirect and apt than a crude analogy between a vacant box and the body as a container of the mind. Judd rectified the analogy first in his plywood pieces of the mid 1970s, at the very end of what I consider to be the Minimalist moment.

In 1976, he showed a group of fifteen plywood floor boxes at what was then the Heiner Friedrich Gallery in New York. Characteristically, they all had identical dimensions and distinct internal structures. The fact that they were made of plywood was a key difference between these and Judd's other serial works. The plywood grain marks each surface—inside and outside—with a pattern as distinct as a fingerprint, a pattern inherent in the material, not applied at the whim of the artist. The details of surface grain heighten the differences among each box's components, even when those parts are of the same dimensions. The boxes' emptiness seems trivial because collectively they offer a profoundly simple—and non-representational—analogue of human individuality: their common condition of being at once as similar and as different as possible.

Judd's art is convincing, or fails to be, because of its contrasts to the broad cultural background in which shoddy goods, pandering design, and planned obsolescence are the rule. It is all but impossible to find in a supermarket so much as a matchbook or a box of facial tissues that is not covered with advertising or a pattern that stands in for advertising. Plastic is made to look like wood, chrome, tile, natural fibers, or leather, both mocking and exaggerating the luxury of the genuine articles. Paper napkins are embossed to simulate embroidered linen. Soft-drink labels are designed to imitate wine labels. Perhaps only a disillusioning analysis of society's class structures suffices to explain why manufactured goods for common use are made with such a surcharge of deceptive detail. Judd's best sculptures, on the other hand, reward curiosity about why something is made the way it is with the rare sensation of seeing an industrially fabricated thing that exists solely to be contemplated (so long as its status as a commodity is not held to discredit it) and which seems wholly to be what it ought to be in. terms its material and structure set forth.

Gradually the market success of Judd's art has undermined this sensation, making irrepressible the questions of who capitalizes the work and at what cost. Even the most apt refinements of his sculpture are downgraded to mere elegance (or sales lubricant) when each work is priced in five or six figures. Like other artists overtaken by market success, Judd has found no way to keep the style of his art from looking like the earmarks of a product line. His work is defenseless, as is most contemporary art, against conversion to luxury goods.[3] Judd's critics accuse him of having permuted materials and formats for sculpture merely to profit from an oeuvre the integrity of which lay in its not being proliferated. The intense consideration Judd plainly gives to the scale and number of parts in each sculpture raises the question whether he reflects just as uncompromisingly on the number of sculptures that should exist at his behest, or whether he simply produces them according to what the market will bear. He might reply that in a culture hooked on the technological acceleration of life (and death) and on mediated visions of reality, the purified coherence that his work offers will always be in too-short supply.

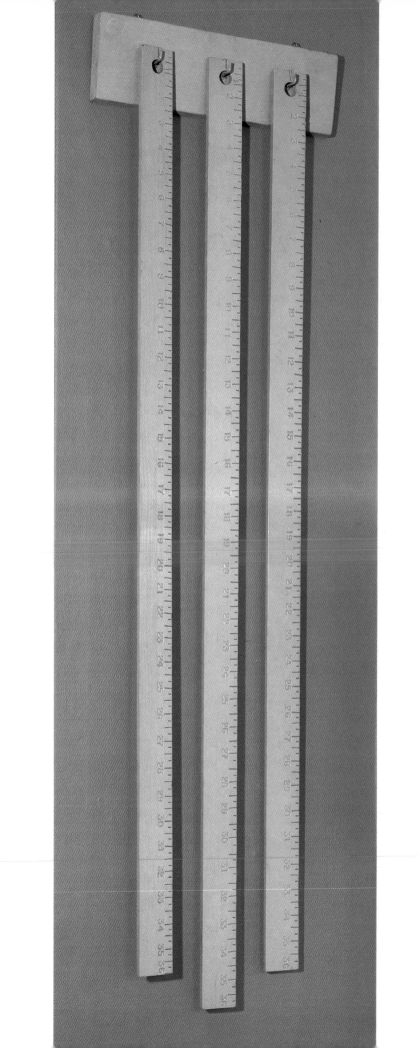

F I V E

The catchall term "Minimalism" exaggerates the affinities between the works of artists such as Donald Judd and Robert Morris. Morris seems never to have been motivated by revulsion for mass-produced kitsch. In the mid 1960s, both were making what Judd once called "specific objects." But their respective attitudes toward the art object soon diverged.

For Judd, the art object is an end in itself. Ever since he began working with fabricators, he has taken great care to insure that each finished object has exactly the look he wants. For Morris, on other hand, the sculptural object is a means to contrive a specific experience for the viewer that will give rise to an idea. Typically, the idea is more than just the plan of the object, for Morris found opportunities in the conventions of exhibiting art to investigate the perceptual and situational factors in seeing.

Like Judd, Morris (born 1931) started out as a painter. He served in the Army Corps of Engineers and studied at art schools in San Francisco and his native Kansas City. He turned to sculpture after deciding, contrary to the Abstract Expressionist precept, that painting misrepresented too much the processes that brought it into being.

His first sculpture, *Box with the Sound of Its Own Making* (1961), was a kind of satire of the art object as a truthful record of its own fabrication: a small cubical walnut box that emitted tape-recorded sounds of the sawing and hammering that went into making it. This piece made reference to Marcel Duchamp's *With Hidden Noise* (1916). It was also a send-up of anthropomorphism in sculpture—for the walnut box on its pedestal symbolized the artist's head and the soundtrack evoked the idea for the work echoing inside it. Many of Morris's early pieces drew upon Duchamp. Like *Box with the Sound of Its Own Making*, they dealt wryly with the ambiguous relations between a work of art and the idea "behind" it.

Morris's early works expressed a skepticism he shared with other artists of his generation. He suspected that most of the metaphysical claims people made about works of art were merely projections, rephrased in art lingo, of beliefs about the nature of human beings. Like Judd and Andre, he tried to take his work in sculpture beyond the dichotomy between representation and abstraction. Doing that seemed to be the only way to make art that was not anthropomorphic, in which viewers could not somehow see themselves mirrored metaphorically. It is not surprising that hostile critics accused him of purging sculpture of human content. That was exactly what he had in mind: making objects that would relocate "human content" where it belonged, in relationships established by the viewer's actions, rather than in the object.

Like so many artists, Morris had been impressed by the way Johns had undone

Robert Morris, *Three Rulers*, 1963
Painted wood, 42½ × 11 in.
Private collection, New York

67

the illusionism of painting, closing the gaps between image and object, between concept and outcome, leaving no slack to accommodate viewers' projections of their own subjectivity. Morris too would expand upon Johns's objectification of qualities that had seemed formerly to be interior to paintings and to invoke the interior lives of people who looked at them.

At first, picking up on the strain of Dadaistic humor in Johns, Morris made punning objects such as *Three Rulers* (1963). Here, he fashioned three yardsticks, each of a different length, that recall Johns's use of a ruler in several works and, more important, evoke Duchamp's *Standard Stoppages*. Almost fifty years earlier, Duchamp had devised his own "standard" measures by dropping three meter-long threads in succession from a height of one meter and gluing them to dark canvas to preserve their chance dispositions. In his piece, Morris straightened the curves of Duchamp's *Stoppages* and added calibrations that belie the perceptibly different lengths of his rulers. Morris may have intended his title as a comment on the perfidy of political rulers and the arbitrariness of rules, perhaps even making wayward reference to the biblical Three Kings. He may even have meant to invoke Einstein's famous relativistic thought experiment in which rulers appear to contract and clocks to slow when gauged in a moving inertial frame of reference different from the observer's own. This might seem like more interpretation than such a simple object could bear. It is validated, however, by the complexity and sophistication of Morris's subsequent works.

Like Stella, Andre, Judd, and others in the early 1960s, Morris thought hard about the objective status of works of art: What kinds of things are they? Are they things at all in the ordinary sense? His thinking was marked by his involvement in improvisational theater and dance.

Rosalind Krauss has detailed the importance to Morris's development as an artist. (Regrettably, critics have yet to give proper consideration to the role in the Minimalist project of Morris's early collaborator, Yvonne Rainer.) In a key theater piece Morris did in 1961, the sole "performer" was an object resembling those he would present as sufficient sculptures soon afterward. It was a six-and-a-half-foot-tall rectangular column of plywood, two feet on a side, painted gray, which stood motionless onstage for three and a half minutes. It then tipped over—toppled by the artist, who stood inside it—and lay motionless on its side for another three and a half minutes before the curtain fell.

Simple as it was, this performance was rich in implications. It reduced dramatic action to the vicissitudes of a stage prop. It dramatized the phallic and anthropomorphic symbolism of a columnar object, forming paradoxical puns on climax and anti-climax. The performance deprived its audience of a "subject" with which to identify, thwarting subjective responses other than expectation and boredom, which heightened the spectator's awareness of time. It also enacted the shift from vertical to horizontal structure in American sculpture to which Morris would soon contribute. The primary aspect of this performance that Morris carried over into his sculpture of the mid 1960s, along with the object's form, was the point that in occupying space, the art object takes up time.

The sensation many people had upon seeing the simple painted plywood sculptures Morris showed in New York in 1964 was frustration in waiting for the objects to disclose some meaning. Some people caught on to the idea that this

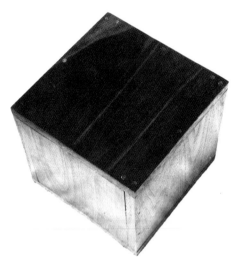

Robert Morris, *Box with the Sound of Its Own Making*, 1961
Wood, 12 × 12 × 12 in.
Private collection

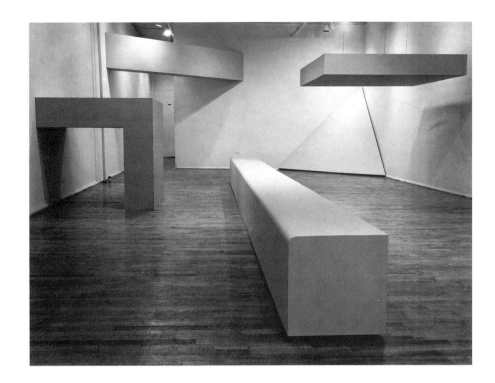

Robert Morris, Installation view of one-person exhibition, Green Gallery, 1964
5 works, all painted plywood

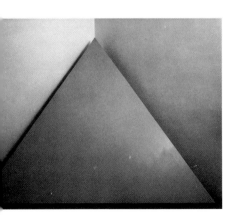

Robert Morris, *Corner Piece*, 1964
Painted plywood, 6 ft. 6 in. × 9 ft.
Panza Collection, Milan

sensation of conclusions indefinitely postponed might *be* the meaning. The range of responses to his work confirmed Morris's inkling that "simplicity of shape does not necessarily equate with simplicity of experience."[1] Some people saw the objects as tokens of anti-art, or anti-audience, subversion aimed at creating a kind of suffocating vacuum where rarefied aesthetic airs were anticipated. Some took Morris to be making objects whose sole art content was their geometry. And others understood him as supplanting aesthetic detail with the subjective texture of the time it took to reconcile oneself to the objects' true emptiness.

Sympathetic commentators, such as Marcia Tucker, saw Morris aiming at a perfect equivalence between the conception and perception of his objects or as clearing the air ruthlessly of artistic fluff. Old-guard critics such as Harold Rosenberg and Clement Greenberg took him to be dehumanizing art or valuing boredom equally with other possible experiences, as Andy Warhol had done in other media. Morris saw himself externalizing relationships that are, or are usually thought to be, internal to works of art—for example, by making ensembles of elements that read as objects complete in themselves. The point was to make viewers aware of perception as an activity, carried on bodily, rather than a passive droning of awareness. In one of the essays Morris published to clarify his viewpoint, he explained that the new sculpture, his own included, "takes relationships out of the work and makes them a function of space, light, and the viewer's field of vision. The object is but one of the terms in the newer aesthetic. It is in some way more reflexive because one's awareness of oneself existing in the same space as the work is stronger than in previous work, with its many internal relationships. One is more aware than before that he himself is establishing relationships as he apprehends the object from various positions and under varying conditions of light and spatial context. Every internal relationship, whether it be set up by a structural division, a rich surface, or what have you, reduces

the public, external quality of the object and tends to eliminate the viewer to the degree that these details pull him into an intimate relation with the work and out of the space in which the object exists."[2]

Morris's shift of emphasis from "an intimate relation with the work" to its overt circumstances is what Michael Fried disparaged as "theatricality" in the most noteworthy critical attack on Minimalism, his long essay "Art and Objecthood."[3] In this essay, Fried contrasted the work of artists such as Judd, Morris, and Andre with that of "modernist" painters and sculptors such as Kenneth Noland, Jules Olitski, Anthony Caro, and David Smith. Frank Stella counted for Fried as a modernist rather than a Minimalist—or "literalist," to use his term—because Stella pioneered the use of a painting's exterior shape to differentiate it from non-art things with which it might be confused. To achieve the status of art, Fried argued, a painting or sculpture had to set itself apart from the unfocused, desultory condition of everyday life and consciousness that literalist work merely affirmed. And it had to set itself apart by means its craft tradition implied. Stella had accomplished this by contriving visual interlock between a painting's surface pattern and its physical profile.

The virtue of modernist art, according to Fried, was to provide the viewer a sensation of relief from subjection to the flow of time, from time's aimless threading together of the most disparate events and thoughts, "one thing after another." Fried did not explain why mindfulness of time should be such an oppressive experience. He merely hinted that the sensation of time passing held unhappy intimations of mortality. Robert Smithson, a Minimal sculptor who sometimes described himself as a Marxist, once remarked that what Fried was really talking about, whether he knew it or not, was the common consciousness of modern history as a march toward catastrophe.[4] Smithson understood Fried's aesthetic ideal of release from time as escapist. Like several other Minimalists, he saw it as part of his artistic responsibility to call attention to the drift of events, and to people's passivity in the face of it.

According to Fried, the sensation of release from time depended on the fact that a modernist painting or sculpture was fully available to the eye at every moment, rather than revealing of itself gradually. It depended too on the artwork's having a proper modernist genealogy. As Fried put it, "seeing something as a painting in the sense that one sees a tacked up [blank] canvas as a painting, and being convinced that a particular work can stand comparison with the painting of the past whose

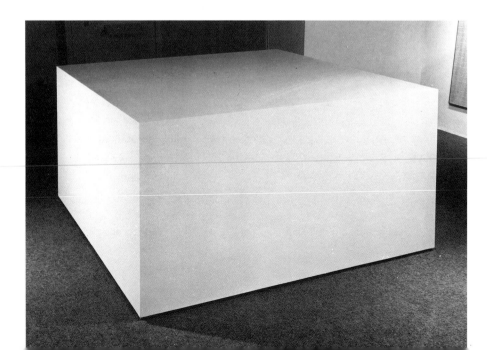

Robert Morris, *Untitled*, 1966
Painted plywood, 4 × 8 × 8 ft.
Panza Collection, Milan

quality is not in doubt, are altogether different experiences: it is . . . as though unless something compels conviction as to its quality, it is no more than trivially or nominally a painting." Therefore, "the task of the modernist painter is to discover those conventions that, at a given moment, alone are capable of establishing his work's identity as painting."[5] Fried's essay as a whole makes the analogous argument for sculpture.

Fried seemed to believe that the visual arts were compromised and disqualified as "modernist" by the introduction of merely topical content. The single issue of defeating "theatricality" was to epitomize the modernist artists' engaged response to their time; for, as Fried saw it, this issue caught the essence of the corruptibility of culture in the present age.

To Morris, Judd, Smithson, and especially Tony Smith, among others, it was a point of pride that their works did not reveal themselves in an instant but forced the viewer to decide how much time was needed to comprehend them and how that time should be spent. They saw such decisions as operative always in experiences of art, but suppressed—kept unconscious—by the decorative seductions of color-field painting and of "constructed" sculpture such as Anthony Caro's. In trying to situate their works in "real time" and to call attention to perception as an activity that in some degree forms the reality it discovers, the Minimalist artists exerted a moral pressure upon the art public, typical of the 1960s in America, to think about how their own actions might affect events in which they took part.

It was Morris's notion in the mid 1960s that sculptural objects ought to have the character of gestalts. In psychological nomenclature, a gestalt is any aspect of a thing that presents itself as a perceptual whole and can thus serve as a kind of reference point in the processes of seeing and thinking. The term "gestalt" refers to perceptions whose content is uncertainly objective. When we see the full moon in the night sky, for instance, we have no doubt that others grasp this gestalt as readily as we do. We are a little less certain that people see "the man in the moon" in the same way we do when we look at the moon's surface. And if we have learned to see in the full moon a rabbit pounding *mochi,* as the Japanese do, we can be fairly certain that this gestalt is not available to most Americans, though we might be able to bring them to see it. Psychological theory is unclear as to whether gestalts are patterns formed by the perceiver's nervous system or are rooted in the nature of external circumstances. This very ambiguity is what Morris wanted his sculptures to bring into focus. Even objects that are part of an ensemble may be graspable as gestalts in themselves, on a par in this respect with the ensemble itself. Although the gestalt of a volumetric shape might be easily grasped, this does not mean that a different view of the object might not banish one gestalt and give rise to another. The inherently provisional quality of gestalts is a reminder of time—of persistence and unpredict-ability—as a factor in things appearing to us as they do. The concept of gestalt assumes that perception seeks wholeness of aspect in things rather than aiming at objectivity or accuracy. In the mid 1960s, Morris sought to highlight the nature of perception by making sculpture whose aspects of wholeness appeared to be both objective and changeable. Easy distinctions between subject and object, mind and body, inwardness and external reality lose some of their credibility for anyone who sees things in gestalt terms. "The universal priority of the whole over its parts is supposed to settle the antinomies of classificatory consciousness," as Theodor Adorno

points out. But "the very concept of the elementary is already based on division. This is the moment of untruth in Gestalt theory."[6]

Gestalt theory may be even more pertinent to Tony Smith's sculpture than to Morris's. Smith (1912–80) produced several absolutely regular sculptural objects in the 1960s. Fried cited one of them—*Die*, a six-foot cube of Cor-Ten steel—as an example of a work that is eminently "theatrical" in that it gives the viewer no clue to how much looking is enough to find meaning in it. For Fried the possibility of discovering meaning in an object, of finding nonarbitrary, observable grounds for its claim to being a painting or sculpture, was what qualified it as a work of art. In his view, Smith's *Die* was only nominally sculpture because there was no viewpoint that made its claim to being art anything but arbitrary, or, as he said, "ideological."[7]

Smith shaped a number of his other sculptures so as to make it impossible to anticipate views as one moves around the object, as if to postpone conclusions about the sculpture's structure as long as possible. The disparities of aspect in *Crocus* and in the other elements of *Wandering Rocks*, for example, affirm the fact that no

Tony Smith, *Wandering Rocks*, 1967
Vapor-blasted stainless steel,
variable dimensions
Private collection

Tony Smith, *Crocus* from *Wandering Rocks*, 1967
Vapor-blasted stainless steel,
48⅜ × 28 × 45 in.
Private collection

Tony Smith, *Crocus* from *Wandering Rocks*, 1967 (alternate view)

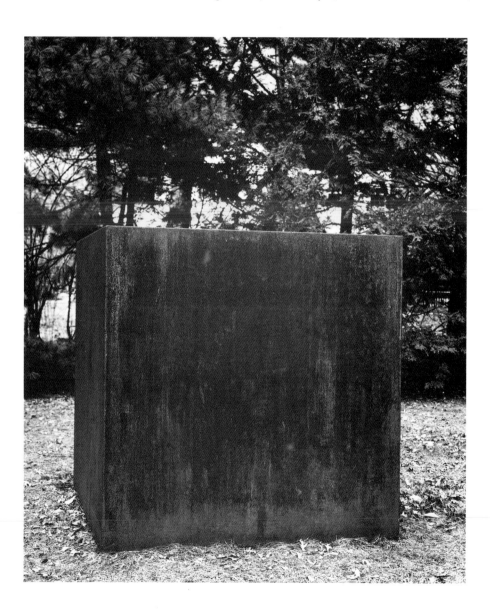

Tony Smith, *Die*, 1962
Steel, 6 × 6 × 6 ft.
Estate of the artist

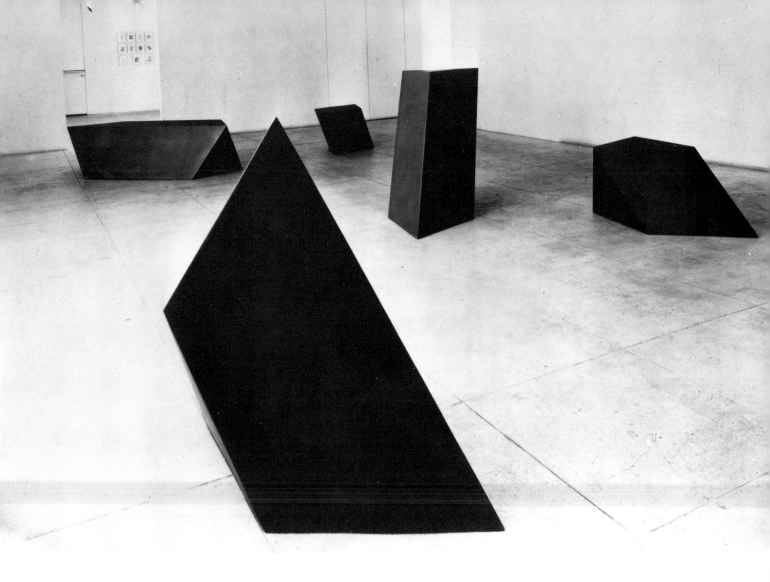

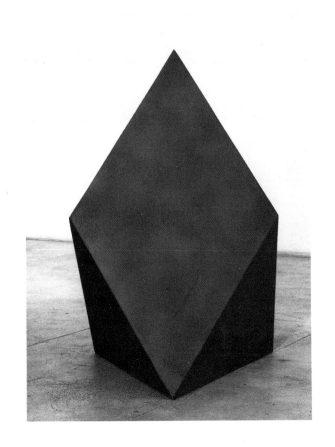

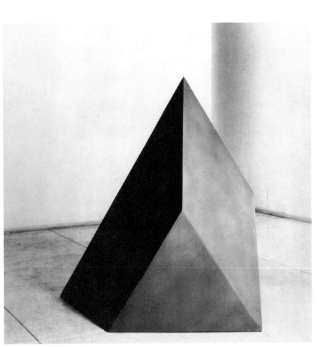

73

intellectual act or idealized vantage point can supplant the process of walking around the objects and that no meander can comprehend the totality of relations implicit in the whole ensemble.

From Smith's perspective, the "art" of a piece such as *Crocus* consisted in inventing a shape that would read from every vantage point as "unitary"—to borrow Morris's term—yet offer the greatest possible diversity of aspects. Such an object would be a lesson in the risks of inductive thinking, of inferring from one viewpoint the experience to be had from another. Thus it would serve to illuminate time as a dimension of existence that sets things (and aspects of things) apart and that in a profound sense gives weight to the details of reality. Smith's work also revived in sculptural terms a question raised by the analytic Cubist paintings of Picasso and Braque: the question whether attention to the changes effected by shifting one's own physical standpoint promotes tolerance of the disparate vantage points on reality that other people embody.

Fried acknowledged no such positive ethical force in the work of Smith or of the other "literalists." In fact, he faulted the artists for making "anthropomorphic" sculpture in the guise of abstract art. He believed that "the entities or beings encountered in everyday experience in terms that most closely approach the literalist ideals of the nonrelational, the unitary and the wholistic are other persons."[8] And in condemning Minimalism as "theatrical," he mistook its insistence on seeing as a constructive activity for a demand that the viewer stylize his own responses to lend the experience of the art object an articulation, a shape or a closure it would otherwise lack.

Finally, Fried criticized Minimalist work for proposing as art content the mere inexhaustibility of physical reality. This criticism, though tendentious, was well-founded. In the late 1960s, Morris, Andre, Barry Le Va, and other New York artists sometimes worked with loose materials such as thread and bits of plastic or wood that, when scattered, could not be grasped readily as objects in themselves, but only as fields of uncomposed physical detail. Works of this sort, such as Morris's untitled "thread room," were aimed at inducing a sensation psychologist Anton Ehrenzweig called "dedifferentiation," a sort of relaxation of the normal processes by which perception selects objects from the flux given to the senses. The notion was that "sculpture" that formed a dedifferentiated field thwarted dualistic thinking. Lacking an object—with dispersed matter in place of an object—the expectant viewer of sculpture

Robert Morris, *Untitled*, 1968
Felt, asphalt, mirrors, wood, copper tubing, steel cable, lead, 21¼ in. × 21 ft. 11 in. × 16 ft. 9 in. (dimensions variable)
Collection, The Museum of Modern Art, New York; Gift of Philip Johnson

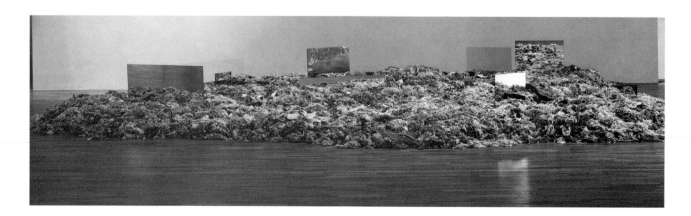

Richard Tuttle, *Silver Picture*, 1964
Painted wood, 18 × 87 × 2 in.
Saatchi Collection, London

Robert Ryman, *Untitled*, 1961
Oil on paper board, 12 × 12 in.
Saatchi Collection, London

Brice Marden, *Grand Street*, 1969
Oil and wax on canvas; 3 panels:
48 × 72¼ in. overall
Saatchi Collection, London

might experience his vaunted subjectivity as a kind of caricature of an unfocused awareness that responds bodily both to mental dispositions (and memories) and to ever-changing circumstances. The experience of dedifferentiation was to be a taste of the condition underlying the division of reality into self and substance. To evoke this sensation, Morris, among others, left off making objects and did some works, such as his "steam pieces," that were all process, almost raw phenomena. It was this development that prompted Harold Rosenberg to observe that "Art in our era oscillates between the conviction that meeting the resistance of a craft tradition is indispensable to acts of creation and the counter-conviction that secrets can be fished alive out of the sea of phenomena."[9]

Where Rosenberg saw "oscillation," Fried saw conflict. Fried believed that the artists he called "modernists" did not simply inherit the "resistance" of their arts' craft traditions. He saw them laboring under a historically novel pressure to transform those traditions from within—almost beyond recognition at times, in the case of Morris Louis, for example—in order to maintain them as sources of artistic imperatives.

The Minimalist view was that people ought to immerse themselves in "the sea of phenomena," that is, in the concrete reality of what they experience, and judge ideas and ideals on that basis, rather than living by views—received from television especially—that must be accepted on faith because they cannot be tested by experience. The Minimalist artists inherited the avant-garde presumption that art could effect changes in the world by changing people's attitudes. Acting on this precept often meant doing just what Fried reproached them with: making incursions beyond the sphere of art into the hugger-mugger of mundane reality.

When Anthony Caro kicked the pedestal out from under sculpture, he set himself the problem of creating abstract structures so dissimilar from everything around them that their appearance would effect the same sensation of aesthetic withdrawal that a pedestal might have provided. Andre, Judd, and Morris put sculpture on the floor in order to transgress the bounds of art.[10] They meant to assert that artists could and ought to redraw unacknowledged bounds of custom and concept, even if in the process art were to annihilate itself and disappear into the non-art background.

To the Minimalist sculptors, the inexhaustibility of physical reality was a source of artistic friction because it is something people so rarely contemplate. They did not believe we are hostages to the meaningless detail of the physical world, as Fried had suggested when he said, "We are all literalists most or all of our lives."[11] On the contrary, these artists observed that people are startlingly blind to the precise reality of things they encounter and that most contemporary art panders to this blindness instead of counteracting it.

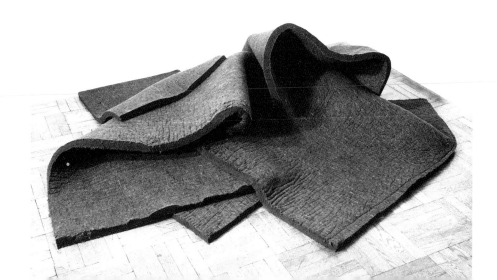

Robert Morris, *Untitled*, 1968
Black felt; 3 pieces, 1 in. thick each
Collection of the artist

Artists of the Minimalist camp matured in a time when media technology and tactics were becoming rapidly more sophisticated and pervasive. Consequently, they tended to make art that intensifies distinctions between the direct experience of life and mediated views of it. One way of declaring the importance of this contrast was to offer up "works" whose only apparent content was the inherent sensuous vividness of their materials. Another was to make objects that contradict the common, unexamined assumption that consciousness is *a medium of representation*, like film, video, photography, and illustration, which purport to portray its functioning. Minimalism might eliminate decoration, expressiveness, and color, but its most drastic privation was the elimination of cues and rhetoric for understanding objects representationally. In a sense, then, Fried was on the mark when he brought up the issue of "theatricality." He intuited that people would seek a representational program for understanding or assimilating barren objects presented as art. His inkling was that they would theatricalize their observation of the art object, replacing the meaning absent from the work with their own self-consciousness of being its viewers. However, the unprejudiced viewer might discover instead that Minimal sculpture tempted forth in him a habit of casting his awareness of his own activity in dramatic or, more likely, in cinematic terms. One of the lessons of Minimal sculpture is the difficulty of being mindful of oneself without resort to the visual rhetoric of the camera, movies, and television.

The emphasis on measure in Minimalism may also be understood as an intuitively adversary response to television's dissolution of the human realities of distance and observable context. Advertising is the chief function of television, and, as George Trow puts it, "the progress of the advertisement is toward the destruction of distance between the product and the person who might consume the product."[12]

Fried was right to call Minimal art "ideological" in that so much of it was tacitly critical of the condition of American culture. In retrospect, the Minimalist impulse to cleanse the workings of art and of aesthetic experience may look like an instance of the activism pervasive in the 1960s. The sixties were years of general prosperity in America that left many people enough economic slack to reflect on such matters as the hypocrisies of government, the immorality of war, and the conformity demanded in everyday life. Popular skepticism and discontent crystallized around the issues of civil rights, the Vietnam War, and the military draft. In this climate, New York–centered Minimalism, which appeared at first to be almost formalist in spirit, gradually evolved into a mode of oblique political gesture.

To live in urban America in the 1960s—as today—was to be subject to constant exhortations to consume products, services, and diversions in a never-ending, short-sighted pursuit of enjoyment and self-esteem. In the guise of art, Minimalism offered anodynes to the self-doubt and impatience induced by television. Even to people who could see no meaning in them, Minimal sculpture and the paintings of artists such as Brice Marden, Agnes Martin, Richard Tuttle, and Robert Ryman presented opportunities for contemplation. By its very quiesence, Minimalist art draws the viewer's attention to the the pace of his experience and thus to the question who or what is setting that pace.

S I X

Whatever its truth, Descartes' picture of human reality as partitioned into mental and physical dimensions, and of individuals as constitutionally opaque to each other, became the common sense of the modern age. The Cartesian fantasy of one's own mind as the solid ground of personal existence remains seductive because of the forms of life engendered and engineered by mass society. As Hannah Arendt observed, "What makes mass society so difficult to bear is not the number of people involved, or at least not primarily, but the fact that the world between them has lost its power to gather them together, to relate and to separate them."[1] The integrity of the world we share with other people is always in doubt partly because so much of our social intercourse rests on representations of events that do not occur in our own lives. Notwithstanding the credulity it commands, the entire world-picture presented by television, for example, is inestimably remote from the lives of everyone spellbound by it (with the arguable exception of a few who produce it). Ours is a culture committed to private lives predicated on public images. In such a culture, confusions about the limits of one's own mind and about what people have in common by dint of their humanity are inevitable. Expressions of uncertainty on these matters appear in all the arts of the postwar era.

The Minimalists engaged the alienated condition of life in our time through the issue of anthropomorphism, which they inherited from the history of sculpture. This alienation is not just a matter of the loneliness of mass society; it is a fiction of disembodiment in constant tension with our incarnateness. Through television, film, and sound recording we indulge in the most vivid escapist entertainments ever devised. Through technologies of transport and communication, we cheat time and distance, extending our senses almost instantaneously across oceans and continents, spanning them bodily in a day. But all of these experiences exact a sacrifice of our awareness of human life as an embodied social process in which we can know something of the part we play. (The sense of knowing the part one plays in the larger world is reserved to the most powerful people. As for the rest of us, no sane inkling of our part in the world outweighs our consciousness of being consumers.) The abstract character of the work most people do to survive now appears symptomatic of a more pervasive pressure to anesthetize the bodily immediacy of life. To be a good consumer is to yield passively to that pressure. Yet the common experiences of fatigue, sickness, sexuality, violence, and pain still exert their drag even on the most disengaged consciousness.

The disembodied quality of contemporary life gives Cartesian psychology more credibility than it ought to have. The more we accept images as pragmatically equivalent

Jackie Winsor, *Plywood Square*,
1973
Plywood and hemp,
24 × 48 × 48 in.
Australian National Gallery, Canberra

79

to what they portray, the more inclined we will be to regard consciousness as immanent and the details of reality as indifferent. The serial sculptures of Judd, Andre, and Morris, among others, call our attention to exactly how many things there are before us and how particular they are, regardless of their resemblances. No object represents another except by convention. The illusionistic vividness of television and film is dangerous because it blinds us to the conventions they employ. With the eclipse of reality by representations of it comes an exaltation of fantasy above other mental powers.[2]

Fried was not entirely wrongheaded when he accused the Minimalists of making anthropomorphic sculpture. Many of them thought hard about the "human content" of art. They were mindful of the fact that sculpture has a long history of depicting people, largely for symbolic purposes. Certain modern sculptors, preeminently Auguste Rodin (1840–1917), had dissociated their art from its traditional functions of personifying the powers of church, court, and state. Rodin reduced human physiognomy to a pretext for exploring form and technique and for reflecting upon the body as a philosophical figure, a metaphoric vehicle for thought about what it is to be a person. "He was a great artist," Clement Greenberg said of Rodin, "but he destroyed his tradition and left only ambiguities behind."[3]

To the Minimalists, this rift was no liability. Their strategies for externalizing purportedly inward aspects of art experience served to refresh old questions about what it is to be a human individual: Does one look out from within one's body as if from inside a shell to which no one else has access? Is the mind a dimension spatially distinct from the body, as Descartes believed? Is the division between mind and body psychological or ideological, a matter of inherent limits common to every individual or the expression of thwarted reciprocity among people? If our own subjectivity is inevitably most real to us, in what sense, if any, do we have a world in common with other people?

Minimal sculpture raises such issues indirectly, not by plying crude analogies between the viewer's constitution and the art object, as Fried charged. In a work such as Morris's untitled L-shaped plywood pieces of 1965, for example, what matters is

Robert Morris, *Untitled* (fiberglass version), 1965–67
Fiberglass, each 8 × 8 × 2 ft.
Private collection

not that these three objects are hollow, but that they are devices for discovering the primacy of perception over concepts. It is possible—indeed, almost conventional—to focus so adamantly on the likeness of the three forms that the immediate fact of their different orientations cannot make itself felt. (Photographs encourage this reading.) But when you view these objects firsthand, it is obvious that their respective positions, no less than their shapes, define them: their sameness is an idea abstracted from direct inspection of them. Fixation on the fact that the three shapes are congruent is one way to process the physical experience of their distinctness. It happens to be a way that blots out bodily awareness of them as discrete realities.

What kind of beings are we who can take two such different viewpoints on real things without our feet ever leaving the ground? Are our capacities for living affected by the images we hold of how body and mind interact?[4] If so, then anthropomorphism is more than a formal issue. Much Minimal sculpture is intended to open us—by

Walter De Maria, *Bed of Spikes*, 1969
Stainless steel; 5 plates: 2½ × 78½ × 41½ in. each; individual spikes: 10½ × ⅞ × ⅞ in.
Private collection, Basel

means of questions such as these—to whatever experience can tell us about our own nature as participants in reality.

Anthropomorphism remains a live issue critically because sculptural images of the human form feed our fixation on the body's opacity, that is, on our belief that rather than *being* the individual, a person's body contains him, veiling and only inadvertently revealing him. In this view, the expressiveness of someone's behavior is a kind of makeshift sign language by which he translates inherently private thoughts and feelings.

Walter De Maria, with his 1969 *Beds of Spikes,* and Richard Serra, with his precarious lead pieces of the same year, aimed to force a revision of this basically Cartesian view. They used physical danger to intensify the viewer's awareness of his own actions. The dramatic heightening of self-consciousness that their works contrived was meant to force the recognition that mind and body are unified in action, something

we experience in moments of danger and lose sight of when reflection intervenes.

Another approach to the sculptural question of analogy to the human constitution is the view that physical hollowness is just too crude—too literal—an image to express the sense in which we are empty. We *may* be truly empty in the sense that our behavior is ultimately groundless, that our explanations never really "penetrate" but are mere conventions that make it possible to proceed with living. This is one way to understand the famous remark by Ludwig Wittgenstein—a philosopher widely read in the art world—that "Explanations come to an end somewhere."[5] Because explanations are so often exhausted well before we feel that we've understood how someone thinks or what motivates him, we are tempted to envision hidden depths that keep the truth from us.

Walter De Maria may have been thinking along these lines when he made *The Ball Drop* in 1961. This object is a wood box over six feet tall, shaped like a shallow coffin stood upright on its narrow end. Two openings have been cut in the front face of the box, one slightly above eye level, the other about waist high. In the niche of the lower opening sits a polished wood ball about the size of a grapefruit. Instructions to the viewer are carved in the front face of the box. They invite you to take the ball from the lower hole and place it in the one above. As you do so, you expect to hear the ball rumble through a maze of channels hidden within the box until it reappears in the hole below. This expectation is exploded by the loud crack which sounds as the ball drops directly from the upper hole to the lower one. You realize in that instant that you have an irrational habit of ascribing complexity and obscurity to what is out of sight. The coffinlike shape of De Maria's piece hints that it enshrines a dead vision of human reality that continues to haunt us.

Issues of ethical content in sculpture were a preoccupation primarily of New York artists during the 1960s. However, a bemused reflection on anthropomorphism may be seen even in the work of a West Coast artist such as Bruce Nauman (born 1941), who began his career with a series of activities aimed at "unpacking the idea of being an artist," to borrow Peter Schjeldahl's phrase. Nauman made wax casts of portions of his own body, for example, some of which form puns with their titles, such as *From Hand to Mouth*. They are deadpan symbols for the condition of being inside his skin. They are also strangely poignant in the way they accord non-facial parts of his anatomy the deathmask treatment usually reserved for the face alone, as if to divert psychological curiosity to other, less expressive parts of the body. In another well-known piece, Nauman made *Neon Templates of the Left Half of My Body Taken at Ten Inch Intervals* (1966), in which softly glowing blue neon elements evoke a ghostly body profile. The neon templates form a kind of self-portrait whose abstractness mocks the presumed distance and dissonance between a living human body and the person it embodies. The *Neon Templates* are indexes of Nauman's appearance rendered in the medium of commercial signage. As such, they parody both the work of art as the artist's self-advertisement and the notion that a person's physical mien is a kind of sign language hinting remotely at his true nature.

Nauman's chief contributions to the Minimalist project were environmental structures that subjected the viewer to spatial constraints, inducing an altered sense of time and other sensations that intensified feelings of one's own body as confining consciousness in a place it would prefer not to be.

A good example of Nauman's environmental work is *Green Light Corridor* (1970–

Walter De Maria, *Ball Drop*, 1961
Wood, box: 6 ft. 4 in. × 2 ft. × 6½ in.; ball: 4 in. diameter
Collection of the artist

Bruce Nauman, *From Hand to Mouth*, 1967
Wax over cloth, 30 × 10 × 4 in.
Joseph Helman

71), a very narrow passageway made of high walls of homosote panel, lit from above with intense green fluorescents. To pass through the corridor, you had to move sideways, shoulders grazing the panel behind. As you moved, the panel you faced would pass by just inches from your eyes. The far-sighted person might experience the passage of this surface as a green blur, while the near-sighted could track every inch of the corridor's length, making the transit seem far longer than its actual measure suggested. Meanwhile, the fluorescent light immersed the viewer in the sensation of green to the point where the word "green" lost meaning, there being nothing not-green with which to contrast it.

Critics have understood these works by Nauman in terms of the widespread interest in phenomenological philosophy among artists in the 1960s. Phenomenology, particularly the thought of Maurice Merleau-Ponty, was the subject of much discussion in the art world during the Minimalist years. Merleau-Ponty had set out to bridge dichotomies in human nature and self-understanding that Descartes had made to seem insurmountable. Merleau-Ponty's approach was to try to describe experience as we live it, in non-dualistic terms, citing experimental data from scientific studies of perception to show that Cartesian dualism is an abstraction that misrepresents the fundamental continuities of existence. The persuasiveness of Merleau-Ponty's thought rests finally on the reader's impression of its truth to his own experience.

Nauman's work proposed perception, rather than abstract concepts, as the basis for human self-knowledge, implying that such self-knowledge is as susceptible to distortion and deception as perception is. His environmental pieces, especially those involving real-time video circuits, seem to muddy the clarity Merleau-Ponty's thought promises, without quite reinstating old dualisms. They translate physical confinement into a sense of subjectivity as subjection. Rather than undo the Cartesian dualism our culture lives by, Nauman's environments suggested that Merleau-Ponty may have oversimplified the quandaries of sensibility to as great an extent as Descartes did, though in different ways.

For many readers, Merleau-Ponty's writings affirmed that to revise the terms in which experience and personhood are understood implies a critique of society's institutional structures. The meaning of a work of art or a person's actions, if it seems hidden, may actually be secreted in the world, so to speak—dispersed in unexamined linkages among people, actions, events, things, and stories told about them—rather than in veiled attributes of persons or objects.

It was Merleau-Ponty's understanding that "subjectivity is inherence in the world,"[6] a notion intimated in the work of a number of women artists, as well as in

Nauman's, around the turn of the 1970s. Eva Hesse (1936–70) and Jackie Winsor (born 1941), for example, were mindful both of the aesthetic principles of the Minimalists and of concurrent efforts by women to define culturally repressed facets of their lives. Questions about subjectivity and how the world is shared inevitably led women artists to issues of power and sexual perspective. What is this "body" discussed so often in art criticism and philosophy? women artists began to ask. Does its philosophical neuterness express anything but men's habits of discrediting the differences between women's experiences and their own? Women artists who adapted Minimalist aesthetics necessarily raised such questions indirectly in their work. In very different ways, Hesse and Winsor did it by rendering Minimalist materials and procedures newly Surrealistic or ironically extreme. They made sculptures in which systematic procedures or sequences of form are qualified—in some cases thwarted— by eccentricities inherent in the workability of their chosen materials. When Hesse made roughly modular cylindrical forms in fiberglass, they took on the quality of organic husks, fragmentary images nightmarishly reifying the idea of the body as a shell. From a woman's perspective, the idea of the body as a vessel had resonances of which men took no account. The Cartesian fantasy of soul and body being related like Chinese boxes was almost a parody of the person-within-a-person truth of maternity. And the idea of the body misrepresenting the true self has a different sort of vividness in social terms for women than for men because of the pressures on women in virtue of their status as a subject population. The philosophical terms "subject" and "object" rang differently in women's ears than in men's, though few acknowledged it.

Such recognitions registered strangely in Hesse's work. Many of her works in fiberglass and latex have a more organic presence than most late Minimalist sculpture does. Her techniques and attitudes toward the art object seemed to ally her with Minimalism. Yet everything she did had kinds of demotic associations uncommon in New York sculpture of the late 1960s. When she hung sheets of latex from the ceiling of a room, for example, they bizarrely suggested both flayed skin and laundry hung out to dry.

Bruce Nauman, *Green Light Corridor*, 1970
Wallboard, green fluorescent lights, 10 × 40 ft.
Panza Collection, Milan

Bruce Nauman, *Neon Templates of the Left Half of My Body Taken at Ten Inch Intervals*, 1966
Neon tubing, 70 × 9 × 6 in.
Private collection

Eva Hesse, *Repetition 19, III*, 1968
Nineteen tubular fiberglass units,
19 to 20¼ in. high × 11 to 12¾ in.
diameter
Collection, The Museum of Modern
Art, New York; Gift of Charles and
Anita Blatt

Eva Hesse, *Contingent*, 1969
Cheesecloth, latex, fiberglass; 8
panels, 11 ft. 5¾ in. × 20 ft. 8 in.
× 3 ft. 6⅞ in. each;
overall dimensions variable
Australian National Gallery, Canberra

Jackie Winsor, *Bound Grid*, 1971–72
Wood and twine, 84 × 84 × 8 in.
Fonds National d'Art Contemporain,
Paris

It is neither so tempting nor so easy to see feminist implications in Winsor's work, although she introduced metaphors of growth into what appeared to be Minimalist procedures and formats. For example, she based a large untitled piece on the ubiquitous Minimalist grid, but for its crosspieces she used saplings with all their natural irregularities. She bound their junctures together with so many rounds of twine that the resulting nodes resemble traces of human labor less than the tireless, instinctive work of some wild creature or species. Similarly, in another untitled piece, she repeated the operation of wrapping a plywood square with twine so many times that the resulting object looks like an autochthonous growth cut off from human intentions. Hesse and Winsor seem not even to have taken as an issue the dualisms that haunted so many male artists of the Minimalist generation.

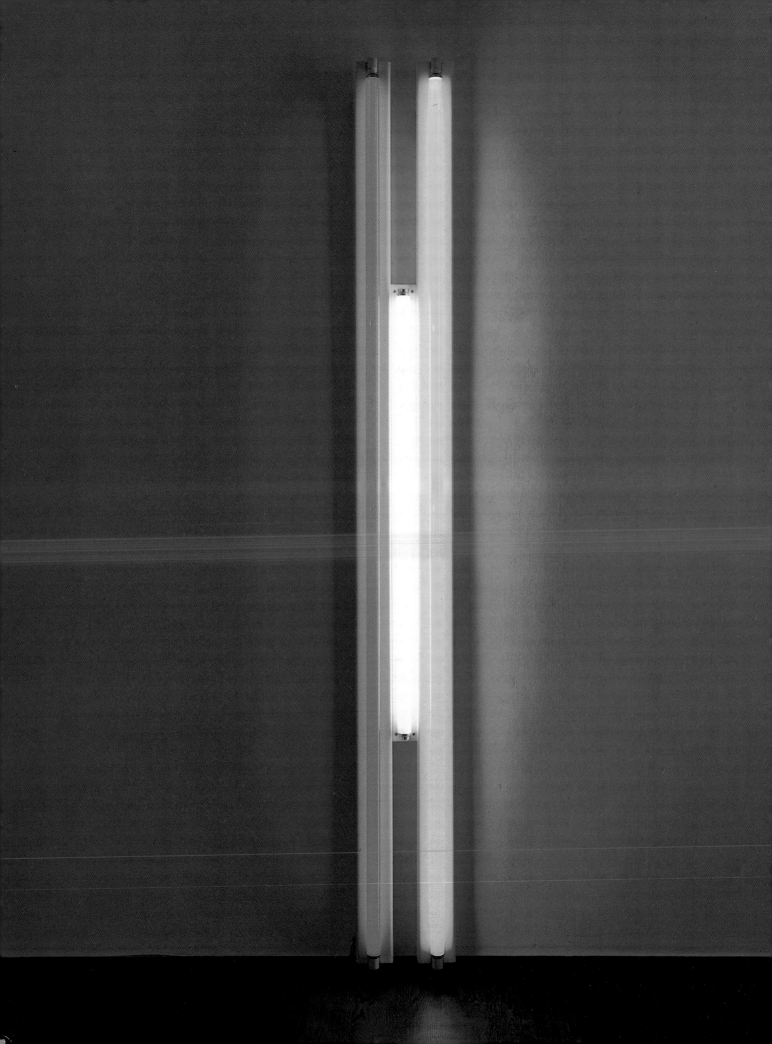

SEVEN

The evolution of Minimalist sculpture in the late 1960s may be understood in terms of two key issues, both of which took on a political cast as the decade waned. One is the revision of Cartesian psychology, the other is the ambiguous status of the art object's meaning in the art market.

Artists' resistance to the business ethic has an obvious, if vague, political import in a culture where money tends to blot out all other values. The political sense of subverting Cartesian psychology was more obscure. However, artists such as Carl Andre, Robert Smithson, and Richard Serra saw that there was ideological weight to the view that one's mind is ontologically prior to one's body, is inscrutable to others, and dwells in time differently than the body does. This Cartesian view is the very opposite of the historical materialist notion that (if one looks at life understandingly) minds may be seen to be as much the products as the producers of the events and social structures in which they are caught up. At different times, Andre, Smithson, and Serra respectively have espoused a historical materialist view of human subjectivity. Meanwhile, Minimal sculpture's once-overt dubiousness, and thus its usefulness for provoking skepticism, became sedimented with sociological quandaries, such as what value remains to thinking politically about a work of art once it has been given a firm place in the institutional structures of the art world.

After 1966, artists began increasingly to confront the fact that the meaning of their works was conditioned as much by the art world's institutional structures—especially those of the market—as by factors they could control. Rapprochement with the market was necessary for anyone who hoped either to find an audience or to live by his art. However, Minimalist works suffered more obviously than, say, color-field paintings from the contradictions of being put forward as commodities, as things made for sale. The reason is that the viewer's uncertainty about his own role as constitutor of the work of art, or of its meaning, is a source of energy and coherence in so much Minimalist art. Faced with something that is merely a commodity, you know too well that your role is that of prospective consumer: all other transactions with the object are subordinate to the possibility of purchase. The contemplative character of Minimalist art—of any art—negates its status as commodity, for contemplation entails willingness to let things stand rather than to try to take possession of them, literally or symbolically. The contradiction between a work of art's character as commodity and as object of contemplation is perhaps most blatant in the case of Minimalist works whose visual simplicity leaves the presentational and promotional circumstances undisguised.

The closing years of the Minimalist period saw artists trying various strategies

Dan Flavin, *Puerto Rican Light (To Jeanie Blake)*, 1965
Red, pink, and yellow fluorescent light, 8 ft. high
Private collection

to keep the conventions of the gallery system from cancelling the non-monetary values of their works. One strategy, pursued by Robert Smithson, Dennis Oppenheim, and Michael Heizer, among others, consisted in siting sculpture in remote landscapes so that no gallery could contain it. Another was to define works of art in terms of ideas alone, siting them, so to speak, in the viewer's consciousness or in the artist's own behavior, as Joseph Kosuth, Douglas Heubler, and Lawrence Weiner did when they used gallery spaces to display words or texts. Still other tactics involved intervening in the normal course of gallery business, as Carl Andre did when he stipulated that his works in a show at New York's Dwan Gallery be priced at one percent of the prospective buyer's yearly income.

Robert Morris took a step in the evolution of these subversive strategies when he decided that his sculpture should be provisional rather than fixed in form. Possibly taking a clue from Joseph Beuys, whose work was not well known in America at the time, Morris began using "anti-form" materials such as felt, thread, and earth that had to be redeployed each time the work they comprised was presented. Such substances took the impress of the artist's behavior and acknowledged the pull of gravity better than rigid materials such as steel or wood. Earth had to be shoveled or swept into place, felt had to be cut, folded, hung, or heaped up. These materials allowed the artist's activity to show itself non-expressionistically as an ingredient in the work. Yet they did not celebrate the artist's touch in the way a modeling medium such as clay or plaster might have done. Morris's scatter piece (1968) is an example

Robert Morris, *Untitled*, 1968–69
Felt, copper, rubber, zinc, nickel, stainless, Cor-Ten, aluminum; indeterminate dimensions
Leo Castelli Gallery, New York

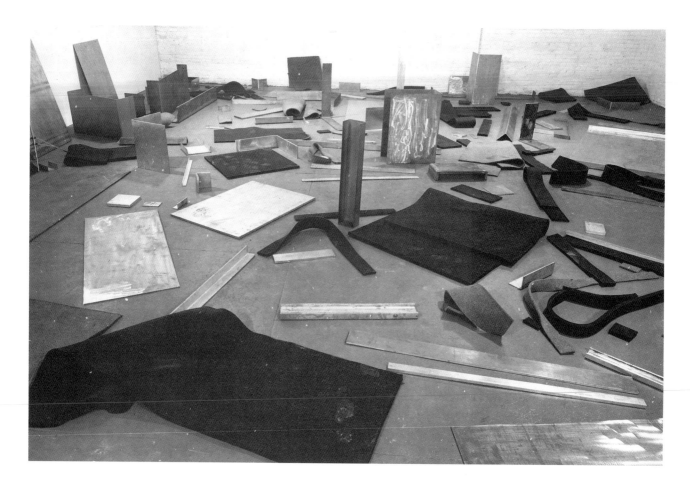

Barry Le Va, *Untitled (within the series of "Layered-PATTERN-Acts")*, 1968–72
Glass on floor, 25 × 85 ft.
Private collection

of a work combining "anti-form" and rigid materials in an array whose looseness keeps the viewer guessing just where the artist's decisions lie, which relationships, if any, are to be seen as definitive of the piece and which as provisional.

The move away from fixed form had several implications in addition to its muddling the clear-cut antithesis of object and subject. It put the viewer's activity almost on a par with the artist's own in construing materials as works of art. The "work" to be done by artist and viewer alike in Morris's scatter piece consists in establishing relations among elements by acts of observation. Scatter pieces such as Morris's and those of Barry Le Va also challenged the formalist notion that the essence of a work of art lay in its precise structure. The idea that a thing must have an essence—a central quality to which its overt details are peripheral, a quality counterpart to the perceiver's "innermost," cognizant self—is one more expression of the dichotomous view of experience that much of the most convincing Minimalist art contradicts. Le Va has done some elaborate floor works that look like scatter pieces in which the elements are disposed in a preconceived pattern. However, the patterns are so complex and layered that they cannot be seen, or can be glimpsed only uncertainly as a structure lying "behind" the array. Far from hinting at a single determinative structural "map," the material counters in Le Va's floor arrays suggest themselves as the intersections of countless possible mutually impinging figures.

Morris's "anti-form" pieces led him to works such as *Steam Cloud*, whose forms—clouds of steam—change uncontrollably and vanish, and *Pace and Progress*, a performance in which he used a horse's behavior as an extension of his own to produce a sort of earthwork. To execute *Pace and Progress*, he rode a horse back and forth repeatedly across a strip of grassy field until he had worn a path of "bald" ground. The horse served as a kind of animate, large-scale marking tool and as a means for Morris to propose behavior—his own shaping that of the horse—as the operative medium.

Morris's works of the late 1960s emerged against a rapidly changing background of other artists' efforts to "dematerialize" the art object, a process that stripped the category "sculpture" of what scant definition remained to it. Sol LeWitt coined the term "conceptual art" to denote his own and other artists' treatment of ideas—in contrast to substances—as the meat of art. Joseph Kosuth, Mel Bochner, and John Baldessari were among the proponents of this approach. An interest in serial forms and in systems for generating them was one of the links between Minimalist and conceptual art.

LeWitt made systematic sculptural objects whose structures were wholly determined by a few decisions about design and dimensions. He regarded the idea for a work as a "machine" for generating its form that freed the artist from having to make arbitrary, speciously "creative" decisions. No matter how programmatic art becomes, "there are many side effects that the artist cannot imagine. These may be used as ideas for new works. . . . The concept of a work of art may involve the matter of the piece or the process in which it is made," LeWitt commented in 1968. "Once the idea of the piece is established in the artist's mind and the final form is decided, the process is carried out blindly," and not necessarily by the artist himself.[1]

Robert Morris, *Steam Cloud*, 1969
Environmental structure; steam
occupies space available
Collection of the artist

Statements such as these suggest that LeWitt did not really share in the tacit Minimalist project of dismantling Cartesian "commonsense" attitudes toward the mind, meaning, and other issues of transcendence. His sculptures in the form of latticed grids are anything but anthropomorphic, however they appear to affirm the Cartesian/Newtonian idea of space as perfectly homogeneous and ontologically independent of what occupies it.

Rosalind Krauss has argued that it is possible to see anti-Cartesian implications in LeWitt's *All Variations of Incomplete Open Cubes*. This work entailed fabricating all the variants on a fragmentary open cube. Several commentators have interpreted it—and LeWitt's whole oeuvre of lattice pieces—as figures for the mind's power of

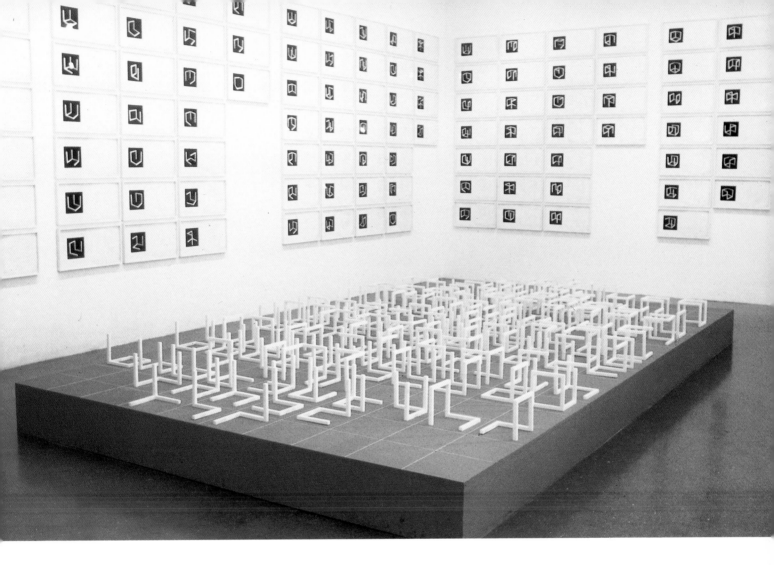

Sol LeWitt, *All Variations of Incomplete Open Cubes*, 1974
122 wood sculptures painted white, each 8 in. on a side; 131 framed photos with drawings, 26 × 14 in. each; Base: 1 × 10 × 18 ft. Saatchi Collection, London

reasoning, of ticking off logical possibilities. This view is itself a bit of veiled Cartesian thinking. Not only did Descartes believe reason to be the central faculty of the mind, but the very idea that the mind is an entity or a place with a center is a Cartesian notion. The view of the mind as having a central attribute to which all its other capacities are tributary squares with the notion of mind or self as centered, and hidden, within the body. Krauss maintains that if LeWitt's aimless variations on grid geometry are symbolic of mentality, what they evoke is a kind of neurotic logical faculty that runs compulsively over all the structural possibilities of the grid in panic at recognizing its own relation to reality as indeterminate.[2] The notion of mind as centerless energy awaiting engagement and orientation is very different from the Cartesian view of consciousness as pure self-awareness pivoting on its own rationality.

Although non-referential, LeWitt's lattice pieces are not without resonance. In addition to three-dimensionalizing the perspective structure of post-Renaissance picture space, they rhyme formally with the grids implicit in much early Minimal sculpture, in modern architecture, city plans, and bureaucratic policy, and in the molecular makeup of crystals. In certain contexts, LeWitt's lattices look like the exposed skeleton of civic space: outcroppings of mass society's rigidity and regimentation. Their implication of indefinite extendability touches our fears of technology and of state power intruding into every cranny of collective and private life.[3]

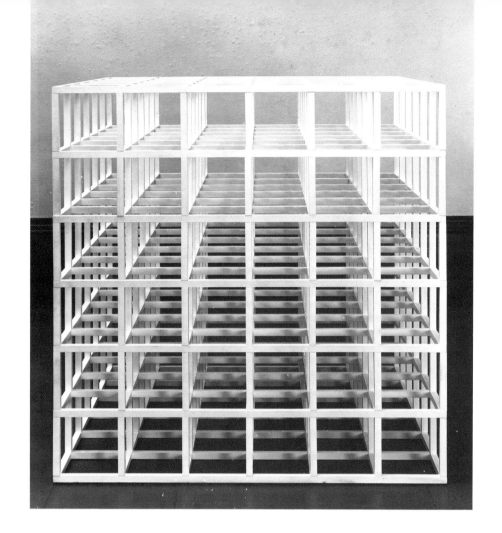

Sol LeWitt, *Open Modular Cube*,
1966
Painted aluminum, 60 × 60 ×
60 in.
Art Gallery of Ontario, Toronto;
Purchase, 1969

 LeWitt's major contribution to the Minimalist project has been his wall drawings,
not his sculpture. The wall drawings are not art objects: they are more like systematic
graffiti, graphic residues that refresh our attention to their settings. Many people who
saw LeWitt's early wall drawings, as I did, at the Paula Cooper and Dwan Galleries
in New York in 1968 and 1969 were convinced immediately that these were works of
great moment. Without making objects, LeWitt managed to produce exhibitions of real
artistic fullness and substance. By using the gallery walls as marking surfaces, he
called attention to and took control of the gallery as an art-making institution. The
early drawings—ruled, measured striations of graphite on the white gallery walls—
were pure traceries of the operations that produced them. The pencil lines were as
regular as LeWitt and his draftsmen could make them, yet viewed up close they
betrayed every nubble of the surface area they covered. The impersonal shimmer of
their visual effect seemed to be the radiance of their economy and elegance as art
ideas. To LeWitt, the wall drawings made sense because they were systematic yet
unpredictable in ways that had nothing to do with whims of his hand or his taste.
 Artists such as Bochner, Kosuth, Lawrence Weiner, and Robert Barry abandoned
the art object to work with ideas because the object as a convention interfered with
the questioning of boundaries that they saw as the most viable aspect of Minimalism.
They understood the physical art object as a symbol of our need to comprehend the
world in terms of categories and definitions we believe to be unchanging. ''The
problem,'' Bochner said, ''is that surrendering the stability of objects immediately

subverts any control we think we have over situations."[4] The trouble with art *objects* is that they keep us from recognizing unconscious decisions that underlie our belief in things as the exemplars of reality. "A fundamental assumption in much recent past art," Bochner wrote in 1970, "was that things have stable properties, i.e., boundaries. . . . Boundaries, however, are only the fabrication of our desire to detect them . . . a tradeoff between seeing something and wanting to enclose it. Concentration produces the illusion of consistency."[5] On that illusory consistency is founded the uncritical view of life and of art that the conceptual artists—like the Minimalists—wanted to challenge.

Bochner proposed replacing the word "conceptual" with "procedural" to avoid the idealist implication that the point of non-object art is to endow mental operations with a specious metaphysical priority. "A procedural work of art is initiated without a set product in mind," he noted. "In a piece of this kind, the interest is only in knowing that the procedures, step by step, have been carefully and thoroughly carried through. The specific nature of any result is contingent upon the time and place of implementation and is interesting as such. It is the 'proceeding' that establishes it."[6] Bochner took this approach in many of his own exhibitions, such as those in which he measured all the major dimensions of a gallery interior and marked them on walls and floor accordingly.

LeWitt's wall drawings, too, exemplify what Bochner meant by "procedural" art. They are generated according to instructions LeWitt devises but rarely executes himself. The visual outcome of his instructions depends upon the setting in which they are carried out and cannot be envisioned in detail prior to their execution. As rule-bound as the wall drawings are, they always yield visual surprises. LeWitt frequently builds in an element of indeterminacy by providing instructions that leave decisions to the draftsman. An example is *Wall Drawing No. 90* (1971), whose instructions read: "Within 6 in. (15.2 cm) squares, draw straight lines from edge to edge using yellow, red and blue pencils. Each square should contain at least one line." The number and placement of lines within each square are decided by the draftsman and the overall dimensions of the piece are dictated by the wall.

The shift in emphasis from product to process, or operations, continued the Minimalist critique of idealist thinking about art and perception. In the idealist view, concepts are more real—at least in the sense of being less destructible—than things, including the thinker's own body. Concepts are metaphysically prior to things and render them intelligible. Similarly, the meaning of a work of art may be thought to transcend it because meaning can "enter" our minds and stay there long after we have left the object behind. To make the meaning of an artwork coterminous with its physical presence—limiting its content to the physical evidence of its production— is to assert that the apprehension of meaning in art entails no crossing of metaphysical boundaries. To show that the meaning of a work of art is a facet of its presence is to argue that understanding the work depends upon one's overt relationship to it without reference to invisibilia. In his wall drawings, and in some of his works on paper, LeWitt supplants the transcendence of meaning with the indeterminacy of relations between instructions and resultant details, relations that are mysterious only in being unpredictable. There is no meaning to the drawings that cannot be explained in terms of objective factors such as the wording of the specifications, the circumstances of the site, the draftsman's decisions, and an account of the cultural context. To have

the work's meaning "enter one's mind" is simply to acquire the knack of explaining the work to someone. (As Merleau-Ponty says, "Consciousness is in the first place not a matter of 'I think that' but of 'I can.' ")[7] The meaning remains indeterminate only to those who cannot imagine how to explain it. The meaning transcends the work only in that it is dispersed in the reference points of historical context (including the work itself) and embodied in the persons of those who can detail it. Much of the best Minimalist art points to the same conclusion: that the seeming invisibility of ideas is a projection of our fear of being unable to specify them.

The matter-of-fact strategies of artists such as LeWitt, Morris, and Bochner made exhibition spaces conspicuous as framing elements in something like the way Frank Stella's early work led people to give unaccustomed attention to the exterior shapes of paintings. When works of art take the form of site-specific installations or of documents describing things or operations a gallery cannot accommodate, gallery space itself becomes an active ingredient in the interpretability of art. "As modernism gets older," Brian O'Doherty observed, "context becomes content. In a peculiar reversal, the object introduced into the gallery 'frames' the gallery and its laws."[8]

Mel Bochner, *Theory of Painting*, 1969
Spray paint on newspaper; variable dimensions
Sonnabend Gallery, New York

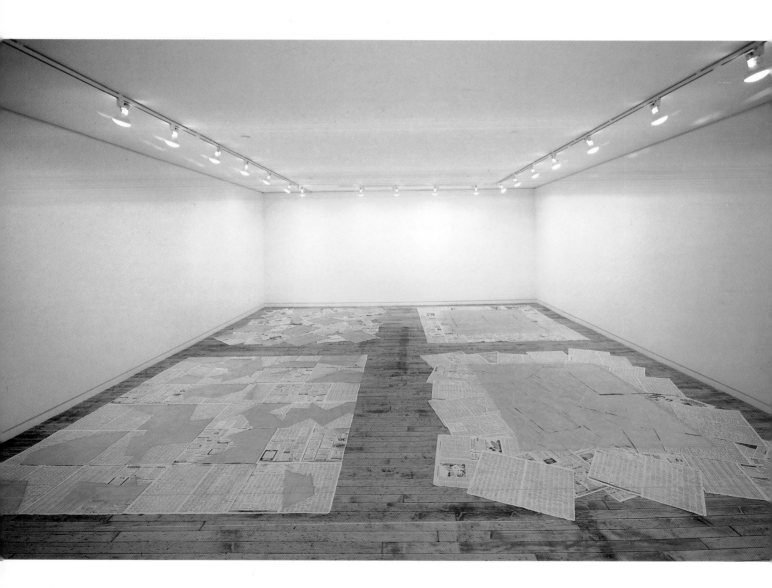

Sol LeWitt, *All Combinations of Arcs from Corners and Sides; Straight, Not-Straight, and Broken Lines,* 1975
White chalk on black wall; wall drawings (one room), 16 × 39 × 14 ft.
Collection, The Museum of Modern Art, New York; Fractional gift of an anonymous donor

One of the first artists to take this approach methodically in the 1960s was Dan Flavin (born 1933). Self-taught as an artist, Flavin began working with fluorescent light in 1963, following training in meteorology in the Air Force and art history studies at Columbia. His art consists in composing standard fluorescent fixtures into glowing structures that form light and color environments. All of his exhibitions except those consisting only of drawings have involved his taking control of gallery lighting.

By the substitution of fluorescent for incandescent light, Flavin made an art medium of what is conventionally an unobtrusive factor in gallery stagecraft. The act of taking standard hardware items—fluorescent light fixtures—and placing them in improbable configurations seems like a direct quotation of Duchamp's "readymade" gambit.

Fluorescents, which cost less to burn than incandescents relative to the light they shed, imply the parsimonious indifference to aesthetics and comfort we associate with institutions of mass employment or consumption—factories, office buildings, and supermarkets. As with some Pop Art, there was a whiff of class antagonism in the anti-high-art air of Flavin's early work. However, this aspect of Flavin's materials was the one that interested him least, or so the development of his work suggests.

When you look at Flavin's art, you find that your attention shuttles between the hardware armatures, the fluorescent elements themselves as radiant objects, and the play of their light and color on the surroundings and on your own body. Flavin's work sheds the light by which we see its setting, epitomizing the Minimalist effort to root the meaning of works of art in the perceptual conditions they set up.

In the context of early Minimalism, Flavin's fluorescents had a significance that his interest in color has gradually eclipsed. A key fact about his work is that when you are in its presence, you see yourself by its light. This might be a trivial point except that in the mid 1960s so many artists in New York were thinking about the

disembodiment implicit in abstract painting's appeal to the eye. An art that addresses vision alone—the way color-field painting such as Jules Olitski's does—implies that art and whatever it distills of life have become affairs of the eye, or of the mind's eye, rather than of fully endowed persons. If art persuades us that ultimately we are our eyes, then, as Brian O'Doherty puts it, "modernism's transposition of perception from life to formal values is complete." In O'Doherty's view, it is the disembodied gaze solicited by formalist painting and by exhibition spaces tailored to it that provoked artists to a critique of gallery space itself. "Unshadowed, white, clean, artificial—the space is devoted to the technology of esthetics. Works of art are mounted, hung, scattered for study. Their ungrubby surfaces are untouched by time and its vicissitudes. Art exists in a kind of eternity of display, and though there is lots of 'period' (late modern), there is no time. . . . The space offers the thought that while eyes and minds are welcome, space-occupying bodies are not—or are tolerated only as kinesthetic mannikins for further study. This Cartesian paradox is reinforced by one of the icons of our visual culture: the installation shot, sans figures. Here at last the spectator, oneself, is eliminated. You are there without being there."[9]

From the very outset of his work, Flavin has subverted the timelessness and

Sol LeWitt, *Wall Drawing No. 90* (detail), 1971
Graphite and colored pencils; variable dimensions
Saatchi Collection, London

Dan Flavin, *Untitled (to a man, George McGovern) 2*, 1972
Warm-white fluorescent light, 10 × 10 ft.
Private collection

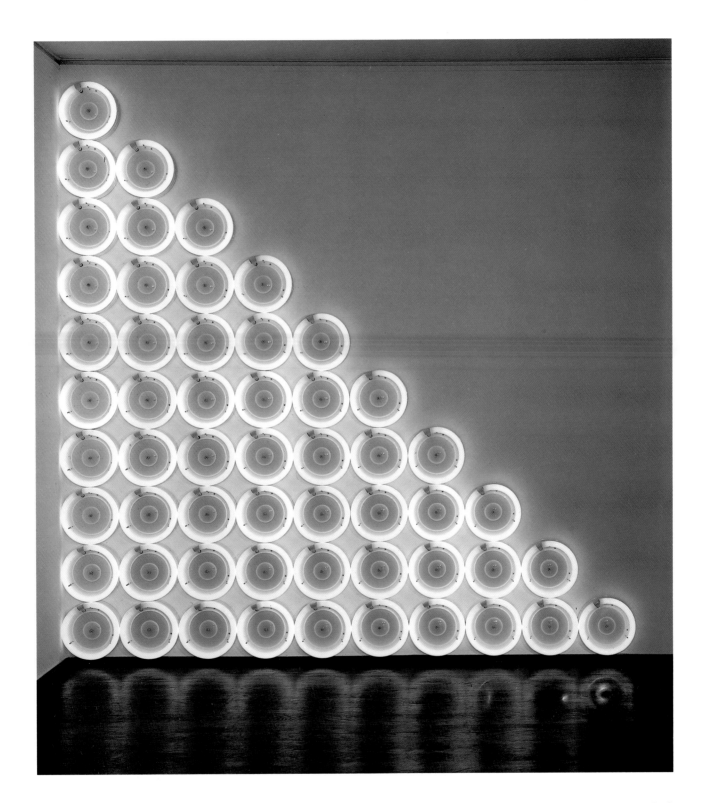

99

neutrality of gallery space. Some of his installations punctuate aspects of the given architecture: they may turn a wall into a radiant barrier or a room's corners into softly colored niches. But even those that do not emphasize architectural specifics, such as the *"monument" for V. Tatlin,* structure one's experience of a room in terms of gradient intensities. The metric of space itself seems to become elastic in those Flavin environments in which there are large intervals of relative darkness. In some of his pieces, such as the barriers that bunch many lighting elements close together, the color seems dangerously vivid, making you wary of drawing close to it.

Because industry produces only so many sizes and colors of fluorescent elements, Flavin's use of them, like LeWitt's cubic lattices, implies a very finite number of structural possibilities. And just as some of LeWitt's wall drawings generate figures and patterns that might be historical allusions but are not intended as such, Flavin's recombinations of standard fixtures can yield surprising associations. Some of his *"monument" for V. Tatlin,* for example, apparently do refer deliberately to Tatlin's thwarted plan for a *"monument" to the Third International*, while others bring to mind Art Deco ornament or the paintings of Barnett Newman.

Flavin's installations always color their settings optically and emotionally, but more important in the Minimalist years was the fact that, as Robert Smithson put it, "Flavin turns gallery space into gallery time."[10] In a show at the old Kornblee Gallery in New York, for example, Flavin punctuated a small room with intense green fluorescents, making the daylight from the single small window turn pink. In this case, he turned the shadowy daylight visible through the window into an arrested rosy twilight.

Whether or not daylight enters into a Flavin installation, you are always aware of the fluorescents as running. For this reason, his work seems always to be doubly on the verge of disappearance. The mere withdrawal of one's consent to seeing his work as art is enough to pull the plug on it. But even if your conviction as to its arthood is firm, the work's reversion to hardware is guaranteed by the flick of a switch at closing time: an unilluminated Flavin is just a misplaced light fixture.

Dan Flavin, *"monument" for V. Tatlin*, 1968
Cool-white fluorescent light,
27 in. × 14 ft.
Private collection

Dan Flavin, *"monument" for V. Tatlin*, 1969
Cool-white fluorescent light,
96 in. high
Walker Art Center, Minneapolis; Gift of Leo Castelli Gallery, 1981

Dan Flavin, *Untitled (to Jan and Ron Greenberg)*, 1972–73
Yellow and green fluorescent light,
8 × 8 ft.
Panza Collection, Milan

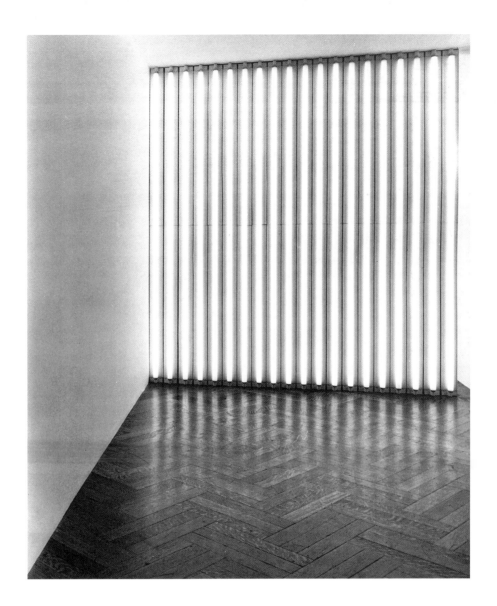

Dan Flavin, *Untitled* (detail), 1969
Daylight and cool-white fluorescent
light (alternating), dimensions
dependent on space available
Private collection

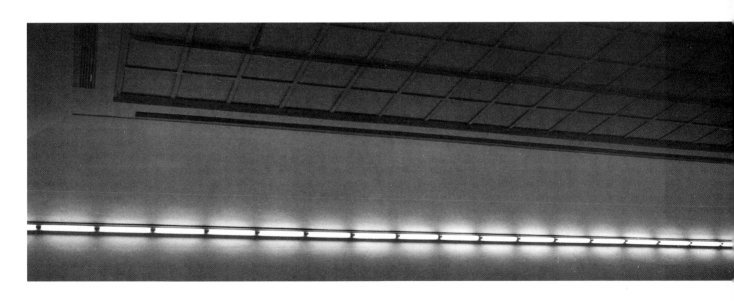

E I G H T

It is not surprising that Robert Smithson was the first to point out the "real time" aspect of Flavin's work. Smithson (1938–73) was particularly sensitive to the placeless, timeless qualities of gallery space. Although he studied intermittently at the Art Students League, Smithson was largely self-taught. He used to say that he got his education at the Cedar Bar, famous as a hangout for New York artists in the late 1950s. Mindfulness of his social role as an artist was always a factor in Smithson's work, as it was in somewhat different ways in the works of Bruce Nauman and Andy Warhol. Smithson came to feel that his work ought to have a critical orientation toward the art world.

Having made his gallery debut in New York as a sculptor with objects fabricated of painted metal, akin to the mid 1960s works of Tony Smith and Robert Morris, Smithson quickly became dissatisfied with this mode of work. As he explained in an interview, "I began to question very seriously the whole notion of Gestalt, the thing in itself, specific objects. I began to see things in a more relational way. In other words, I had to question where the works were, what they were about. The very construction of the gallery with its neutral white rooms became questionable. So I became interested in bringing attention to the abstractness of the gallery as a room. . . . it became a preoccupation with place."[1]

Some of the objects Smithson exhibited in the late 1960s resembled Judd's geometric boxes except that they were filled with gravel and stones and were usually accompanied by aerial photographs or maps. Smithson referred to his boxes as "non-sites." The materials they contained were vestiges of the sites documented in the maps and photographs. The non-sites set up a play of containers—boxes of stones, map coordinates boxing parcels of land, photographs "entombing" views of terrain, the gallery boxing them all architecturally—that called attention to the gallery's, and the culture's, denial of its place in nature. To the extent that he conceived himself as the fleshly container of a mind, the viewer's attention to the non-sites extended further their concatenation of enclosures. With the non-sites, Smithson abashed Cartesian thinking by making symbols of the mind's grasp of nature clash with evocations of the mind's envelopment in nature. The view of mind as innately personal and interior to the body was, Smithson believed, mere egoistic denial of the truly baffling fact of the mind's inherence in a physical universe.

The dialectical complement to the non-site was the site, a real spot on the earth—the less picturesque the better—designated by Smithson as a foothold in the reality underlying maps and human history. Because it lacks bearings apart from our symbol systems, the site always threatens to expose how ephemeral those systems

Robert Smithson, *Spiral Jetty*, 1970
Black basalt, limestone rocks, and
earth; length: 1500 ft.
Great Salt Lake, Utah
Estate of the artist

103

are, hence Smithson's resort to devising earthworks for remote locations.

The non-sites were intended to contrast the enormously disparate measures of time implied by the maps, the fabricated boxes, and the geological rubble they contained. Smithson evoked geologic time because he wanted to range art history against a time scale long enough to force us to rethink human self-importance and its unwitting expressions in art. He claimed to be "very aware of time on a geological scale, of the very great extent of time which has gone into the sculpting of matter." He contrasted his attitude toward time with that of sculptors who think only in terms of their artistic ancestry. "Take an Anthony Caro: that expresses a certain nostalgia for the Garden of Eden view of the world, whereas I think in terms of millions of years, including times when humans weren't around. Anthony Caro never thought about the ground his work stands on. In fact, I see his work as anthropocentric cubism. He has yet to discover the dreadful object. And then to leave it. He has a long way to go."[2]

People hostile to early Minimalism accused the artists who had objects fabricated industrially of starving the viewer's subjectivity. However, Smithson intended something much more drastic. The dialectic of site and non-site was his program for developing an art centered on physical reality, not on humanity, an art that would cancel rather than cajole the subjectivity of those who saw it. Instead of countering subjective response with objectivity, he wanted to confound it with entropy, that is, with the tendency of everything in the physical universe to deliquesce toward states of greater disorder.

"I am for an art that takes into account the direct effect of the elements as they exist from day to day apart from representation," Smithson declared in 1972.[3] He saw modern culture's mania for representations of life as narcissistic pathology, an effort to make every facet of reality reflect back to us falsely reassuring traces of human control. He believed that denial of death lay behind this pathology, and that his responsibility as an artist was to interrupt the culture's self-preoccupation with reminders of transience, disintegration, entropy. "Our culture has lost its sense of death," he wrote in 1968, at the height of the Vietnam War, "so it can kill both mentally and physically, thinking all the time that it is establishing the most creative order possible."[4]

Smithson planned many more works than he was able to carry out. Even in the freewheeling, affluent 1960s, it was not easy to raise money to build earthworks in remote places that few people might ever visit. The few he executed resulted from private or public commissions. One of his projects, which called for dropping broken glass on an island near Vancouver, was foiled by environmentalists. He might strike a tone of moral outrage in his writing, but he was unafraid of contradictions, such as making an ecologically unsound proposal when it suited his purposes as an artist. He could come out against media and yet make documentation an important facet of his work. He devoted many months of effort to getting the *Spiral Jetty* built in a remote part of Utah and then seemed to compromise its integrity by making a film that records and inteprets it in such detail as to leave those who see the film wondering whether or not they need to bother to go to Utah.

In 1973, Smithson died in the crash of a light plane from which he was inspecting his last earthwork, *Amarillo Ramp*, in an unfinished state. (After his death, *Amarillo Ramp* was completed by his widow, Nancy Holt, and his friend, Richard

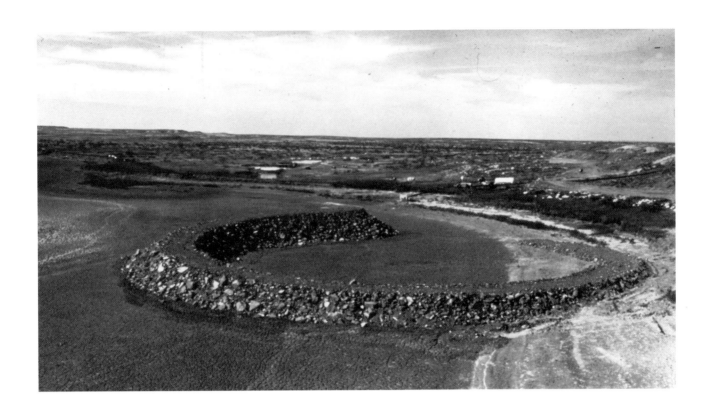

Robert Smithson, *Amarillo Ramp*,
1973
Diameter: 150 ft.
Amarillo, Texas
Estate of the artist

Serra.) Because he lived to realize so few large projects, and because so few people have seen firsthand those he did complete, Smithson's influence has been transmitted largely by the essays and interviews he published in catalogs and art magazines. A voracious reader interested in everything from philosophy and cultural criticism to geology, astronomy, and the fiction of Samuel Beckett and Jorge Luis Borges, he broadened wildly, if only briefly, the bibliographical scope of art talk on the New York scene. Many of his writings appeared in *Artforum*, which became a kind of house organ of late Minimalism, with Philip Leider as editor. Some of Smithson's pieces were polemical, though flavored with anarchic humor; others documented projects he carried out in remote places.

"Incidents of Mirror Travel in the Yucatan," which appeared in *Artforum* in September, 1968, is a characteristic example of Smithson's writing. Documenting a series of *Mirror Displacements* in Central America, the article leaves the reader wondering whether the work was carried out to fulfill an artistic program, to provide the literary pretext for voicing pet attitudes, or as an excuse to travel. To do the *Mirror Displacements*, Smithson went to the Yucatan peninsula, arrayed a set of mirrors at various "sites" in the jungle landscape, then photographed and removed them. In the photographs, the slightly off-square mirrors, their edges loosely aligned, bring to mind Carl Andre's metal floor plates. Both photographs and text seem to pay backhanded homage to Andre, wryly rebuking his citified address to the ground. "A sense of arrested breakdown prevails over the level mirror surfaces and the unlevel ground," Smithson wrote of the *Mirror Displacements*. "The distribution of the squares followed the irregular contours on the ground. . . . Bits of earth spilled onto the surfaces, thus sabotaging the perfect reflections of the sky. Dirt hung in the sultry sky. Bits of blazing cloud mixed with the ashy mass. . . . The mirror displacement

Robert Smithson, *Second Mirror
Displacement*, 1969
Mirrors in landscape
Yucatan, Mexico
Estate of the artist

cannot be expressed in rational dimensions. The distances between the twelve mirrors
are shadowed disconnections, where measure is dropped and incomputable. . . .
Reflections fall onto the mirrors without logic. . . . Sight consisted of knotted reflections
bouncing on and off the mirrors and the eyes. Every clear view slipped into its own
abstract slump. All viewpoints choked and died on the tepidity of the tropical air. . . .
Trying to look at the mirrors took the shape of a game of pool under water. All the
clear ideas of what had been done melted into perceptual puddles, causing the brain
to gurgle thoughts. Walking conditioned sight, and sight conditioned walking, till it
seemed only the feet could see. . . . Oh, for the happy days of pure walls and pure
floors. Flatness was nowhere to be found. Walls of collapsed mud and floors of
bleached detritus replaced the flatness of rooms."[5]

The wayward diction and rhetorical drive of Smithson's writing seemed to enable
him to say things that many people in the art world felt but could not formulate. No
one spoke more intemperately of society's fear of art. "Museums, like asylums and
jails, have wards and cells—in other words, neutral rooms called 'galleries,'" he
wrote. "A work of art when placed in a gallery loses its charge and becomes a
portable object or surface disengaged from the outside world. . . . Works of art seen
in such spaces seem to be going through a kind of aesthetic convalescence. They
are looked upon as so many inanimate invalids, waiting for critics to pronounce them
curable or incurable. The function of the warden-curator is to separate art from the
rest of society. Next comes integration. Once the work of art is totally neutralized,
ineffective, abstracted, safe and politically lobotomized it is ready to be consumed by
society. All is reduced to visual fodder and transportable merchandise. Innovations
are allowed only if they support this kind of confinement."[6]

Concurrently with "land artists" such as Walter De Maria and Michael Heizer,

Smithson started developing projects that broke the institutional confines of the art world. In 1968, De Maria did the first version of the *New York Earth Room*, in which he filled an entire gallery with loam to a depth of almost two feet. (Today the *New York Earth Room* exists as a permanent installation in Manhattan.) Between 1969 and 1971, Michael Heizer orchestrated the removal of some 240,000 tons of rock and soil from the walls of a mesa canyon in the Nevada desert. The resulting work, called *Double Negative*, is a pair of 50-foot deep, 30-foot wide notches in the mesa, with their tailings of displaced earth, that face each other across the canyon.

In 1969, Smithson was commissioned to do a piece called *Asphalt Rundown*, in which a truckload of asphalt was spilled down the side of a ravine outside Rome, where it took the form that gravity, the slope, and the material itself dictated. *Asphalt Rundown* was right in step not only with "process art," which was then the going thing in New York, but also with Arte Povera in Italy. Arte Povera ("Poor Art") is a term coined by Germano Celant in 1968 to refer to the activities of artists such as Michelangelo Pistoletto, Mario Merz, and Jannis Kounellis, who employed a wide variety of forms and materials strictly for their aptness to specific ideas. In the better works of Arte Povera, it is impossible to guess whether materials suggested ideas to the artist or an idea necessitated the materials. Arte Povera artists frequently used materials that, like asphalt, were thought aesthetically impoverished or irredeemable. The emphasis in American process art tended to fall on clarifying the artist's relationship to materials and operations, whereas practitioners of Arte Povera aimed for an inexplicable, poetic rightness in their choice of procedures and media. A good example

Walter De Maria, *The New York Earth Room*, 1977
250 cubic yards of earth and earth mix (peat and bark) weighing 280,000 pounds, covering an area of 3,600 square feet of floor space to a depth of 22 inches
Dia Art Foundation New York

of Arte Povera is Michelangelo Pistoletto's *Orchestra of Rags* (1968). It is an installation piece consisting of a donut-shaped heap of discarded clothes placed on the floor. A sheet of glass presses down upon the heap. It collects steam from the water-filled tea kettles, heated by hotplates, at the open center of the circle of rags. The tea kettles have whistles on their spouts so that they emit high-pitched sighs as steam escapes them.

In 1970, Smithson completed his most famous piece, *The Spiral Jetty*, an earthwork at the edge of the Great Salt Lake in Utah, financed by his dealer, Virginia Dwan. With this piece, he finally realized his ambition of making sculpture—if "sculpture" is the word for it—that is rooted in its site. Rocks and soil from the shores of the lake were used in building the fifteen-hundred-foot helical prominence. The finished piece seems to belong both to contemporary art and to the ranks of immemorial landmarks such as Stonehenge and the mysterious markings on the desert floor in Nazca, Peru.

Gianfranco Gorgoni's photographs of *The Spiral Jetty*, taken in 1970, have become icons of the Minimalist moment in American art, vivified further by the fact that—with an irony Smithson might have appreciated—the water level in the Great Salt Lake has since risen several feet, submerging the work itself indefinitely.

The Spiral Jetty has not yet become the touchstone that it looked as if it might be when images of it were first published. Smithson's work has not had an influence

Robert Smithson, *Asphalt Rundown*,
1969
Asphalt dumped down hillside,
Rome
Estate of the artist

on younger American sculptors comparable to that of Richard Long's work on British artists, for example. Long, too, makes alterations in far-flung landscapes and records them in photographs. And he sometimes collects material from sites he visits and arrays it indoors: yet Long's touch is lighter than Smithson's in every way. Their works converge only in being on the margins of artistic nonentity.

The philosophical incitements of Minimalism have been transmitted less by Smithson's work than by that of other artists of his generation, such as Carl Andre and Richard Serra and by several artists whose careers ended sooner or began later, such as Eva Hesse, Nancy Holt, and Joel Shapiro. Smithson remains a provocative, paradoxical figure whose reputation lives currently more by his self-interpretations than by his art.

Richard Serra (born 1939) broke upon the New York art scene with as much force as had Jasper Johns a decade earlier. Once again, Leo Castelli presided. In December, 1969, Castelli gave Serra a one-man show in an Upper West Side warehouse space. Serra had exhibited some pieces at the Guggenheim Museum and in gallery group shows during the previous year, but as yet few people were aware of his galvanizing artistic intelligence. Philip Leider scarcely overstated the case in his review of the Castelli show when he wrote, "Stepping into sculpture as if no one were home, Richard Serra continues to systematically lay claim to the entire estate."[7]

Born in San Francisco, Serra studied English literature at the University of California at Berkeley and at Santa Barbara and later got undergraduate and graduate degrees in art at Yale. While a student, he supported himself with part-time jobs as a steelworker. Academic fellowships enabled him to live for two years in Europe, where he met composer Philip Glass. In 1966, Serra settled in New York, where he befriended several other like-minded artists, including Andre, Smithson, filmmaker Michael Snow, and composer Steve Reich. They shared an interest in procedures and structures that would objectify and depersonalize aspects of their works that people believed to be "expressive." Rather than try to banish expressive qualities from their work, they sought to account for them in non-psychological terms.

Andre's sculpture and Stella's early paintings had suggested that art owes its emotional content to people's projections onto it of feelings for which they do not want to take responsibility. Might not people "bored," "disappointed," or "outraged" by abstract art simply find such art a handy scapegoat for feelings about their own lives, or about their own ignorance of art? This question became harder to evade as the nature of human self-knowledge gradually emerged as a tacit theme of much New York sculpture during the 1960s.

By shifting focus from art as object to art as the outcome (or execution) of a process, Serra's sculpture and films and the music of Reich and Glass showed how works of art can develop energies that register as feeling yet are discernibly independent of the intentions of both artist and audience. These artists thought of art as a phenomenon that works effects on us because to be alive is to be subject to phenomena (from the weather, and mental states, such as onslaughts of emotion or memory, to the cycles of day and night, and the irreversibility of aging).

The music of Reich and Glass came to be associated with Minimalism because of their interest in musical performance as a process. They carried forward and modified attitudes toward performance and audience expressed earlier in dance works by Simone Forti, Yvonne Rainer, and others. Like the Minimalist sculptors, Reich

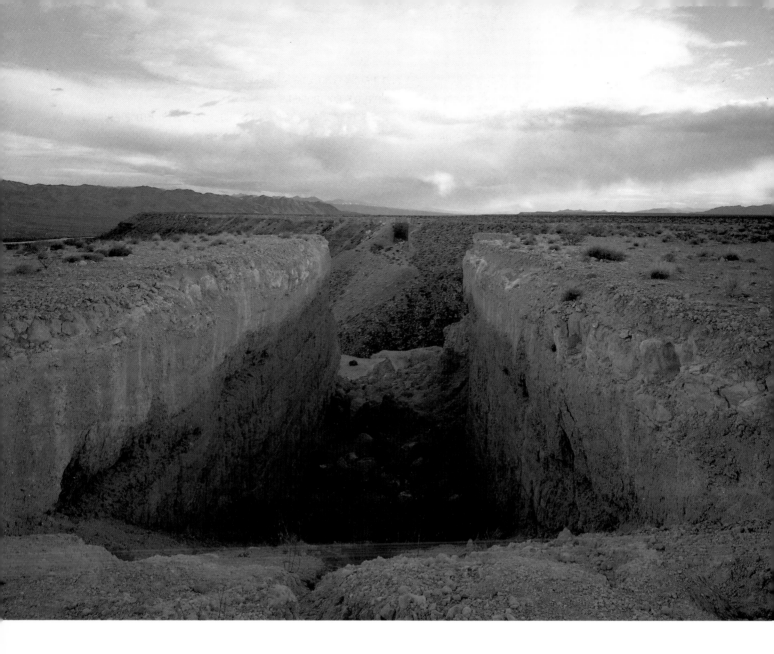

wanted his art to display overtly (in his case, to sound) all of the decisions that went into it, or as many as possible. His *Writings About Music* is one of the signal documents of the time. As a composer, he explained in 1968, "I am interested in perceptible processes. I want to be able to hear the process happening throughout the sounding music. . . . John Cage has used processes and has certainly accepted their results, but the processes he used were compositional ones that could not be heard when the piece was performed. . . . The use of hidden structural devices has never appealed to me. Even when all the cards are on the table and everyone hears what is gradually happening in a musical process, there are still enough mysteries to satisfy all. These mysteries are the impersonal, unintended, psycho-acoustic by-products of the intended process. These might include sub-melodies heard within repeated melodic patterns, stereophonic effects due to listener location, slight irregularities in performance, harmonics, difference tones, etc."[8] The unintended details perceived in listening to Reich's music are somewhat analogous to the gestalts in terms of which, according to Robert Morris, viewers were to see Minimal sculpture.

Michael Heizer, *Double Negative*, 1969–70
240,000-ton displacement in rhyolite and sandstone
Mormon Mesa, Overton, Nevada
The Museum of Contemporary Art, Los Angeles; Gift of Virginia Dwan

In Serra's work, they find parallels in one's kinesthetic responses to the mass and precariousness of his sculpture's components.

Without reinstating a discredited idealism, artists such as Serra, Bruce Nauman, and Alan Saret allowed into their works some of the psychological and emotional complexity that Stella, Andre, and Judd had banished. The younger artists' works of this period argue that the emotional force we ascribe to art is not an excrescence of the artist's sensibility but a phenomenon in a field where everything is interpretable. The language, space, and history we have in common and our very visibility (and audibility) to each other engender a field of signifying forces. Some of those forces we call feelings, and we deal with their unlocatability by assigning them to mysterious dimensions of ourselves. Whatever appears in this field—an object, an action, an utterance—appears meaningful, even if it has only the meaning of nonsense, madness, or the inexplicable.

Almost from the outset of his career, Serra has used his work to investigate the overlap of fields in which things and events weigh with various signifying emphases. His sculptures are devices for registering the perceptual, emotional, and political charges things take on according to how they are made and positioned in physical and social space. Since the late 1960s, Serra's focus has shifted from the work of art as an object privileged with meaningful structure to art as a tool to sharpen and recast people's awareness of ordinary, unexamined situations and actions.

In 1967, Serra began thinking in terms of simple actions that would convert materials into sculpture without prettifying them or making them celebrate his sensibility. He made a now famous list of transitive verbs—"to crease, to fold, to store, to bend, to shorten, to twist," etc.—acts just legible enough that they might amount to techniques of sculpture if exercised on the right materials.[9] This line of thinking yielded works such as *Tearing Lead from 1:00 to 1:47 (10/19/68), Thirty Five Feet of Lead Rolled Up* (1968), and *Splashing* (1968).

The latter piece, in which he hurled molten lead—"cast" it in a double sense— into the junction of a wall and floor, is a kind of sculptural counterpart to Jackson

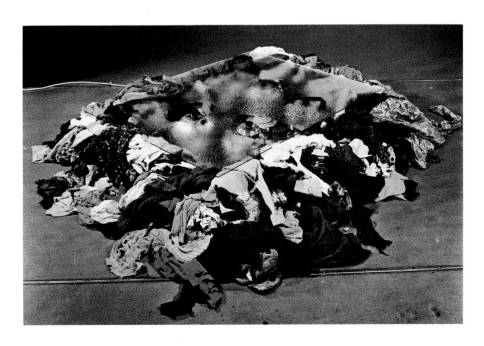

Michelangelo Pistoletto, *Orchestra of Rags*, 1968
Rags, glass, hot plates, and kettles with whistles, 59 × 66⅞ in.
Giorgio Persano, Turin

Pollock's drip paintings. In it, Serra acknowledged Pollock's surrender to gravity and to the physics of paint as a source for his own generation's attraction to process as art content. Yet Serra seemed also to criticize the expressionistic temper of Pollock's art, though not its implicit violence. Pollock believed that his paint-slinging was a technique that short-circuited conscious intention, enabling unconscious impulses to govern his art. In the Pollock legend, the transmutability of creative and self-destructive energies in the artist's unconscious—in which Pollock himself believed—is attested by his ability to win a magical coherence on canvas from what might have been (and occasionally ended up being) mere chaos. Like all of Serra's art, his lead splash pieces are skeptical of psychoanalytic belief. *Splashing* abstracted from Pollock's bravura painting performances the mere operation of flinging fluid matter. No one would ascribe to Serra's splashing procedure the upsurge of creative spontaneity that people see in Pollock's gestural painting: the use of molten lead requires planning and precautions. The artist's spontaneity takes a back seat to the urgency of controlling a dangerous material. The details of Serra's lead splashes simply can't be thought to matter in the same way that the details of Pollock's paint-handling can. Pollock may have been enacting a psychoanalytic allegory of creative/destructive ambivalence when he painted. Serra put the constructive and hazardous aspects of his activity out in the open by using a dangerous material and a set of very unmystifying operations.

Perhaps most important to Serra was the question whether he could intimate a critical perspective on the culture by controlling the way his sculpture stands out against the background of non-art reality. Could sculpture be made to stand in the present tense of history, in the domain of real events—rather than negating it as monuments typically do—and thereby evoke a world view not founded on representations?

At the Castelli warehouse, in addition to a splash piece, Serra made a series of "prop pieces," as he called them, with four-foot-square lead plates—larger versions of those Andre had used—and sheets of lead rolled into cylinders. To give sculpture vertical structure was to raise again the specter of anthropomorphism, for the horizontality of Andre's floor sculpture is the ultimate rejection of analogy between sculpture and its viewers. Serra resurrected the analogy only in order to criticize and reformulate it.

Each prop piece was a precarious structure of standing lead plates. Every vertical element stood balanced on edge by leaning against other poised plates or by being held upright with the downward pressure of a lead cylinder resting on top of it. Although a couple of prop pieces made contact with the wall, no clips, bolts, or braces held the sculptures together; gravity was the only fastening force involved in them.

Lead made sense as a medium for Serra because it is chemically elemental, is synonymous with weight, and in thin sheets is malleable enough to be worked by hand. (Earlier he had worked with rubber, which registered well operations such as cutting and folding, but lacked lead's aspect of seeming to be soaked with mass.) He accepted the logic of Andre's work whereby sculpture ought to respect gravity, ought to be unframed and structurally self-justifying, and introduce no new illusions to a society already engorged with them. Within these principles, Serra set himself the task of making sculpture rise again, as if to prove that Andre's floor plates really need not be the historical dead end of sculpture that some people believed them to be.

Alan Saret, *Deep Forest Green Dispersion*, 1969
Galvanized hex netting, painted; height: 4 ft. (variable)
Dallas Museum of Fine Arts; Gift of John Weber

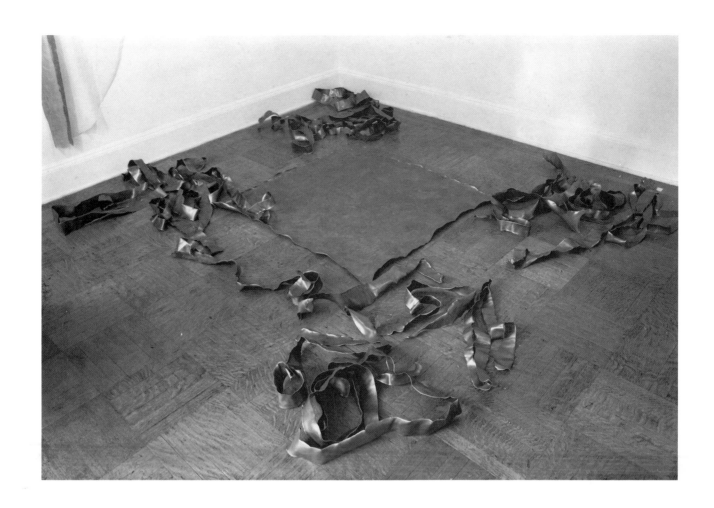

Richard Serra, *Tearing Lead from
1:00 to 1:47*, 1968
Lead, 10 × 10 ft.
Panza Collection, Milan

Richard Serra, *Thirty Five Feet of
Lead Rolled Up*, 1968
Lead, 24 × 5 in. (approximate)
Collection Holly and Horace
Solomon, New York

Richard Serra, *Splashing*, 1968
Lead, indeterminate dimensions
(Destroyed)

That Andre himself saw a problem in making sculpture justifiably upright once more is suggested by some of his works of the late 1960s, such as *Copper Ribbon* and *Aluminum Ribbon* (both 1969). These pieces are coiled strips of metal foil that are deployed horizontally on the floor but are vertical as can be, in that they stand on edge. (In photographs, the ribbons, long unfurled loops, bring to mind Smithson's *Spiral Jetty*. In 1968, Serra too had made a spiral piece, a coiled belt of lead.)

To move close to Serra's prop pieces was to feel yourself in danger of bodily harm. Their weight and precarious balance gave the sculptures a visceral immediacy that art rarely possesses. Their precariousness made their verticality analogous both to one's own upright posture and to the vulnerable immanence of the powers that sustain it. Although these sculptures were in no sense images, they read as figures for the interdependence of anatomy and consciousness, both as aspects of life and as concepts of human self-understanding. Their threat of collapse was an aggressive reminder of mortality. The sculptures objectified one's subconscious identification of the upright posture with awakeness, self-control, presence of mind, and of the horizontal with sleep, helplessness, death. By these means Serra reintroduced into sculpture—in an impersonal manner—an emotional intensity that Minimalism had largely eliminated.

Richard Serra
2–2–1; to Dickie and Tina, 1969
Steel antimony, 4 ft. 4 in.
× 8 ft. 2 in. × 11 ft. (approximate)
(Destroyed)

Carl Andre, *Copper Piece* (left),
Aluminum Piece (right), both 1969
Copper and aluminum, 3 in.-wide
metal ribbons, lengths vary with
installation
Installation: Wide White Space,
Antwerp, Belgium

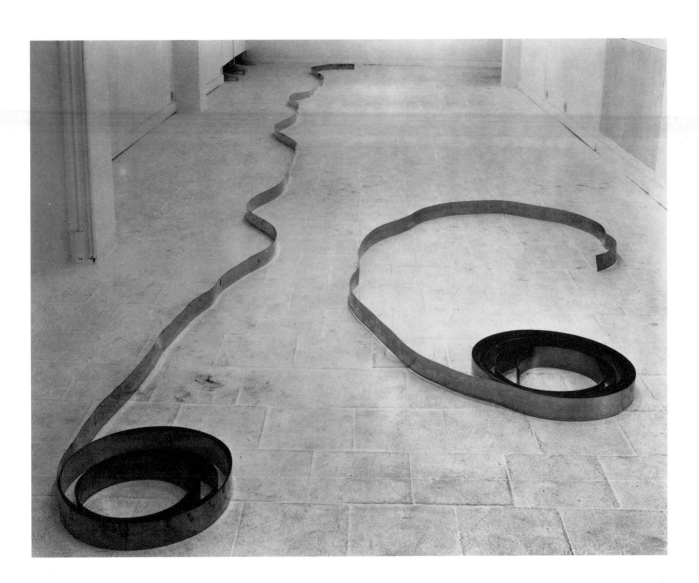

Of the artists who worked on the margins of non-art in the 1960s, only Joseph Beuys wrung from such inert materials the kind of impact Serra's work had. And he usually did so by subtler means. His *Fat Chair* (1964), for example, is a discarded chair whose seat has been filled with a wedge of tallow, rendering it useless as furniture but arresting as a metaphor for visceral self-consciousness. Instead of being descriptively representational, it gives physical form to a key feeling of embodiment: a conjunction of the central sensations of hardness and softness we associate with flesh and bone. It is not so much the anthropomorphism of the chair (chairs have legs: we have legs) as our habitual intimacy with such objects that lends the chair what power it has as the stuff of art.

Serra gave his work an extraordinary power of implication without allowing into it anything structurally superfluous. His use of lead stirred associations he almost certainly did not intend, associations that seem never to have been stirred by Andre's handling of elemental metals. After the 1968 student uprisings in Paris, with widespread political unrest in America and anti-war sentiment running high in the art world, Serra's prop pieces not only brought to mind "lead" as slang for ammunition, they resonated with prevailing utopian hopes for the downfall of authoritarian structures. Their dominant note was one of pessimism, however, a brooding recognition of the fragility of human understanding and well-being. Seeing one of the prop pieces reconstructed in Serra's 1986 retrospective at New York's Museum of Modern Art, I thought of the alchemical reverie of a character in a story by Primo Levi. "Lead is actually the metal of death," this character says, "because it brings on death, because its weight is a desire to fall, and to fall is a property of corpses . . . lead is a material different from all other materials, a metal which you feel is tired, perhaps tired of transforming itself and that does not want to transform itself anymore: the ashes of who knows how many other elements full of life, which thousands upon thousands of years ago were burned in their own fire."[10] In their paradoxical dependence on

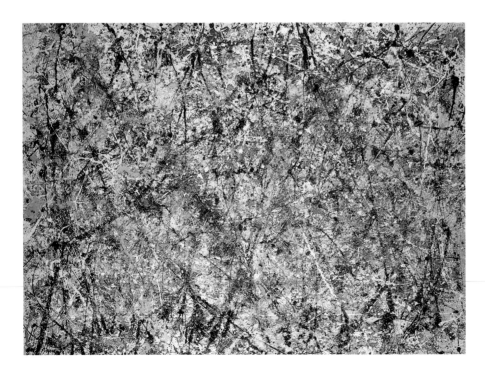

Jackson Pollock, *Number 1, 1950 (Lavender Mist)*, 1950
Oil, enamel, and aluminum paint on canvas, 87 in. × 9 ft. 10 in.
National Gallery of Art, Washington, D.C.; Alisa Mellon Bruce Fund

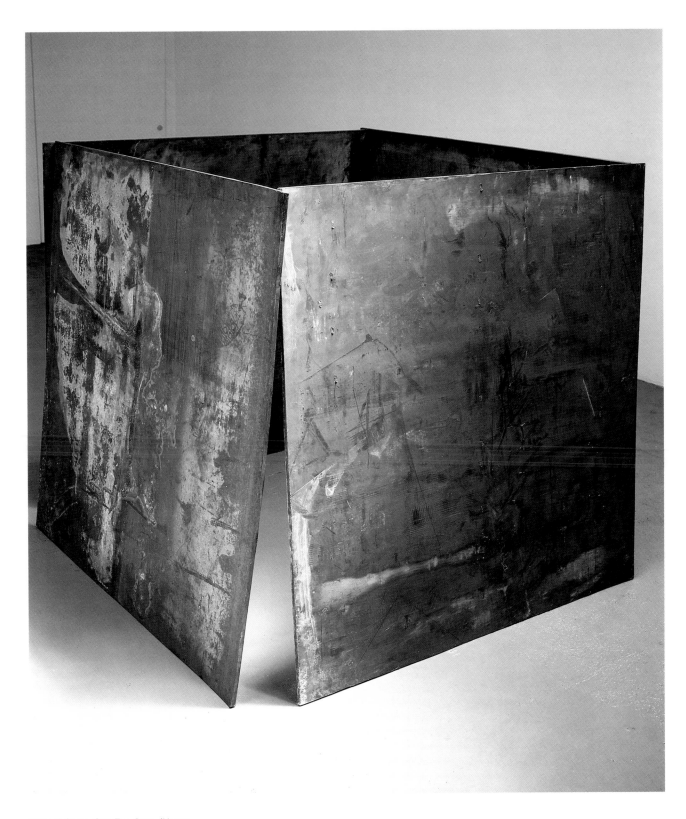

Richard Serra, *One Ton Prop (House of Cards)*, 1968–69
Lead, 48 × 55 × 55 in.
Saatchi Collection, London

gravity to stay standing, the prop pieces also bring to mind the Greek mythic character Antaeus, who owed his strength to constant contact with his mother, the earth. In the history of Western sculpture are several famous versions of the killing of Antaeus by Hercules, who overcame him only by holding him off the ground.

Gravity-bound and gravity-threatened, Serra's prop pieces asserted the identity in time of their structural integrity and their meaning as art, not unlike Flavin's fluorescents. When one of them falls apart or is dismantled, it reverts to meaningless

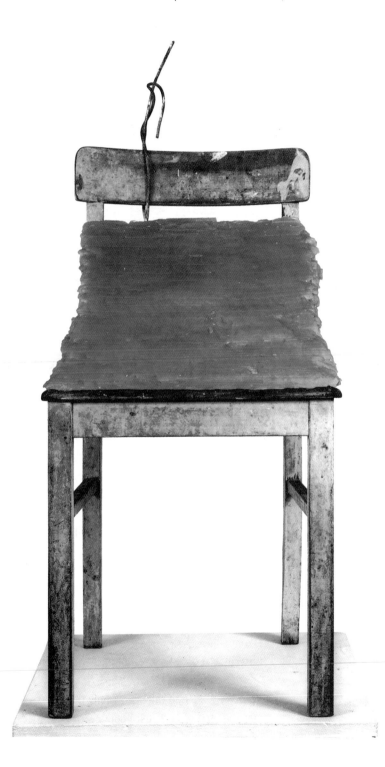

Joseph Beuys, *Fat Chair*, 1964
Wooden chair with fat, 35⅜ ×
11¾ × 11¾ in.
Hessisches Landesmuseum,
Darmstadt, West Germany

Richard Serra, *Stacked*, 1969
Steel, 32 × 30 × 25 ft.
(Destroyed)

raw material, for its structural logic collapses with it. Unlike, say, a painting, a Serra sculpture cannot be moved without loss of meaning. Because each piece is fabricated where it stands, part of its meaning is its immobility; its meaning is an aspect of the object's presence. The meaning is idealized only when it is abstracted in language or photographs (as here). Whereas freestanding sculpture traditionally might have justified its placement by marking the scene of a pivotal event or the burial place of a leader, the prop pieces earn their ground—wherever it happens to be—by the kind of purified structural sense they make. The sculptures' meaning is not unintelligible to those who fail to see them standing. However, to understand them correctly is to recognize any secondhand account of them—including this one—as a tangential but distinct artifact in another medium, rather than a trace of the works' most intangible attribute.

The problem of keeping mass vertical without arbitrary or deceptive structural complications has been central to Serra's art since 1968. In a series of site-specific pieces done at a steelyard in Fontana, California, in 1969, he investigated stacking, another procedure Andre had used for making materials rise. In making *Stacked* (1969), for example, Serra worked with a gantry-crane operator whom he directed to pile up steel mill tailings to a point at which, in Serra's judgment, any further increment would cause the structure to collapse. Again, gravity was the only fastening force involved. The work, while it lasted, was recognizable as art only by dint of the extreme improbability that steel in a scrapyard would ever just happen to be heaped into such tall, teetering configurations.

119

Serra's *Skullcracker* series—as the steelyard pieces were called—responded not only to Andre, but to Brancusi, whose *Endless Column* is one of the great icons of modernity in sculpture. Brancusi's monument, which rises ninety-six feet, repeating the same vertical double-plinth form, is endless in principle but arbitrarily limited in height. Each of its structural units may be seen as an abstracted human figure; reiterated, they form a kind of towering, totemic spinal column. Whereas stacking is primarily a formal device in the *Endless Column*, Serra made it a self-limiting procedure by using loose, irregular material units. Brancusi's piece may be read as a faceless monument to human erectness (both postural and sexual) and generativity. It is an abstract analogy not only to bodily uprightness but to humankind, arising from the earth (and rejoining it) in potentially endless succession. In contrast to the elevated mood of Brancusi's *Endless Column*, Serra's stacked pieces rose only towards their own collapse. They commemorated no history but their own.

Richard Serra, *Pulitzer Piece (Stepped Elevations)*, 1970–71 Cor-Ten steel; 3 plates: 5 ft. × 47 ft. × 2 in.; 5 ft. × 55 ft. × 2 in.; 5 ft. × 60 ft. × 2 in. Mr. and Mrs. Joseph Pulitzer, Jr.

Some of Serra's most minimalistic works—those that have achieved most by the simplest means—have made use of existing landscape or interior architecture. *Pulitzer Piece (Stepped Elevations)* (1970–71) was the first work in which he kept steel plates vertical by inserting them into the ground. The interior piece *Twins* (1972) consists of two congruent right triangles of steel inserted vertically into opposite corners of a room. The title hints at the fact that the two elements of the work joined would form a single plane. But the physical situation confounds the viewer's tendency to imagine the two elements as one, to conjure an idealized plane in which the two triangles might be reunited in a rectangle. Their hypotenuses sloping in opposite directions, the steel sheets are locked into asymmetry by their dependence on the architecture to remain standing. To envision them united is to negate the real

circumstances and to sense the power of that negation and of the temptation to perform it. The mass of Serra's materials enables the viewer to feel what a power of negation is needed to blot out immediate circumstances in favor of an idealized concept of them.

With such works as *Twins* and *Circuit* (1972), Serra shifted his art's emphasis from materiality and gravity to the object's placement and its effect on viewers' awareness of themselves and each other. Despite its massive physical presence, the perceptual subtleties of his work can be so difficult to articulate that they provoke the desire for company. These works arouse a curiosity that does not concern the objects themselves so much as other people's style of delineating perceptions, of choosing and marking out in language or movement the still points around which, for them, ambiguities and uncertainties revolve. In other words, Serra's work arouses curiosity about other people's styles of "worldmaking," to borrow Nelson Goodman's term.

Circuit is one of Serra's most anti-anthropomorphic works in that to enter it is to experience embodiment and animateness as factors that expose rather than cloak you. The piece consists of four large rectangular plates of steel, each of which is inserted vertically into one corner of a room, so that it stands supported by the architecture alone. The plates converge at the center of the room, leaving an open space about three feet square between them. The work is intended for a room with only one doorway. To walk into the central space, even with no one else present, is to feel yourself dangerously outflanked at the cynosure of distinct but convergent vantage points. You soon recognize this position to be a special case of your normal exposure to the gaze of others and realize that to be seen is to be subject to understanding (and, therefore, to misunderstanding) by others. The sensation of being unguarded on every side, so intense at the center of this piece, is an assault upon our vanity of feeling that we govern the figure we cut in the eyes of the world. In *Circuit*, Serra enables us to sense that notions of how body and consciousness relate bear upon the ways we see and behave.

By making actions, rather than the human image, the focus of his art, Serra has composed the ultimate critique of sculpture's anthropomorphic tradition. He has undone Western sculpture's idolatrous fixation on the exterior of the body, the fixation that poses us the false and impossible choice of identifying either body or mental process as the essential self. More fundamental than the individual self, Serra's work suggests, is the community of fellow beings that precedes and survives us and imposes on us uses of such concepts as "body," "consciousness," and "self." As Jose Ortega y Gasset put it, "Body and soul are two intellectual constructions of mine, two hypotheses, two theories which I have made or have received from others in order to clarify for myself certain problems which my life possesses for me."[11] To take those "intellectual constructions" literally, in the Cartesian, the Freudian, or any other sense, is to sacrifice their usefulness for thinking about life.

Serra's sculpture marks a kind of conclusion to the Minimalist project. It aims to break the spell of dualism by revealing the human world to be conditioned as much by reciprocity—and the failure of it—as by the nature of one's own perception or by the inertia of material life. Serra showed that the rigor of Minimalist thinking need not exclude from art the resonance with disparate aspects of life that we hope to find in it, though to date few artists have been able to follow his example in this regard.

Serra's art unfashions the dualistic vision inherited from anthropomorphic sculpture in a manner comparable to Gilbert Ryle's philosophical revision of Cartesian thought. "The statement 'the mind is its own place,' as theorists might construe it, is not true," Ryle wrote in a characteristic passage, "for the mind is not even a metaphorical 'place.' On the contrary, the chessboard, the platform, the scholar's desk, the judge's bench, the lorry-driver's seat, the studio and the football field are among its places. These are where people work and play stupidly or intelligently. . . . When a person talks sense aloud, ties knots, feints or sculpts, the actions which we witness are themselves the things which he is intelligently doing, though the concepts in terms of which the physicist or physiologist would describe his actions do not exhaust those which would be used by his pupils or his teachers in appraising their logic, style or technique. He is bodily active and he is mentally active, but he is not being synchronously active in two different 'places,' or with two different 'engines.' There is one activity, but it is susceptible of and requiring more than one kind of explanatory

Richard Serra, *Circuit*, 1972
Hot rolled steel, 4 plates:
8 ft. × 24 ft. × 1 in. each;
36 sq. ft. overall
Collection of the artist

description. . . . It makes no difference in theory if the performances we are appraising are operations executed silently in the agent's head, such as what he does, when duly schooled to it, in theorising, composing limericks or solving anagrams. Of course it makes a lot of difference in practice, for the examiner cannot award marks to operations which the candidate successfully keeps to himself."[12]

Serra is preeminently the sculptor who has shown the mind's places to be public and to be therefore the domain of conscience no less than of consciousness. His art even intimates that the chronic modern fixations on body and consciousness as mutually exclusive may be socially, not ontologically, determined. Perhaps in our culture those fixations serve as psychological defenses against the atrophy of conscience by social and economic institutions that appear to render political action futile. In that case, Serra's art may not be as pessimistic as it seems.

Serra's sculpture is pivotal because it brings into focus the "human" content of Minimalism that puts the best examples of it in the category of enduring works of art, not just of period artifacts. In the way that it deflects our attention back upon ourselves, the inertia of Minimal sculpture orients us to one of the great human mysteries: our ability to originate our own actions. The passion for self-description in modern thought and art may be rooted less in historical circumstances than in the impenetrability of this mystery. Minimalism is a peculiarly indirect, yet intense, engagement with it. Richard Serra's sculpture has outlasted the main force of Minimalism precisely because it taps the energy of this enigma, whether that is Serra's intention or not.

Much of this book has been cast in the past tense, as though Minimalism can be handily bracketed between dates, like the lifespan of someone deceased. It cannot be. As the 1980s wore on and people tired of the slash-and-burn stylistics of Neo-Expressionism and of the rule of fashion over the art world, forecasts of a return to Minimalism—or to abstraction—began to circulate. But there are many reasons why Minimalism cannot "return." One is that, in some sense, it has not yet receded. Many of the key figures of the Minimalist period are still artistically active and working their signature styles: Sol LeWitt, Donald Judd, Dan Flavin, Walter De Maria, and Richard Serra among them. Others, such as Frank Stella and Robert Morris, have gone on to do things that seem worlds away from their key works of the 1960s yet lend those early works a retrospective resonance. (Morris, for example, has taken to making large mixed-media images evoking catastrophes of anatomy and society. Most critics see them as protests against the possibility of nuclear holocaust. Whatever their meaning, their hallmark is the feeling that their every detail is under Morris's control, the very feeling most characteristic of his Minimalist works.)

During the 1980s, sharp reversals beset well-known artists of the Minimalist generation.[1] People who saw only negativity in Minimalist aesthetic rigor and claimed to sense suppressed violence in it believed their intuitions vindicated by the Minimalists' troubles. Painter Audrey Flack expressed a sentiment too common in the art world when she wrote: "The work of minimalist artists was so tightly buttoned down that there was no place for their anger to go except into their lives."[2]

The Dia Art Foundation, its funding tied to the world oil economy, found itself drastically overextended during the oil-flush eighties. Its advisory board was purged and new people were appointed to reorganize its operations. Its patronage of Minimalism retrenched accordingly, although at this writing, it shows signs of gearing up again, with the recent opening of a mammoth exhibition space on the far West Side of Manhattan. Dia continues to maintain several of the projects completed by artists under its patronage in the late 1970s, including Walter De Maria's *Lightning Field* in New Mexico and his *Broken Kilometer* and *New York Earth Room* in New York.

I regard De Maria's *Lightning Field* (1977) as the closest thing to a masterpiece to come out of Minimalism. (Although not completed until the late 1970s, it was conceived almost a decade earlier.) Situated on a high plateau in the remote North Plains of New Mexico, the *Lightning Field* is a grid array of 400 vertical stainless steel poles covering a mile-by-kilometer area. The poles, which stand about 220 feet apart, emerge from the ground as if growing there: no visible trace remains of the

Walter De Maria, *The Lightning Field*, 1971–77
Stainless steel poles, 20 ft. 7 in. high (average); 5,280 × 3,300 ft. overall
Near Quemado, New Mexico
Dia Art Foundation

engineering involved in their placement. Each pole tapers to a needle-sharp point—well out of the visitor's reach—and the tips of the 400 poles define a plane parallel to sea level. Accordingly, their lengths, averaging 20 feet, vary with the land elevation.

The *Lightning Field* bears a misleadingly literal resemblance to De Maria's 1969 *Beds of Spikes*. To fall upon one of the *Beds* would mean serious injury, whereas the threat posed by the *Lightning Field* is far more indirect, though also more profound. There is little likelihood of seeing lightning strike the *Lightning Field* poles, although the site is in a meteorologically volatile area. De Maria considers lightning strikes a false climax to a work whose effect depends upon being observed over time and on the tension between untrammelled nature and objects that embody science's coldly penetrating attitude toward it. This tension is unremitting in the clash between the timelessness of the surrounding mountain horizons and the historically specific forms of the poles.

Almost invisible under high sunlight or overcast skies, the poles reveal themselves to be cylindrical mirrors whenever the sun is near the unclouded horizon. At such times they blaze with reflected light and calibrate the space of the plain in a manner that links pictorial perspective conventions and the modern Western mania for appropriating and subduing the earth. With its perfectly regular sight lines and icy formality, the array of poles suggests some sort of "big science" instrumentation whose function is obscured by unseen tiers of power. (This implication is eerily

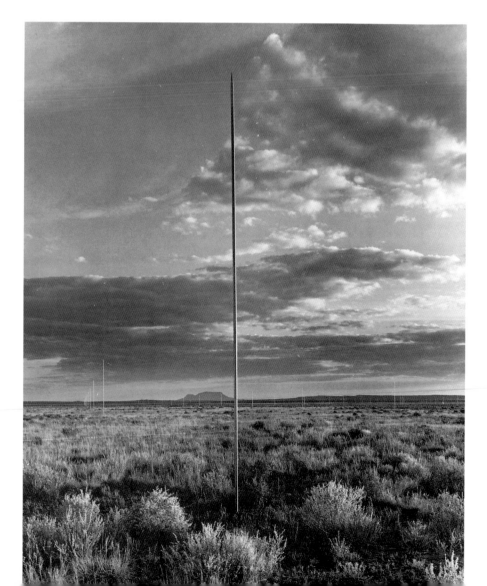

Walter De Maria, *The Lightning Field*, 1971–77
View of single pole,
20 ft. 7 in. high (approximate)
Near Quemado, New Mexico
Dia Art Foundation

appropriate in that the resources of the Dia Art Foundation, which funded the work's construction, stemmed from labyrinthine structures of international finance secured ultimately by military power.) Certain critics have disparaged the *Lightning Field* as a mere tribute to the power that made it possible, but it embodies a much subtler historical understanding than such an interpretation acknowledges.

The most vivid sensation one has on arriving at the *Lightning Field* is of having left the world behind. There is an old, renovated cabin at the site, where guests are accommodated, but it is the poles that insinuate themselves as tokens of the forsaken world. While bearing no recognizable trace of the human touch, they invoke the vast collective projects of science and technology. Their elegant, potentially lethal forms stir associations to high-tech weaponry and its ancestry of spear, dart, and arrow. Their phallic and anthropomorphic symbolism is refracted through references to Brancusi's *Bird in Space* and *Endless Column*. And as Franz Meyer observed of the spikes on the 1969 *Beds*, the poles conflate symbolism of weapons and the human figure to evoke a vision of society as a war of each against all. But underlying all these associations is the poles' most emotionally immediate quality: their air of tempting a response from the sky, from the natural order into which they intrude.

The lightning most liable to strike at the *Lightning Field* is psychological, not meteorological. The work is a device for coaxing into consciousness one's worst fears about the present moment and direction of history. However, this function of the *Lightning Field* has a dialectically complementary aspect. The piece also serves as an instrument for intensifying one's grasp of the beauty of the earth. Emerging and disappearing from sight with the movements of the sun (at night the 400 poles are virtually unlocatable), the *Lightning Field* acquaints the visitor with the possibility that beauty may be the only conscionable and feasible refuge from history. That is, the apprehension of reality as everywhere *radiant with its being* may be the only bearable consciousness of life that does not entail repressing awareness of the horrors of our time. Beauty in this sense is just what the *Lightning Field* makes available even as it gives sculptural anchorage to one's worst forebodings of the world's fate.

Thanks to the Dia Art Foundation, De Maria was able to author the grandest Minimalist work of the 1970s. Yet Richard Serra, more than any other American artist, has become the representative figure of the Minimalist generation. The reason is that since 1970 he has modulated into a new key the Minimalist interest in "placing" subjectivity. Early in the Minimalist years, certain artists looked upon the conventions of art exhibition as a kind of model for investigating the subject/object dichotomy. Almost from its outset, Serra's work has treated this dichotomy as dynamic rather than static. His public works have become increasingly confrontational, aiming to expose the normal workings of power to scrutiny by intervening in them. In the past fifteen years, Serra's work has gone beyond the Minimalist project of undoing anthropomorphism and clarifying relations between objects and human action. His work's shift in emphasis calls for a shift in critical perspective from the phenomenological to one closer to that of the late Michel Foucault, who inquired into the nature of power in order to understand "the modes of objectification which transform human beings into subjects."[3] As skeptical as the Minimal sculpture of the 1960s was, it never quite shed the assumption that individuality is subjectivity. Serra's recent work reflects the view that alienated subjectivity is a kind of implosion of individuality under the pressures of power, most of which operate openly but unrecognized for what they

127

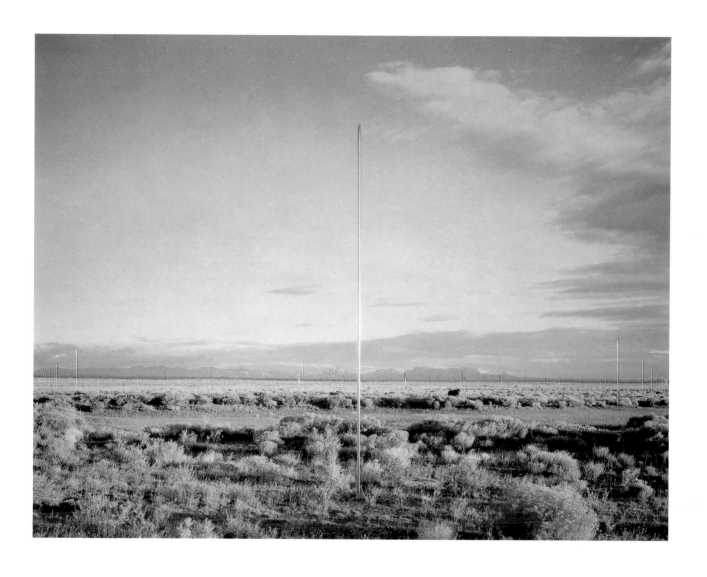

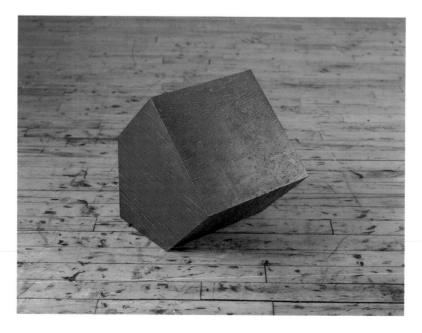

128

Walter De Maria, *The Lightning Field*, 1971–77
Stainless steel poles,
20 ft. 7 in. high (average);
5,280 × 3,300 ft. overall
Near Quemado, New Mexico
Dia Art Foundation

are. His work aligns itself tacitly—his critics say spuriously—with the adversary spirit of various anti-authoritarian struggles that have developed in the past decade or so. The struggles, in Foucault's view, include "opposition to the power of men over women, of parents over children, of psychiatry over the mentally ill, of medicine over the population, of administration over the ways people live."[4] Their main objective, Foucault believed, "is to attack not so much 'such or such' an institution of power, or group, or elite, or class but rather a technique, a form of power. The form of power applies itself to immediate everyday life which categorizes the individual, marks him by his own individuality, attaches him to his own identity, imposes a law of truth on him which he must recognize and others have to recognize in him. It is a form of power which makes individuals subjects. There are two meanings of the word 'subject': subject to someone else by control and dependence; and tied to his own identity by a conscience or self-knowledge. Both meanings suggest a form of power which subjugates and makes subject to."[5] It is the currency of Serra's work with this change in perspective on the issue of subjectivity that makes his art both more responsive to the times and more rooted in Minimalist ideals than that of any other American artist of his generation. To look at Serra's major works of the past ten years is to feel viscerally that power is an issue in one's own responsiveness to life and that art is—at least potentially—an aid to clarifying this fact. Serra himself seems torn between the intimate and the overbearing aspects of his own work. The manifestation of that conflict in his sculpture makes it hard to take at times. But confronting his sculpture is a lesson in segregating the springs of action in ourselves from our powerlessness.

The artistic backlash against Minimalism was slow in coming, but by the late 1970s it hit hard. A hunger for "forbidden" content and emotional surprise, coincident with the need to stimulate a cooling contemporary art market, gave rise to a spate of works in new media. "Pluralism" became the catchword for the new forms and for the resurgence of painting marked by decoration, narrative, fantasy, and pastiche. Some works in new media reflected social struggles such as those mentioned by Foucault. A great many others merely registered career ambitions with a new shamelessness characteristic of the time.

Of younger artists to emerge in the Minimalist lineage after 1970, Joel Shapiro is certainly the most resourceful and inventive. Although his work developed smatterings of representation and narrative, it continued to look Minimalistically spare and severe as the art world began to welcome back "expressive" values.

Some of Shapiro's early works make plain his debt to Minimalist thinking. *75 lbs.* (1970), for example, consists of two rectangular bars of metal, one of lead, one of magnesium. Because their weights are equivalent, as the title informs us, their respective lengths "represent" the metals' difference in mass. Before long, Shapiro began flirting overtly with representational form. He made small cast-iron objects in shapes simple enough to look Minimalistic, but suggestive enough to tempt viewers to read them representationally: a "coffin," a "house" that, upturned on one of its roof slopes, might be seen as a head.

The play of shapes and metaphors grew more complex in Shapiro's work until he started assembling wood beams like those Andre favors into configurations whose human reference was unmistakable. Some he cast in bronze, others he considered finished in wood. No matter how referential Shapiro's sculpture becomes, it is always abstract enough so that the viewer feels the act of choice in any representational

Joel Shapiro, *Untitled*, 1980
Cast bronze,
12³⁄₁₆ × 9⅞ × 11¹¹⁄₁₆ in.
Paula Cooper Gallery, New York

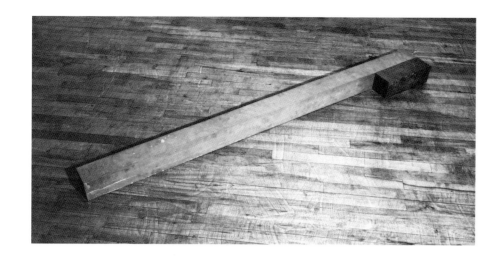

Joel Shapiro, *75 lbs.*, 1970
Magnesium and lead,
4 × 73¼ × 8 in.
Paula Cooper Gallery, New York

Joel Shapiro, *Untitled*, 1973–74
Cast iron, 5½ × 6⅝ × 5 in.
Private collection

Joel Shapiro, *Untitled*, 1971–73
Cast iron, 2½ × 11½ × 5 in.
Panza Collection, Milan

Joel Shapiro, *Untitled*, 1980
Wood, 52⅞ × 64 × 45½ in.
The Edward Broida Trust, Los
Angeles

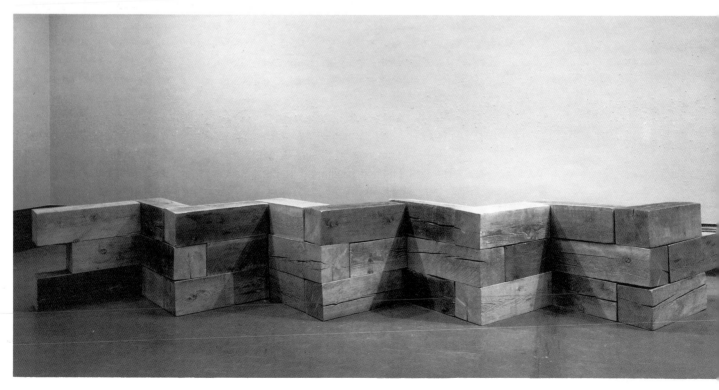

reading of the work. The object never "disappears" into representation. Shapiro's work embodies the view that representations—and therefore illusions—are inescapable. Banishing them entails a loss of the clarity it is supposed to achieve, for illusions belong to reality. At best, his work appears to argue, illusions and representations can be played with until they lose their bewitching qualities and become as observable and enjoyable as any aspect of life.

Abstract painting is back, but the anticipated resurgence of Minimalism has yet to occur. Many a critic will argue that it cannot occur because Minimalism lies on the far side of the post-modernist watershed (which seems to be undatable). The appearance of so-called Neo-Geo or Simulation art in the mid 1980s seems to support this view. The term "Neo-Geo" fits the works of painters such as Peter Halley and Philip Taaffe, who give figural twists to geometric motifs that allude to abstract painters of earlier generations, including the disparaged "Op" artists of the 1960s. "Simulation" applies better to the works of people such as Jeff Koons and Haim Steinbach, who use found—that is, purchased—mass-produced objects to make latter-day, media-conscious reprises of Marcel Duchamp's "readymades." Both these developments have a stale air of inevitability about them, so obviously do they plunder the most strategic aspects of 1960s American art. Strategy preponderates over the presence of these new art objects to such an extent that only a theoretical appreciation of them seems possible. They discredit all acts of observation except those that issue in a knowing smirk. Works of Neo-Geo and Simulation are not objects of thought, not even in the sense that Duchamp's readymades were. Indeed they appear to announce the obsolescence of the work of art as a "thought thing," to use Hannah Arendt's phrase. So far, they seem to serve only as social currency for fashion-conscious collectors or as catapults for critics with socio-political shells to lob.

From the vantage point of Neo-Geo, Minimalism looks as though it will prove to have been the end, not the beginning of something. Since 1960, the stuff of everyday life has come to bristle with ambiguities that make those of art seem almost pastorally simple. At best, Simulation and Neo-Geo embody accurately the despair of living in a context in which we sense that any object—even the most needful and useful—may be unmasked as accessory to someone's agenda of profit or social control.

We live now in a culture so overcoded and context-addled that in it even the most trivial and passing forms and happenings appear to carry messages. The enduring value of Minimalist art in such a culture may be its voicelessness, its patent silence. The best Minimal sculpture has been made with no intent to communicate. People who daily weather storms of specious "communications" as we do had better keep such islands of silence in sight.

Joel Shapiro, *Untitled*, 1981
Wood, 8¾ × 31¼ × 8½ in.
Private collection

Carl Andre, *Redan*, 1964
(destroyed; reconstructed 1970)
Wood; 27 units, 12 × 12 ×
36 in. each; 36 in. × 42 in. ×
245 in. overall
Art Gallery of Ontario, Toronto;
Purchased with assistance from the
Women's Committee Fund, 1971

ENDNOTES

Epigraph:

Antonio Porchia, *Voices,* translated by W. S. Merwin (New York: Knopf, 1988), p. 37.

ONE

1. To my knowledge, Rosalind Krauss was the first historian-critic to detail the affinity of Brancusi's works and those of Duchamp in the ancestry of Minimalism. See her *Passages in Modern Sculpture* (New York: Viking Press, 1977), pp. 69–103.

2. David Shi, *The Simple Life* (New York: Oxford University Press, 1985), p. 278.

3. Carl Andre quoted in *Carl Andre Sculpture*, exhibition catalog (Stony Brook: Fine Arts Center Art Gallery, State University of New York, 1984), n. pag.

4. Abe Peck, *Uncovering the Sixties* (New York: Pantheon, 1985), p. xiii.

5. Thomas Nagel, *The View from Nowhere* (New York: Oxford University Press, 1986), p. 27.

6. The painter David Burliuk appears to have been the first to use the term in writing about John Graham's work in a 1929 catalog essay. It is unclear whether he borrowed the term from Graham or vice versa. See Eleanor Green, *John Graham, Artist and Avatar* (Washington, D.C.: The Phillips Collection, 1987), p. 38, n. 13. Graham's definition may be found in Marcia Epstein Allentuck, ed., *John Graham's 'System and Dialectics of Art'* (Baltimore: Johns Hopkins University Press, 1971), pp. 115–16.

7. Richard Wollheim, "Minimal Art" in Gregory Battock, ed., *Minimal Art* (New York: Dutton, 1968), pp. 387–99.

8. Donald Judd quoted in Battcock, ed., *Minimal Art*, p. 162.

9. Quoted in *Carl Andre Sculpture*, n. pag.

TWO

1. William Carlos Williams, "The American Spirit in Art" in Bram Dijkstra, ed., *A Recognizable Image: William Carlos Williams on Art and Artists* (New York: New Directions, 1978), p. 210.

2. Jack Tworkov quoted in Dore Ashton, ed., *Twentieth Century Artists on Art* (New York: Pantheon, 1985), pp. 259–60.

3. Jean-Paul Sartre, *Being and Nothingness*, translated by Hazel E. Barnes (New York: Washington Square Press, 1969), p. 623.

4. Quoted in William C. Seitz, *Abstract Expressionist Painting in America* (Cambridge: Harvard University Press, 1983), p. 140.

5. Quoted in *Ibid.*, p. 141.

6. Quoted in *Ibid.*, p. 143.

7. Quoted in Serge Guilbaut, *How New York Stole the Idea of Modern Art* (Chicago: University of Chicago Press, 1983), p. 159.

8. Harold Rosenberg, *The Tradition of the New* (Chicago: University of Chicago Press, 1960), p. 25.

9. Motherwell quoted in Seitz, *Abstract Expressionist Painting in America,* p. 141.

10. For a detailed account, see Guilbaut, *How New York Stole the Idea of Modern Art.*

11. Quoted in Ashton, *Twentieth Century Artists on Art,* p. 260.

12. Meyer Schapiro, *Modern Art, 19th and 20th Centuries: Selected Papers* (New York: Braziller, 1979), p. 218.

13. Frank Stella, *Working Space* (Cambridge: Harvard University Press, 1986), pp. 153, 155.

14. Quoted in William Rubin, *Frank Stella* (New York: Museum of Modern Art, 1970), p. 13.

15. Quoted in *Ibid.*, p. 10.

16. Quoted in *Ibid.*, pp. 41–42.

17. Harold Rosenberg, *Discovering the Present* (Chicago: University of Chicago Press, 1973), p. 124.

18. Quoted in Rubin, *Frank Stella*, p. 42.

19. Quoted in Battcock, ed., *Minimal Art*, p. 159.

THREE

1. Ben Belitt, ed. and trans., Antonio Machado, *Juan De Mairena* (Berkeley: University of California Press, 1963), p. 15.

2. Quoted in *Carl Andre Sculpture*, n. pag.

3. Quoted in *Ibid*.

4. Quoted in *Ibid*.

5. Arthur C. Danto, *The Transfiguration of the Commonplace* (Cambridge: Harvard University Press, 1981), p. 65.

6. Quoted in Lucy Lippard, ed., *Surrealists on Art* (Englewood Cliffs: Prentice-Hall, 1970), p. 7.

7. Quoted in *Carl Andre Sculpture*, n. pag.

8. Quoted in Battcock, ed., *Minimal Art*, p. 119.

9. For an illuminating account of how projection occurs see Richard Wollheim, *Painting as an Art* (Princeton: Princeton University Press, 1987), pp. 82–85.

10. Quoted in *Carl Andre Sculpture*, n. pag.

FOUR

1. Quoted in Battcock, ed., *Minimal Art*, p. 156.

2. Quoted in *Ibid.,* p. 155.

3. Literary critic Terry Eagleton has recently voiced a surprisingly sanguine view of the commodification of art, but his view entails a subtle anthropomorphism. "If the ethical dimension of social life has attained a worrying new kind of autonomy," he writes, "so has the cultural or aesthetic region; and a set of mutually beneficial alliances might always be struck up between them. With the increasing commodification of art, aesthetic objects come to exist not for any specific audience or social function, but just for anybody with the money to buy them and the abstract taste to appreciate them. Art comes to exist increasingly for itself, since it exists for nobody and nothing in particular. Its very economic integration into capitalist production has paradoxically helped to render it socially pointless. But art can always turn to advantage the autonomy which its commodity status has forced upon it, making a virtue out of sordid necessity. Its whole *point* is to be gloriously pointless; its very splendor is to exist entirely for its own sake. *Like humanity itself, art is entirely self-validating* [my italics]; and it can therefore come to function as a kind of negative politics, a mute, lonely refutation of the remorseless instrumentalization of powers it observes everywhere around it." "The Ideology of the Aesthetic" in *Times Literary Supplement*, January 22–28, 1988, p. 84.

FIVE

1. Robert Morris, "Notes on Sculpture" in Battcock, ed., *Minimal Art*, p. 228.

2. *Ibid.*, p. 232.

3. Michael Fried, "Art and Objecthood" in Battcock, ed., *Minimal Art*, pp. 116–47. Originally published in *Artforum*, June 1967.

4. Robert Smithson in conversation with the author.

5. Michael Fried, "Art and Objecthood" in Battcock, ed., *Minimal Art*, p. 123, n. 4.

6. Theodor Adorno, *Against Epistemology: A Meta-Critique*, translated by Willis Domingo (Cambridge: MIT Press, 1983), pp. 158–59.

7. Fried, "Art and Objecthood," p. 116.

8. *Ibid.*, pp. 128–29.

9. Harold Rosenberg, "De-aestheticization" in *The De-definition of Art* (New York: Macmillan, 1972), pp. 37–38.

10. Annette Michelson titled an important essay on Morris "The Aesthetics of Transgression" in *Robert Morris*, exhibition catalog (Washington, D.C.: Corcoran Gallery of Art, 1969).

11. Fried, "Art and Objecthood," p. 147.

12. George W. S. Trow, *Within the Context of No-Context* (Boston: Little, Brown, 1981), p. 8. Trow's book is one of the most perceptive analyses of television as a phenomenon yet published, especially as it pertains to Minimalism. Trow emphasizes certain aspects of television that no one else comments on. For example,

he writes: "Television has a scale. It has other properties, but what television has to a dominant degree is a certain scale and the power to enforce it. No one has been able to describe the scale as it is experienced" (p. 5). And "The work of television is to establish false contexts and to chronicle the unraveling of existing contexts; finally to establish the context of no-context and to chronicle it" (p. 51). With respect to the situation Trow evokes, Minimalism may be understood as a rearguard action against the onset of the so-called post-modernist condition.

SIX

1. Hannah Arendt, *The Human Condition* (Chicago: University of Chicago Press, 1958), pp. 52–53.

2. For an analysis of the ascendency of representations over the rest of reality, see Jean Baudrillard, *Simulations*, translated by Paul Foss, Paul Patton, and Philip Beitchman (New York: Semiotext(e), 1983).

3. Clement Greenberg, *The Collected Essays and Criticism* (Chicago: University of Chicago Press, 1986), vol. 2, p. 316.

4. Richard Wollheim suggests that they are so affected when he discusses the mental habit of envisioning emotions as bodily experiences: "We corporealize these phenomena when, for instance, we think of hate as something that tears us apart, or we regard love as necessarily diminished or divided when it is shared or we love two people at once. These thoughts are shadows cast by the mind upon its own workings. But they are shadows that succeed in staining that upon which they fall, for the mental phenomena become as they are envisioned. . . . The mind starts to conform to its own prejudices about itself." *The Thread of Life* (Cambridge: Harvard University Press, 1985), p. 145.

5. Ludwig Wittgenstein, *Philosophical Investigations*, translated by G.E.M. Anscombe (New York: Macmillan, 1967), p. 3e.

6. Maurice Merleau-Ponty, *Phenomenology of Perception*, translated by Colin Smith (London: Routledge & Kegan Paul, 1962), p. 405.

SEVEN

1. Sol LeWitt, "Sentences on Conceptual Art, 1968" in Ursula Meyer, ed., *Conceptual Art* (New York: Dutton, 1972), p. 175.

2. Rosalind Krauss, "LeWitt in Progress" in *The Originality of the Avant-Garde and Other Modernist Myths* (Cambridge: MIT Press, 1985), pp. 244–58.

3. George Trow uses the image of grids to evoke the fearsome social effects of television: "The middle distance fell away, so the grids (from small to large) that had supported the middle distance fell into disuse and ceased to be understandable. Two grids remained. The grid of two hundred million and the grid of intimacy. Everything else fell into disuse. There was a national life—a *shimmer* of national life—and intimate life. The distance between these two grids was very great. The distance was very frightening. People did not want to measure it. People began to lose a sense of what distance was and of what the usefulness of distance might be." *Within the Context of No-Context*, p. 7.

4. Mel Bochner, "Excerpts from Speculation (1967–70)" in Meyer, ed., *Conceptual Art*, p. 50.

5. *Ibid.*

6. *Ibid.*, pp. 55–56.

7. Merleau-Ponty, *Phenomenology of Perception*, p. 137.

8. Brian O'Doherty, *Inside the White Cube* (San Francisco: Lapis Press, 1986), p. 15.

9. *Ibid.*

10. Robert Smithson in Nancy Holt, ed., *The Writings of Robert Smithson* (New York: New York University Press, 1979), p. 10.

EIGHT

1. Smithson, *Ibid.*, pp. 155–56.

2. *Ibid.*, p. 175.

3. *Ibid.*, p. 133.

4. *Ibid.*, p. 87.

5. *Ibid.*, pp. 95, 97, 102.

6. *Ibid.*, p. 132.

7. Philip Leider, "Richard Serra, Castelli Warehouse" in Amy Baker Sandback, ed., *Looking Critically: 21 Years*

ARTISTS' STATEMENTS

CARL ANDRE

There is no symbolic content to my work. It is not like a chemical formula but like a chemical reaction. A good work of art, once it is offered in display and shown to other people, is a social fact. . . . I like works that you can be in the room with and ignore when you want to ignore them.

The art of association is when the image is associated with things other than what the art work itself is. Art of isolation has its own focus with a minimum association with things not itself. The idea is the exact opposite of multi-media communication. My work is the exact opposite of the art of association. I try to reduce the image-making function of my work to the least degree.

Americans are more interested in things by association than by direct experience of them. They are sentimental, which explains the popularity of Pop Art.
—*Quoted in Dodie Gust, "Andre: Artist of Transportation,"* The Aspen Times, *July 18, 1968.*

My work has never been architectural. I began by generating forms, then generating structures, then generating places. A place in this sense is a pedestal for the rest of the world. . . . Works of art are fetishes; that is, material objects of human production that we endow with extramaterial powers. My works are intended to give pleasure, nothing else. . . . My work has not been about the least condition of art but about the necessary condition of art. I will always try to have in my work only what is necessary to it. . . . [Frank] Stella's influence on me was practical and profoundly ethical. What he demanded from himself and from those for whom he had respect was that an artist must discover between himself and the world that art which is unique to him and then purge that art of all effects that do not serve its ends.
—*Carl Andre Sculpture (exhibition catalog), State University at Stony Brook, Stony Brook, New York, 1985, n. pag.*

I think it is futile for an artist to try to create an environment, because you have an environment around you all the time. . . . A place is an area within an environment which has been altered in such a way as to make the general environment more conspicuous. Everything is an environment, but a place is related particularly to both the general qualities of the environment and the particular qualities of the work that has been done.
—*Transcript of a symposium at Windham College, Putney, Vermont, on April 30, 1968, quoted in* Carl Andre *(exhibition catalog), Haags Gemeentemuseum, 1969, pp. 5–6.*

MICHAEL HEIZER

I'm involved in sculpture that can be produced outside of the art community and without the use of art materials; sculptures made of materials such as dirt, gravel and rock. I'm also interested in the dialectical opposite to this position. . . . My obligation as a sculptor is to work with anything that is tangible and physical. I realize there is expressive potential in materials, but I'm more interested in the structural characteristics of materials than their beauty. I think earth is the material with the most potential because it is the original source of material. . . . When I began to build sculpture I always made it outdoors. I immediately encountered large amounts of material and eventually tried to incorporate gravity as a free and natural source of energy. . . . The *Double Negative*, due to gravity, was made using its own substance, leaving a full visual statement and an explanation of how it is made. In *Double Negative* there is the implication of an object or form that is actually not there. In order to create this sculpture material was removed rather than accumulated. The sculpture is not a traditional object sculpture. The two cuts are so large that there is the implication that they are joined as one single form. The title *Double Negative* is a literal description of two cuts but has metaphysical implications because a double negative is impossible. There is nothing, yet it is still a sculpture.
—Michael Heizer: Sculpture in Reverse *(exhibition catalog), Los Angeles Museum of Contemporary Art, 1984, pp. 14–16.*

DONALD JUDD

Three dimensions are real space. That gets rid of the problem of illusionism and of literal space, space in and

of Artforum Magazine (Ann Arbor: UMI Research Press, 1984), pp. 294–95.

8. Steve Reich, *Writings About Music* (Halifax and New York: Press of Nova Scotia College of Art and Design and New York University Press, 1974), pp. 9–11.

9. See Rosalind E. Krauss, *Richard Serra/Sculpture* (New York: Museum of Modern Art, 1986).

10. Primo Levi, *The Periodic Table*, translated by Raymond Rosenthal (New York: Schocken, 1984), p. 87.

11. José Ortega y Gasset, *Some Lessons in Metaphysics*, translated by Mildred Adams (New York: Norton, 1969), p. 51.

12. Gilbert Ryle, *The Concept of Mind* (New York: Barnes and Noble, 1966), pp. 50–51.

NINE

1. A number of people saw financial support jeopardized or terminated by the restructuring of the Dia Art Foundation. But two incidents received almost sensationalistic treatment in the press. In 1985, Carl Andre was arrested on suspicion of having murdered his wife. He was acquitted when the case came to trial in 1988. For several years, Richard Serra has been involved in acrimonious litigation over the removal of his public sculpture, "Tilted Arc," from its lower Manhattan site threatened by the General Services Administration, which commissioned the work in the first place. See discussion of "Tilted Arc" in Kenneth Baker, "Vectors of Viewer Response," *Artforum*, September 1986, pp. 102–8.

2. Audrey Flack, *Art and Soul* (New York: Dutton, 1986), p. 106.

3. Michel Foucault, "The Subject and Power" in Brian Wallis, ed., *Art After Modernism: Rethinking Representation* (Boston: David R. Godine, 1984), p. 417.

4. *Ibid.*, p. 419.

5. *Ibid.*, p. 420.

around marks and colors—which is riddance of one of the salient and most objectionable relics of European art. The several limits of painting are no longer present. A work can be as powerful as it can be thought to be. Actual space is intrinsically more powerful and specific than paint on a flat surface. Obviously, anything in three dimensions can be any shape, regular or irregular, and can have any relation to the wall, floor, ceiling, room, rooms or exterior or none at all. Any material can be used, as is or painted. . . . In the three dimensional work the whole thing is made according to complex purposes, and these are not scattered but asserted by one form. . . .

The use of three dimensions makes it possible to use all sorts of materials and colors. Most of the work involves new materials, either recent inventions or things not used before in art. Little was done until recently with the wide range of industrial products. Almost nothing has been done with industrial techniques, and, because of the cost, probably won't be for some time. Art could be mass-produced and possibilities otherwise unavailable, such as stamping could be used. Dan Flavin, who uses fluorescent lights, has appropriated the results of industrial production. Materials vary greatly and are simply materials—formica, aluminum, cold-rolled steel, plexiglas, red and common brass, and so forth. They are specific. If they are used directly, they are more specific. Also, they are usually aggressive. There is an objectivity to the obdurate identity of a material. . . . Most of the new materials are not as accessible as oil on canvas and are hard to relate to one another.
—"Specific Objects," Arts Yearbook, 1965; reprinted in Donald Judd: Complete Writings 1959–1975, Press of the Nova Scotia College of Art and Design, Halifax, and New York University Press, New York, 1975, pp. 184, 187.

[The] separation of means and structure—the world and order—is one of the main aspects of European or Western art and also of most older, reputedly civilized, art. It's the sense of order of Thomist Christianity and of the rationalistic philosophy which developed from it. Order underlies, overlies, is within, above, below or beyond everything.

I wanted work that didn't involve incredible assumptions about everything. I couldn't begin to think about the order of the universe, or the nature of American society. I didn't want work that was general or universal in the usual sense. I didn't want to claim too much. Obviously the means and the structure couldn't be separate and couldn't even be thought of as two things joined. Neither word meant anything.

A shape, a volume, a color, a surface is something itself. It shouldn't be concealed as part of a fairly different whole. The shapes and materials shouldn't be altered by their context. One or four boxes in a row, any single thing or such a series, is local order, just an arrangement, barely order at all. The series is mine, someone's, and clearly not some larger order. It has nothing to do with either order or disorder in general. Both are matters of fact. The series of four or six doesn't change the galvanized iron or steel or whatever the boxes are made of.
—"Portfolio: 4 Sculptors," Perspecta, New Haven, March/ May, 1968; reprinted in Donald Judd: Complete Writings, p. 196.

ROBERT MORRIS

The kinds of identification between the body and things initiated by certain art of the '60s and continued today was not so much one of images as of possibilities for behavior. With the sense of weight, for example, goes the implicit sense of being able to lift. With those estimations about reasonableness of construction went, in some cases, estimations of the possibility for handling, stability or the lack of it, most probable positions, etc. Objects project possibilities for action as much as they project that they themselves were acted upon. The former allows for certain subtle identifications and orientations; the latter, if empha-sized, is a recovery of the time that welds together ends and means. Perception itself is highly structured and presupposes a meaningful relation to the world. The roots of such meanings are beyond consciousness and lie bound between the culture's shaping forces and the maturation of the sense organs which occurs at a pre-verbal stage. In any event, time for us has a direction, space a near and far, our own bodies an intimate awareness of weight and balance, up and down, motion and rest and a general sense of the bodily limits of behavior in relation to these awarenesses. A certain strain of modern art has been involved in uncovering a more direct experience of these basic perceptual meanings and it has not achieved this through static images but through the experience of an interaction between the perceiving body and the world which fully admits that the terms of this interaction are temporal as well as spatial, that existence is process, that the art itself is a form of behavior that can imply a lot about what was possible and what was necessary in

engaging with the world while still playing the insular game of art.... Around the beginning of the '60s, the problem presented itself as to what alternatives could be found to the Abstract Expressionist mode of arranging. The Minimal presented a powerful solution: construct instead of arrange. Just as that solution can be framed in terms of an opposition (arrange/build) so can the present shift be framed dialectically: don't build ... but what? Drop, hang, lean, in short act. If for the static noun of "form" is substituted the dynamic verb of "act" in the priority of making, a dialectical formulation has been made. What has been underlined by recent work in the unconstructed mode is that since no two materials have the same existential properties, there is no single type of act that can easily structure one's approach to various materials.... What is clear in some recent work is that materials are not so much brought into alignment with static a priori forms as that the material is being probed for openings that allow the artist a behavioristic access.

—*"Some Notes on the Phenomenology of Making: The Search for the Motivated"; reprinted in* Looking Critically: 21 Years of Artforum Magazine, *UMI Research Press, Ann Arbor, 1984, p. 92.*

RICHARD SERRA

In all my work the construction process is revealed. Material, formal, contextual decisions are self-evident. The fact that the technological process is revealed depersonalizes and demythologizes the idealization of the sculptor's craft. The work does not enter into the fictitious realm of the "master."... My works do not signify any esoteric self-referentiality. Their construction leads you into their structure and does not refer to the artist's persona. However, as soon as you put a work into a museum, its label points first to the author. The visitor is asked to recognize "the hand." Whose work is it? The institution of the museum creates self-referentiality, even when it's not implied. The question how the work functions is not asked. Any kind of disjunction the work might intend is eclipsed. The problem of self-referentiality does not exist once the work enters the public domain. How the work alters a given site is the issue, not the persona of the author. Once the works are erected in a public space, they become other people's concerns.

If you reduce sculpture to the flat plane of the photograph, you're passing on only a residue of your concerns. You're not only reducing sculpture to a different scale for the purposes of consumption, but you're denying the real content of the work. At least with most sculpture, the experience of the work is inseparable from the place in which the work resides. Apart from that condition, any experience of the work is a deception.

But it could be that people want to consume sculpture the way they consume paintings—through photographs. Most photographs take their cues from advertising, where the priority is high image content for an easy Gestalt reading. I'm interested in the experience of sculpture in the place where it resides.

—Richard Serra/Sculpture *(exhibition catalog), Museum of Modern Art, New York, 1986, pp. 47–48.*

TONY SMITH

I'm interested in the inscrutability and the mysteriousness of the thing. Something obvious on the face of it (like a washing machine or a pump) is of no further interest. A Bennington earthenware jar, for instance, has subtlety of color, largeness of form, a general suggestion of substance, generosity, is calm and reassuring—qualities which take it beyond pure utility. It continues to nourish us time and time again. We can't see it in a second, we continue to read it. There is something absurd in the fact that you can go back to a cube in the same way. It doesn't seem to be an ordinary mechanical experience. When I start to design, it's always corny and then naturally moves toward economy.

I view art as something vast.... In terms of scale, we have less art per square mile than any society ever had. We are puny.... When I was teaching at Cooper Union in the first year or two of the fifties, someone told me how I could get on the unfinished New Jersey Turnpike. I took three students and drove from somewhere in the Meadows to New Brunswick. It was a dark night and there were no lights or shoulder markers, lines, railings or anything at all except dark pavement moving through the landscape of the flats, rimmed by hills in the distance, but punctuated by stacks, towers, fumes and colored lights. This drive was a revealing experience. The road and much of the landscape was artificial, and yet it couldn't be called a work of art. On the other hand, it did something for me that art had never done. At first I didn't know what it was, but its effect was to liberate me from many of the views I had had about art. It seemed that there had been a reality there which had not had any expression in art.

The experience on the road was something mapped out but not socially recognized. I thought to myself, it

ought to be clear that's the end of art. Most painting looks pretty pictorial after that. There is no way you can frame it, you just have to experience it.

—*Samuel Wagstaff, Jr., "Talking with Tony Smith," in* Looking Critically: 21 Years of Artforum Magazine, *UMI Research Press, Ann Arbor, 1984, pp. 50–52.*

ROBERT SMITHSON

The scale of the *Spiral Jetty* tends to fluctuate depending on where the viewer happens to be. Size determines an object, but scale determines art. A crack in the wall if viewed in terms of scale, not size, could be called the Grand Canyon. A room could be made to take on the immensity of the solar system. Scale depends on one's capacity to be conscious of the actualities of perception. When one refuses to release scale from size, one is left with an object or language that *appears* to be certain. For me scale operates by uncertainty. To be in the scale of the *Spiral Jetty* is to be out of it. On eye level, the tail leads one down into an undifferentiated state of matter. One's downward gaze pitches from side to side, picking out random depositions of salt crystals on the inner and outer edges, while the entire mass echoes the irregular horizons. And each cubic salt crystal echoes the *Spiral Jetty* in terms of the crystal's molecular lattice. Growth in a crystal advances around a dislocation point, in the manner of a screw. The *Spiral Jetty* could be considered one layer within the spiraling crystal lattice, magnified trillions of times.

—*"The Spiral Jetty" in* The Writings of Robert Smithson, *New York University Press, 1979, p. 112.*

I am for an art that takes into account the direct effect of the elements as they exist from day to day apart from representation. The parks that surround some museums isolate art into objects of formal delectation. Objects in a park suggest static repose rather than any ongoing dialectic. Parks are finished landscapes for finished art. A park carries the values of the final, the absolute, and the sacred. Dialectics have nothing to do with such things. I am talking about a dialectic of nature that interacts with the physical contradictions inherent in natural forces as they are—nature as both sunny and stormy. Parks are idealizations of nature, but nature in fact is not a condition of the ideal. Nature does not proceed in a straight line, it is rather a sprawling development. Nature is never finished. When a finished work of 20th century sculpture is placed in an 18th century garden, it is absorbed by the ideal representation of the past, thus reinforcing the political and social values that are no longer with us.

—*"Cultural Confinement" in* The Writings of Robert Smithson, *p. 133.*

FRANK STELLA

My whole way of thinking about painting has a lot to do with building—having foundations to build on. The Black pictures were a groundwork structure in more ways than one. I enjoy and find it fruitful to think about many organizational or spatial concepts in architectural terms, because when you think about them strictly in design terms, they become flat and very boring problems. So I guess I use a little bit of the outside world by bringing in architecture as another way of looking at the problems, as a way of expanding them. But I think my painting remains a distinctly pictorial experience—it's not finally an architectural one. It doesn't really need to have anything to do with architecture, or the [spectator's] ability to understand architecture. . . . The bands in the Black pictures weren't meant to "travel" that much—those pictures were more a pattern imposed on a field. The units in the Aluminum pictures were intended to be more individual, put together to make something like a "force field" (to use the term Carl Andre was fond of). . . . The aluminum surface had a quality of repelling the eye in the sense that you couldn't penetrate it very well. It was a kind of surface that wouldn't give in, and would have less soft, landscape-like or naturalistic space in it. I felt that it had the quality of being slightly more abstract.

The sculptors just scanned the organization of painting and made sculpture out of it. It was a bad reading of painting; they didn't really get much of what the painting was about. Repetition is a problem and I don't find it particularly successful in the form of sculptural objects. There are certain strong qualities in the pictorial convention—the way in which perimeter, area, and shape function—that allow a serial pattern to derive benefits from them. Repeated units on a unified painted ground function a lot differently than do separate units standing on a floor or nailed to the wall. Of course the sculptors will say that it's just a failure in the development of *our* ability to see—that we're not seeing their work right.

—*Quoted in William Rubin,* Frank Stella, *Museum of Modern Art, New York, 1970, pp. 46, 60, 70.*

I N D E X

PHOTO CREDITS
All photographic materials were obtained directly from the collections indicated in the captions, except for the following:

Courtesy Larry Bell: p. 10 (Bell); Courtesy Leo Castelli Gallery, New York: jacket front, endpapers, pp. 57, 61, 63, 68, 69 (Morris installation), 76, 80, 84, 88, 92, 99, 100 (Flavin, *"monument,"* 1968), 101 (both), 113 (both), 114, 115 (Serra), 119; Photo by Giorgio Colombo, Milan: p. 85; Courtesy Paula Cooper Gallery, New York: pp. 11 (both), 13 (Andre), 16, 43, 44, 46, 47 (Andre, *8 Cuts*), 48, 49, 53, 72, 73 (all), 87, 115 (Andre), 130 (all), 131, 132 (Shapiro); Courtesy Andre Emmerich Gallery, New York: p. 51; © 1986 Gianfranco Gorgoni/Contact: p. 102; Courtesy Margo Leavin Gallery, Los Angeles: p. 22 (Kelly); Courtesy Lisson Gallery, London: p. 36; Photo by Robert Lorenzson, New York: p. 32; Courtesy Michelangelo Pistoletto: p. 111; Photo by Robert Rubic, New York: p. 66; Courtesy Sonnabend Gallery, New York: pp. 24, 37 (Kounellis), 91; Courtesy Washburn Gallery, New York: p. 14; Courtesy John Weber Gallery, New York: pp. 105, 106, 108; Photos by Rob Wilson, New York: frontispiece, pp. 59 (Judd, *Untitled*, 1972), 62 (Judd, *Untitled*, 1980–86).